**Felix H. Man**

Born in Freiburg, Germany, in 1893, Felix H. Man has lived in England since 1934. For more than seven years he was chief photographer on *Picture Post* and later served as color consultant to that publication. He is the author of *150 Years of Artists' Lithographs*, *Eight European Artists*, *Lithography in England 1801-1810*, and of a catalogue raisonné of Graham Sutherland, *The Graphic Work 1922-70*. In 1965 he was awarded the 'Kulturpreis' by the German Photographic Society for his work as a pioneer in modern photo-journalism and in 1968 the German Order of Merit 1st Class for his services in the field of culture. Since 1962 he has been editor of *Europaeische Graphik*.

# Artists' Lithographs

# Artists' Lithographs

A world history from Senefelder to the present day

Felix H. Man [pseud.]

Bauman, Hans F15

G. P. Putnam's Sons New York

This book is dedicated to the memory of ALOYS SENEFELDER, Inventor of Lithography and Chemical Printing, the two-hundredth anniversary of whose birth will be celebrated on 6 November 1971.

**Errata**

p.69, line 49   For 'of his art' read 'of this art'
p.91,   The identification numbers below pls 29 and 30 should be transposed.
p.193, line 2   For 'L'Estampe Française . . .' etc. read 'Toulouse-Lautrec, his complete lithographs and drypoints'
p.195, note 40 line 3   For 'Paul Vernet' read 'Carle Vernet'
p.199, note 103 line 3   For 'LD 159/IIII' read 'LD 159/III'
p.202, note 149 line 4   For 'M2' read 'M1'
p.208, line 16   For 'd'Estrauipes' read 'd'Estampes'
p.212, line 23   For 'James —ard' read 'James Ward'
p.213 (index) For 'La Charivari' read 'Le Charivari'

Library of Congress Catalog Card Number: 76–117501
Illustrations printed in Italy
Text printed in England

# Contents

# Introduction

'Artists' Lithographs' is the title of this book. The spirit of this phrase is better served by the French who have the expression 'peintre-graveur', reserved for the creative artist as distinct from the professional engraver or lithographer, whose task it is merely to reproduce works of art invented by an artist.

When lithography first came into being great progress was made in the field of *reproduction* by lithography in particular in Munich, and the names of Strixner and Piloty are important in this connection. However, even though the highest technical skills and understanding were necessary for translating paintings and drawings into the medium of lithography, these works were still not original lithographs or works of art, but reproductions.

In those early days it was customary to call lithography 'the new art'. As a process or a technique should by itself bear such a title only when exercised by a creative artist, this general term was misleading, though it was adopted by the Gallery Director von Mannlich, in his memoirs, and even by Goethe, neither of whom made as clear a distinction between art and technique as we with hindsight must today. It is precisely true, therefore, that the professional lithographer came into existence the moment the first lithographic reproductions of works of art appeared on the market.

A word about hand-signed prints: until the 1880s prints were not usually signed by the artist; there are the occasional exceptions on dedication proofs. It is therefore pointless to search for prints signed by Goya, Manet or Corot for instance. Signing prints in pencil became a habit which American dealers demanded and today it is the custom, and is generally acknowledged as a proof that the artist has passed the impression as satisfactory. Naturally only limited editions are signed by the artist. In recent years, however, some of the best-known leading French artists have signed not only their original graphics, but also lithographic reproductions of their oil paintings or watercolours. This must be deeply regretted since the general public cannot in all cases distinguish between an original lithograph and a reproduction by lithography executed by a craftsman.

But worse still than this is the fact that original colour lithographs of artists whose copyright has expired are now reproduced with the help of lithography in exactly the same sizes as the originals. Modern techniques have advanced so much that these facsimiles are so true to the original that only the expert can see the difference—much to the general public's disadvantage.

\*   \*   \*   \*   \*

The author wishes to thank all those who have given permission to reproduce their prints, in particular the Departments of Prints of the British Museum and the Victoria and Albert Museum in London, the Museum of Fine Arts in Philadelphia, the Städelsche Kunst Institut in Frankfurt, the Redfern Gallery and Marlborough Fine Art in London, the Galerie Louise Leiris and the Galerie Maeght in Paris, and the Galerie Wolfgang Ketterer in Munich. Special thanks are due to the well-known collector Dr A. Winkler in Munich, who gave me some valuable hints.

London, Spring 1970

Throughout the book dates given in brackets have been verified but do not appear on the plate itself.

For the convenience of the general reader original titles of lithographs have been translated into English both in the main text and in the captions beneath the pictures. For reference purposes, however, and for the benefit of the collector, the original titles are included in the extended notes to illustrations on pages 193–205 or, when the lithograph mentioned is not illustrated, in footnotes to the text.

# 1 Aloys Senefelder 1771–1834

Since printing was invented by Johann Gensfleisch zum Gutenberg, nothing has influenced the craft so much and directed it into such new channels as the invention of 'Chemical Surface Printing' by Aloys Senefelder towards the end of the eighteenth century. In the world of artists' prints today, lithography is preferred to any other medium, and what we now call offset printing (a mechanical method of reproduction) is based on Senefelder's original discovery: Chemical Printing.

This new, electronic age is seeing out the era of mechanical composing machines, using metal type, and is heralding a new age where plates are prepared for printing by means of light rays and electronics, cutting the production time for printing plates to a fraction and using surface printing (offset).

It is certain that the inventor of Chemical Printing did not dream of his process achieving such world-wide distribution and such immense importance for modern printing. Senefelder's genius had, typically, to fight constant difficulties and continuous setbacks, for in the early nineteenth century the regulation of the laws of copyright and the protection of intellectual property knew few of the regulations current in all civilized countries of the West today.

Moreover, at the turn of the century, the whole of Europe was shaken for more than a decade by the disorders of the Napoleonic Wars, and normal conditions of trade between countries were greatly hampered. But in spite of all this, Senefelder could certainly have gained more profit from his invention if his attitudes towards life and his own work had been different and if he had not been his own worst enemy. 'Character is destiny'—the course of Senefelder's life proves this adage.

Aloys Senefelder was born on 6 November 1771 in Prague, the son of Franz Peter Senefelder, the actor. At this time Frederick the Great was still reigning, Goethe was a twenty-two-year-old student at Strasbourg, and Schiller was his senior, nearly to the day, by twelve years. The disruptions of the Seven Years' War were over and the old German Empire under the House of Habsburg-Lothringen remained intact. The restless days following the fall of Louis XVI in France did not spread over Europe for another twenty years, by which time Senefelder had completed his studies in Ingolstadt.

The Senefelder family came from Lower Franconia in Bavaria. Soon after the birth of his son Aloys, father Senefelder became a member of the court theatre in Mannheim. In 1778 he finally settled in Munich and joined the court theatre of the Elector. At first Aloys attended the Gymnasium in Munich. He was a good pupil and left the Electoral Lyceum, where he studied from 1787–9, with a brilliant certificate. His wish to become an actor was opposed by his father, and with a grant from the Elector he studied Law at Ingolstadt University for three years, until 1793. But his artistic leanings and prolific gifts gave him no peace. He wrote verse and plays, and his comedy *Die Mädchenkenner* was enthusiastically received at the Munich court theatre in February 1792. Encouraged by this success, he had the play printed at his own expense. He gave part of the edition away and sold the rest, but his profit amounted to only 50 Guilders. In spite of this—his father had died in the meantime—he gave up his studies, joined the theatre, and spent the following years as an actor with strolling players, writing plays at the same time. His success as an actor being only moderate, he concentrated his energies on playwriting.

At this period, the common man preferred the popular theatre to the court theatre. He liked robust farces where he could laugh heartily. One of the most popular authors of the time was Emanuel Schikaneder, who had made his name as the librettist of Mozart's *The Magic Flute*.

The cost of having his works printed was a heavy burden for Senefelder. Petitions to the Elector for support were refused, and in order to reduce his expenses he considered establishing a printing shop of his own. But he had not sufficient means. Genius, however, finds its own way, and Senefelder began experimenting to find a method by which he himself could produce type for printing. After all kinds of tests and when he was even thinking of taking lessons from the engraver Mettenleiter he struck upon the idea of etching stones. By 1796 he had achieved his first printed product produced by block printing from stone. But this was not lithography. Two years later, in 1798, he invented an entirely new process of printing from a flat surface. He called it Chemical Printing.

Senefelder's life was typical of that of a gifted man whose interests were too widely scattered, who forgot reality and chased his phantoms. He wandered restlessly from one

place to another. As soon as he had reached one goal he would be moving on with new ideas, never properly consolidating his achievements. He found a real benefactor in Johann Anton André, music publisher and Aulic Councillor from Offenbach, a well-meaning man who became for a time his business partner, never exploiting the genial inventor. In fact André was always quite willing to come to a sharing arrangement with Senefelder and even planned to make him a partner in a large growing business.

But Senefelder, restless as ever, would not accept this. While on the one hand with his natural loquacity he would give away the secrets of his inventions, on the other his suspicions were so great, though possibly mixed with jealousy, that he even parted from his benefactor, in order to pursue new goals and explore new ideas in Vienna. Yet he remained devoted to his family and took great interest in the welfare of his brothers, giving them permission to set up printing works using his process and forgiving them their sometimes shady business activities.

On 3 September 1799 he had received a privilege for fifteen years from the then Elector of Bavaria. But during his absence in Vienna from 1801–6, this privilege was not only ignored by pirate operators but the government of Bavaria itself set up lithographic printing works, overriding Senefelder's legal rights. When he returned from Vienna he took the matter to court, supporting his action by a petition to the king. King Maximilian, hearing of the scandalous situation through this petition, ordered a thorough enquiry to be made and asked his minister Josef von Utzschneider to compensate Senefelder accordingly. After this, Senefelder was appointed Royal Inspector of Lithography in the service of the State, with a salary of 1500 Guilders. His old friend and partner Gleissner, with whom he had collaborated since 1796, received 1000 Guilders.

For the moment his financial worries were over, and early in January 1810 he married. But soon he was in difficulties again. His wife, whom he had hoped could direct his printing shop, became ill, and in June 1813 died while giving birth to a son. The restless Senefelder asked for leave and set off again on his travels. In Leipzig, in association with the large music publisher Breitkopf & Härtel, he tried to obtain a privilege, but the King refused.

Not only was Senefelder's intellectual property pirated, but articles were published disputing his right to the invention. In these articles Professor Mitterer was named as the inventor of the chalk technique, while von Rapp was alleged to be the inventor of the transfer method. In 1813 even his brother Theobald tried to obtain a privilege in Augsburg, having made a miserable attempt to proclaim himself the inventor.

Senefelder married again in 1813 and worked on improving his methods—using metal for the plates, portable presses—hoping for more profits. As he had instructed his workmen well, and his brothers supervised the printing works, he was not very busy as a Royal Inspector. Johann Anton André had for some time been encouraging him to write and publish his own textbook, and Senefelder occupied himself with this task assiduously. But his *Wanderlust* once more caused him to abandon this work, and towards the end of 1816 he paid another visit to Vienna to start a new printing shop. As he had no sense of time he would have stayed in Vienna far longer, had not his friends Adolf Heinrich Friedrich von Schlichtegroll, Director of the Royal Academy of Science, and André pressed him to publish his long overdue book on his inventions, in order to set down once and for all his rights of priority. At the suggestion of the Royal Academy, King Maximilian Joseph accepted the dedication of this book, which was finally published for the Leipzig Book Fair in 1818. In the following year an English and a French edition appeared.

Once more Senefelder became restless and paid a short visit in November 1818 to Vienna, going from there to Paris, where he defended his latest invention, the 'Cartons Lithographiques'. These artificial stone tablets were designed to enable artists to lithograph while travelling, and a specially constructed hand press was available. A company to launch this 'stonepaper' was formed in Paris in association with Treutel & Würtz, and Joseph Knecht, an employee of André, became a director. Senefelder had optimistically stated that these stone tablets were not only cheaper than the traditional heavy stones, but just as good. However, as time wore on, problems over using stonepaper arose, and Senefelder had to return to Paris in 1821 to set things right. But even this did not help, and eventually the Paris company was dissolved and taken over by Knecht.

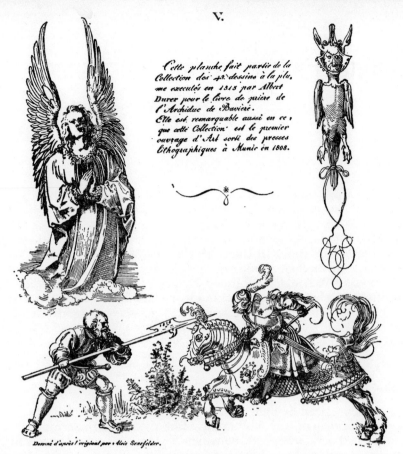

*Prayerbook of the Archduke of Bavaria, pen drawing by Senefelder, after Dürer, 1819. Published in Senefelder's book on lithography, French edition, Paris 1819.*

The King was annoyed that Senefelder had chosen to establish his new invention in France and not in Bavaria. At that time Bavaria was an independent kingdom, a state of its own, and was naturally keen to play a part not only in the politics of Europe but as a leading cultural centre in Central Europe. Since 1805, when Napoleon had made his headquarters in Augsburg at the inn 'Zu den Drei Mohren', many changes had taken place in Bavaria, and in 1806 the country had been raised to the status of kingdom, with an absolute monarch. Bavarian beer had made the country known beyond its frontiers; the meticulous scientific research carried out in the brewery schools meant that Bavarian master-brewers were sought all over the world, including North America. Senefelder's contemporaries in the field of invention were Josef Fraunhofer, whose discoveries at the turn of the nineteenth century paved the way for today's optical industry, Franz Xaver Gabelsberger, inventor of one of the many forms of shorthand, and Friedrich König, constructor of the mechanical printing press which changed the face of newspaper printing everywhere.

In October 1827, Senefelder relinquished his post as a Royal Inspector and was pensioned off. During his final years he occupied himself with oleography in an attempt to reproduce paintings in colour. He died in 1834 after a life filled with work and disappointments. In spite of his many successes he never became prosperous. His incorrigible optimism, his mixture of trust and distrust, his permanent lack of funds, brought about by his inability to keep money together, all conspired to deprive him of the rewards due to him.

King Ludwig ordered a tombstone to be erected for this genius at the old southern cemetery of Munich, bearing the inscription on Solnhofen stone:

Dedicated by His Majesty King Ludwig I. Here lies Aloisius Senefelder, Inventor of Lithography—born in Prague—6 November 1771—died in Munich—6 February 1834.[1]

The magistrate of Munich decided in 1856 that the grave should remain inalienable for all time.

In 1835, in *Le Lithographe* (Paris), there appeared an article proposing a monument for Senefelder, who, it was said, died in poverty. Le Comte de Lasteyrie suggested that a committee should be formed to erect such a monument and to strike a commemorative medal. This suggestion was supported by both Knecht and Engelmann. By 1838 there were already 280 lithographic printing shops in Paris alone; in the whole of France there were about 700.

[1] Translated from the German inscription.

# 2 Senefelder's invention

The actual idea of printing from stone was not a new one. Trials had been made with stone a considerable time before. But in every case stone was used purely as a substitute for other materials, and the method of printing remained one of those in common use, relief or intaglio. Etching stone to make pictures or letters visible had also been known long before Senefelder's time. In the sixteenth century sculptors were using this as a simple and quick method of producing inscriptions on tombstones—a method even described in books.[1] A booklet published by the Maximilian Museum, Augsburg, in 1927, mentions that relief etchings were made in the middle of the sixteenth century by the printer Philipp Uhlhard. The Museum itself possesses a quadratic plate, with five lines of music etched in relief, dated Anno Domini 1550, apart from other plates of later date. Senefelder admits this, and in his book he even explains:

> I was firmly convinced that I was not the inventor of the art of etching or engraving on stone, or of taking impressions from stone; I even knew that etching on stone had been practised several centuries before me.[2]

It is also known that Dean Schmid, regarded in Munich as Senefelder's rival during his lifetime, designed a map of Africa on stone before 1796, and in about 1797 wrote in Old Type letters, etched with *aqua-fortis*, by which he obtained raised letters for printing. A little later Schmid even etched a bird, poisonous plants and parts of the human anatomy on stone. He used the prints thus obtained for instructional purposes at school.[3]

There is no argument over whether Schmid or Senefelder first invented lithography. Schmid had printed from etched stone before Senefelder but this was not a lithographic process. The only thing he had in common at the beginning with Senefelder was the use of stone. Senefelder's invention, however, was not dependent on the use of stone and he himself printed from other surfaces. His method was an entirely new one, not relying on the two known forms of printing, relief and intaglio, but on planography, a purely chemical process, which he called Chemical Printing. No arguments can alter these facts, not even those of director Von Mannlich (1817), nor those of Nagler, nor the not entirely clear discussion by Wilhelm Weber in *Saxa Loquuntur* (1961).[4]

It cannot be shown that Senefelder knew of Dean Schmid's experiments, but his friend, and later partner, the musician Gleissner certainly knew Schmid. Yet it is extremely doubtful that Gleissner can be regarded as a link between the two. It has often happened that different inventors have busied themselves with the same problems, without knowing of one another's work, and while Senefelder was experimenting in Germany, William Blake, the poet and painter, was searching in England for new ways of printing for his own use. Though Blake restricted himself to metal plates, he at first followed in principle the same tracks as Dean Schmid and Senefelder. He wrote his poems, with their illustrations and marginal drawings, on metal plates in an acid resistant fluid, and then etched the plates to obtain a relief printing surface. By this means, Blake produced a number of precious books which he then hand coloured.[5] In Blake's own words this process 'was revealed to him by the spirit of his dead brother'. Naturally he knew nothing of Schmid's work. In fact his researches were carried out several years before Schmid's, and his first book printed by hand by his new method was published in 1789.

None of these early experiments, even where stone was used, had anything to do with lithography. They were all based on relief printing. The oft related story that Senefelder, writing a laundry list one day and lacking paper, used stone—and through this got the

---

[1] *Curieuse Kunst und Werkschule von J.K.* (Nürnberg, 1705). Gives instructions on how to transfer drawings on to stone and etch the same. *Peuthers Gnomica* (Augsburg, 1768) describes another method. There are etched tombstones in Munich Cathedral.

[2] Aloys Senefelder *A Complete Course of Lithography* (London, 1819).

[3] Dr K. Nagler *Alois Senefelder und der geistliche Rath Simon Schmid als Rivalen* (Munich, 1862). (In this book, Schmid is named as the first known inventor of printing from stone by mechanical means. Gleissner is mentioned as the intermediary between Schmid and Senefelder.) See also Nagler *Künstler Lexicon* (Vol. 15, 1845).

[4] Dr K. Nagler *Alois Senefelder und der geistliche Rath Simon Schmid als Rivalen* (Munich, 1862).

[5] These excessively rare books are very expensive and even in May 1958 were fetching the following prices at an auction at Sotheby's: *The Book of Thel* 1st ed. 1789 £1900 ($5229); *Visions of the daughters of Albion* 1793 £23,000 ($64,630); *Songs of Innocence* 1789 £3800 ($10,458); *Songs of Los* 1795 £3800 ($10,458).

idea for his invention—is nothing but a nice story, though Senefelder himself wrote about it. His really important invention of a new way of printing was not discovered by accident but as the result of systematic research over a long period. Working with different materials he at last made his discovery, Chemical Printing. Senefelder described his invention in full detail in his book *A Complete Course of Lithography*:

> Lithography is a branch of a new method of printing, differing in its fundamental principles from all other methods now in use, and known by the name of Chemical Printing. All the other methods of printing, hitherto known, might be divided into two branches: the one multiplying the original by elevated forms, the other by engraved forms. To the first branch belongs the common letter-press printing, where the letters and signs are moulded in a composition of metal, or in wood, in such a manner that those lines and points which are to receive the colour, and be printed, are elevated; while the rest of the plate, which is to remain blank on the paper, lies deeper. The wooden blocks, for calico-printing, are of the same description.
>
> Under the second branch may be included all the different methods of engraving on copper or tin, as well as calico-printing from copper-plates or cylinders.
>
> It is evident that in both these methods of printing, the charging of the types or plates with colour, by which the impression is obtained, depends entirely on mechanical principles, viz. that, in the letter-press printing, the colour adheres only to those places that come in contact with it; and, in the copper-plate printing, to those from which it is not wiped off.
>
> The chemical process of printing is totally different from both. Here it does not matter whether the lines be engraved or elevated; but the lines and points to be printed ought to be covered with liquid, to which the ink, consisting of a homogenous substance, must adhere, according to its chemical affinity and the laws of attraction, while, at the same time, all those places which are to remain blank, must possess the quality of repelling the colour. These two conditions, of a purely chemical nature, are perfectly attained by the chemical process of printing; for common experience shews that all greasy substances, such as oil, butter etc., or such as are easily soluble in oil, as wax, bitumen, etc., do not unite with any watery liquid, without the intervention of a connecting medium; but that, on the contrary, they are inimical to water, and seem to repel it. The principal dissolving and uniting liquid for the above-mentioned substances is alkali, which, by proper management, forms a sort of soap, soluble in water.
>
> Upon this experience rests the whole foundation of the new method of printing, which, in order to distinguish it from the mechanical methods, is justly called the chemical method; because the reason why the ink, prepared of a sebaceous matter, adheres only to the lines drawn on the plate, and is repelled from the rest of the wetted surface, depends entirely on the mutual chemical affinity, and not on mechanical contact alone.

These original writings of Senefelder describe not only his first invention but also those which followed over the next twenty years. This long historic document shows without any doubt that Senefelder was looking far into the future and considering every possibility. He improved his invention technically to such a degree that little room was left for later additions:

> The chemical process of printing is not only applicable to stone, but likewise to metals etc., and Lithography, therefore, is only to be considered as a branch of the more general chemical process of printing . . . But there are besides several other methods that are altogether peculiar to Lithography, and cannot possibly by imitated by type, or copper-plate printing. Of these I shall notice here only, first, the chalk manner, by which every artist is enabled to multiply his original drawings; and, secondly, the transfer manner, by which every piece of writing or drawing with the greasy ink on paper, can be transferred to stone, and impressions taken from it.

In his book he describes another invention, 'stonepaper', a synthetic composite made from various materials—clay, chalk, linseed oil and metallic oxides on paper, canvas or wood (pl. 15). Plates made in this way were to be used as a substitute for the heavy stone and were easy to carry about. Senefelder was responsible for many other inventions apart from these, but even from the few mentioned here one can see how widely his searching genius ranged: artificial stones, metal plates, transfer paper, colour printing from several stones. These ideas and materials, used by the inventor 160 years ago, have since been attacked as *ersatz*, and ignorant people have tabooed their use and even gone

so far as to deny that prints made with these materials have any right to be called litho-graphic. The use of transfer paper was even the subject of an English High Court action, Pennell *v.* Sickert. Sickert held that a lithograph made by means of transfer paper had no right to be called an 'original' lithograph. The Court took the historical facts into con-sideration and came to a different conclusion. Pennell won his case and today nearly all artists of importance use transfer paper. They transfer their drawings first to the stone or zinc and then continue to work direct on to the plate.

Certainly the name 'litho' (Greek *lithos*, stone) is misleading, and Senefelder originally did not call the process by this name. Today 'lithography' is the blanket word for all processes of this kind which have a chemical basis. The name had already been used in France by 1803. A sheet of music, *Menuet favori*, by Mozart, bears a concluding sentence as follows: 'A Charenton chez Vernay à l'imprimerie lithographique.' (At the lithographic printers, Charenton chez Vernay.) Since from 1803 all publications had legally to be registered with the Bibliothèque Nationale, the date of publication can also be assessed. Another early instance of the word lithography being used for this process can be found in France. In 1804 the painter Pierre Nolasque Bergeret (1782–1863), a pupil of David, drew a vignette, a Mercury, with the rubric 'Imprimerie Lithographique' for a lithographic press situated at 24 rue St Sébastien in Paris.[1] There is also a sheet of music with the vignette *Le Joueur de Violon* by Fraenzl. These facts are enough to show that the word 'lithography' originated in France and that Ferchl was mistaken[2] in thinking that is was first used in Munich for the publication of the series *Lithographic Artworks* in 1805.[3] It can also be taken for granted that it was not Senefelder who coined this misleading name. He and his partners, the Andrés, originally called the process 'Polyautography', and the first artists' prints made by this method were published in London in 1803 with the title *Specimens of Polyautography*. When the name 'lithography' spread from France to become the current term in all countries, Senefelder had necessarily to accept this inaccurate conception for his invention. Yet while he lived he only accepted the word with reservations and indeed in 1818 wrote in his own book: 'Lithography is only to be considered as a branch of the more general process of "Chemical Printing".' In that same year Lorenz Quaglio lithographed his famous portrait of Senefelder (pl. 1) and had to write beneath it 'Erfinder der Lithographie und der chemischen Druckerey' ('Inventor of Lithography and Chemical Printing'). At the front of Senefelder's own book is the inscription 'Inventor of the Art of Lithography and Chemical Printing'.

The important point about Senefelder's invention was not that it used stone, but that it was a purely chemical process, and this distinguished it from all hitherto in use. For the first time it was possible to make prints without any mechanical means.[4]

Senefelder was not a painter. All his early attempts were directed towards reproduc-ing his plays inexpensively. It was not his original intention to create a new branch of art. He was concerned therefore with manufacturing printing letters, but this he could not do through lack of facilities.[5] He next tried to make a copper plate resistant to acid by coating it with wax, scratching his writing through the wax in reverse, and then etching the plate. But the difficulties of grinding and polishing the copper plate were too great, and so he continued his experiments with a piece of marble from Kehlheim, which he had originally bought to grind his colours. Hoping for some success he per-severed until he got the idea of writing on the stone with an acid resistant ink. The stone was then etched so that the script was raised above the surrounding areas and he could

[1] 'Par brevet d'invention/imprimerie lithographique, 24 rue Saint Sébastien, Ier Frimaire an 13 [22 November 1804].'
[2] F. M. Ferchl *Übersicht der einzig bestehenden, vollständigen Incunabeln—Sammlung der Lithographie* (Munich, 1856).
[3] *Lithographische Kunstprodukte:* The word Lithography, or, as was usual in the eighteenth century, the Latinized form *Lithographiae*, was not an innovation. Originally it was used to describe stones, rocks and fossils, as well as the art of engraving and working on precious stones.
[4] Different names sometimes in use, such as autography, zincography, algraphy, transfer-lithography etc., describe only technical processes which have no bearing on the value of a print. It is an error to regard a lithograph not printed from stone as inferior.
[5] See Carl Wagner *Alois Senefelder, Sein Leben und Wirken* (Leipzig, 1914).

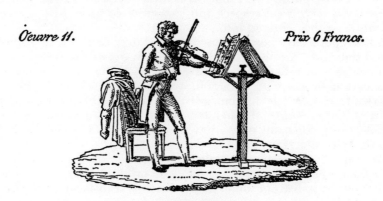

*Pierre-Nolasque Bergeret, The Violinist 1804*[1]

print from it in relief.[2] This method proved successful and he hoped to obtain a privilege for the process. In 1796 he and his partner at the time, Franz Gleissner, printed their first commission by this method, a composition by Gleissner, *Feldmarsch der Churpfalzbayrischen Truppen*, in an edition of 120 copies. It took two weeks. The title was still in copperplate. Though there were further successful printings of Gleissner's music by this process, the Electoral Academy was not enthusiastic, nor, because of trouble with the new printing press, did he succeed in carrying out new orders on time.

After this, Senefelder made all sorts of experiments to improve his methods and to get over the difficulty of writing in reverse. He tried writing on paper with a special ink and transferring this to the stone. (First trial of transfer method.) This was eventually so successful that there was no need to retouch the transfer on the stone. He then discovered that a material coated with gum arabic would resist printers' ink, while writing made on the stone with a greasy substance would willingly accept the ink. From these two discoveries, Senefelder developed his great invention, 'Chemical Printing' (1798).

[1] Unknown to Gräff. Pen. This print is one of the earliest on which the expression 'lithography' is used; it has the imprint '*à Paris, à l'imprimerie lithographique, rue St Sébastien No 24, propriété enregistrée*'.
[2] This is where the famous laundry-bill story fits in.

# 3 First practical use of the new process

An account of the early history of lithography cannot be restricted to the land of its origin. Art is international: frontiers do not exist. Yet special circumstances made the spread of Chemical Printing through several European countries happen almost simultaneously. Senefelder and his partners had carefully organized its diffusion.

On 3 September 1799, Senefelder received a privilege for his invention for Bavaria and the Electorate, which protected Chemical Printing in that country. Only a few weeks later, on 28 September, he signed his first contract for the use of this new printing method with the music publisher Johann Anton André in Offenbach on Main. André was his new partner. Through this agreement, Senefelder went to Offenbach in December 1799 to set up a printing works and gave instruction to the workmen. For this he received 2000 Guilders.

Johann Anton André was both a successful businessman of private means and a man of culture. He was widely travelled and had studied at the University of Vienna. He had a great personal interest in music and was himself a composer. Later he became Grand Ducal conductor. He had also acquired all Mozart's remaining manuscripts, many of which he later published. From his earliest encounters with Senefelder, André treated the inventor with great respect and considerable generosity, as we know from the various contracts they entered into.

Unfavourable reports have been repeatedly circulated about the relationship between Senefelder and the André family. In his book *Lithography and Lithographers*[1] Pennell even calls Philipp André a swindler, because he put his name as patentee on the first lithographic publication in England (London, 1803)—as we shall see, he was perfectly entitled to do so. In fact, Senefelder imprudently fell out, to his great disadvantage, with his benefactor, J. Anton André, through difficulties he encountered in Vienna over an Austrian privilege—'as too many people have been involved, Frau Gleissner, Senefelder's mother, André, Herr von Hartl etc.'[2]

Though the English translation of Senefelder's own book describes the quarrel with André which finally ended their partnership, the original German version reveals far more, as a passage on p. 63, not found in the English translation, will show:

> It was arranged that I live in André's house, for he had grown more fond of me, and that I take meals with him. He even provided me with a horse of my own, so that I might take necessary exercise for my health. Whenever he bought a piece of clothing for himself, I was sure to receive a similar article from him as a present . . . Many years later, when I looked back calmly on the whole course of our relations, I became sufficiently convinced that Mr André's intentions towards me had always been honourable . . . Had our partnership lasted longer, there is no doubt that the lithographic art would have attained a higher degree of perfection, and have yielded great profit to its possessors. [Author's translation]

Though Senefelder had at first been looking for a simple and cheap way of printing, he very soon realized that his process could be used for printing pictures. The agreement with André of September 1799 stated in its first paragraph that 'Messrs Gleissner and Senefelder in Munich are bound to reveal to Mr André the secret of how to print music and pictures from stone', and the second paragraph of this agreement also mentions picture printing.[3]

During Senefelder's period in Offenbach, five lithographic presses were set up and workmen trained for them. André immediately realized the possibilities of the new process, and that he should take out patents in every civilized country to protect the interests of Senefelder and himself. The Andrés were a large family of Huguenot descent, and other members were involved in the introduction of lithography. Johann Anton André

[1] Joseph and Robin Pennell *Lithography and Lithographers* (London, 1898).
[2] The Austrian privilege was entered in 1803. An unsuccessful business was started with von Hartl. After wasting years in Vienna, Senefelder sold his privilege and his shares for 600 Guilders.
[3] The first known attempts of this kind are:
    1797 *The fire of Neuötting*, tailpiece to a song. Dussler 15 (stone etching in relief)
    1798 *Head of Christ in profile*. Dussler 16 (transfer of a copper engraving and the first chemical print of a picture)
    1799 *Landscape with arch*. Dussler 26 (first attempt in chalk. According to Wagner it was drawn by Mitterer)

thought they should open branches in London, Paris, Vienna and Berlin and he discussed these ideas with Senefelder, whom he intended to make his partner. He travelled to London, but the visit was brief for he discovered that a patent had to be claimed by the inventor in person. Senefelder, after some show of reluctance, was persuaded by André to go to London. He suffered a six-day stormy crossing from Cuxhaven to Yarmouth and arrived in the capital towards the end of 1800.

In London his adviser was Philipp André, a brother of Johann Anton, who was already living there. The plan had been from the beginning that Philipp should become manager of the London branch, which would be set up as soon as the patent was granted. Just before leaving for England, Senefelder had been experimenting with printing from a stone cylinder, and indeed thought that he had discovered a new method of printing on cotton. But to his disappointment he found that the textile mills were already printing from a cylinder—though not a stone one.

His stay in London lasted six or seven months and Senefelder talks about it in his book. He complained that he was kept 'during the whole time of my stay in a perfect seclusion, for fear of losing the secret . . . The time I spent in London, however,' he continued, 'was not entirely lost for me and my art, for I employed it in the study of chemistry . . . I also made some progress in the aqua-tinta manner, in which Mr Gessner, son of the poet, an artist of some talent, drew some pleasing landscapes.' Here the English translation has again omitted a paragraph of the greatest importance for the early history of lithography in England. The original German (translated) reads: 'At that time, the son of the Swiss idyllic poet Gessner was staying in London . . . It was he who made for us a number of pleasing drawings in the crayon manner, which I also had invented in Munich, soon after the discovery of chemical printing, and which I had then shown to Professor Mitterer, whose opinion that this method, if sufficiently improved, could be of interest to the fine arts greatly encouraged me.'

Finally, on 20 June 1801, King George III granted a patent to Senefelder for the Kingdom of England, the Principality of Wales, and the town of Berwick upon Tweed. The patent for the Kingdom of Scotland had already been issued for a fourteen-year period at Edinburgh on 19 June.[1]

Having made all the necessary arrangements with Philipp André, and furnished him with the technical information to enable him to run the London enterprise, Senefelder returned to Offenbach towards the middle of July 1801. We know for certain that he was in Offenbach on 10 August, for on that date he signed an important document, witnessed by Georg Jacob Vollweiler, a family friend, who was later to take over the London business.

In this document,[2] he sold the two letters patent which he had obtained in England and Scotland a few weeks before to Johann Anton André, Domstrasse, Offenbach on Main. He sold his privileges outright, with no stipulations, and 'with all rights and prerogatives, embodied in the two royal letters of patent, granted to him for his named invention for a new method of printing . . . and the named Aloys Senefelder acknowledges through his signature in the presence of the witnesses that he has not only received the promised Three Thousand Florins, but that he now hands over all the privileges with all consequences . . . which he renounces in favour of this Johann Anton André, his heirs and assigns . . .'

This document makes it sufficiently clear that Philipp André, as the London representative and head of the London branch of André, was legally entitled to call himself 'Patentee'.

[1] In his book *A. Senefelder* (Leipzig, 1914) Wagner talks (p. 40) of a privilege for Ireland. This was never sought nor granted. Also Wagner's date for the Scottish privilege (3 August) must be wrong.
[2] This highly interesting document was discovered in 1944 in an attic in André's house in Offenbach. It was destroyed by bombing in that year, but a photograph survived. The negative is now in the Senefelder Museum in Offenbach. The full text of the document is reproduced in Dr Hans Platte's thesis (Freiburg, 1953) and in Felix H. Man *Lithography in England, 1801–1810* (New York, 1962 and Hamburg, 1967).

# 4 The early days in England

Philipp André established his London business at 5 Buckingham Street, Fitzroy Square. While the Offenbach enterprise was mainly concerned with using the new invention to print music, Philipp André made every effort to develop lithography as a graphic art. He approached almost all the artists of importance, asking them to try out the new medium, and supplying them with the necessary materials, stones and ink. If finally he was unsuccessful, the blame cannot be laid at his door. The public was simply indifferent, and the artists themselves, though supplied with the best materials made exactly to the inventor's orders, were not at this time interested in drawing, still less in printed graphics (with the exception of Blake), preferring watercolour, which dominated the English scene. Yet one might have expected that Blake at least would have been enthusiastic about the new method which could have served him better than any other means for the illustration of his books. Perhaps he learnt about it too late, and his absence from London, in Felpham, at the time when André was promoting the process in the capital, may account for the fact that he made only one lithograph (pl. 9), in 1807, the year in which the London office closed down.

From Senefelder's own account, we know that as early as 1801, when he was staying in London, a lithographic press was in operation, and that he carried out further experiments in the chalk manner with the painter Conrad Gessner (1764–1826). During the first months of 1801, Gessner did quite a number of drawings in chalk, under the personal supervision of Senefelder, who supplied him with his best materials. From the examples in the British Museum, one can see how the chalk techniques were gradually improved. These advantages—the correct ink, chalk, proper stones, the helping hand of the inventor—were denied to painters experimenting at the same time on the Continent. That Senefelder attached much importance to these Gessner lithographs is indicated by the fact that André took them with him to Germany as samples. In his book on Wilhelm Reuter, Paul Hoffman,[1] mentions a report on lithography, dated Berlin, 12 December 1804, which Johann Christian Frisch, Professor at the Berlin Academy, sent to the Prussian Minister of State, von Hardenberg, who had been inquiring about Senefelder's invention. It reads, in translation:

> Two years ago, the undersigned became acquainted with this new branch of fine art through the merchant André from Offenbach, while he stayed here . . . In reference to drawings, this André carried with him some attempts by Gessner and others, which had been made with crayons, specially chemically prepared for use on stone.

The President of the Royal Academy, Benjamin West (1738–1820), American by birth, was one of the first to try his hand at the new art. His first lithograph, or, as it was then called in England, 'polyautograph',[2] was a pen drawing, *Angel of the Resurrection* (pl. 2), with the caption 'He is not here, for He is risen', signed and dated on the stone 'B. West. 1801'. Considering the fact that this allegorical creation was West's first attempt in a new technique, it was quite an achievement, and it must be regarded as the most important artist's lithograph executed anywhere at so early a date. Perhaps the only major criticism one can make of it is that West's hatching technique was related to etching, and failed to exploit the freedom of line which is possible in lithography. But such an understanding of the medium could only develop after the initial technical problems had been overcome.[3] Another of West's attempts, *John the Baptist*, executed in chalk, is also dated 1801.

West's prints were not the only polyautographs made in England in 1801. Apart from

[1] Paul Hoffman *Wilhelm Reuter, ein Beitrag zur Geschichte der Lithographie* (Berlin, 1924).
[2] In 1801 the word 'lithography' was not yet in use. It was called 'polyautography'. It is not certain who coined this word. It is found on two prints designed by Matthias Koch, Offenbach, and printed by Johannot in 1802, but it is more likely that Philipp André invented it in London, for we know definitely that early samples came from his press to Offenbach before 1802.
[3] In *Die Lithographie* (Vienna, 1903), Hans W. Singer wrote of West's Angel: 'The drawing is too quick and slightly sketched; one has to lay on the stone with great care, as the gradation of the penline causes only a dirty impression like overbiting on copperplate. It appears that part of the stone was not kept clean. Perhaps he touched it with his hand . . . at all events the plate is partly dirty.'
Author: To this damaging criticism one must answer that the print in question is one of the first made by lithography by an artist, and the early prints, such as the one reproduced in this book, and those in the British Museum and the Victoria and Albert Museum, show no dirty spots nor lack of clarity. Singer most probably only saw the reprints of 1806.

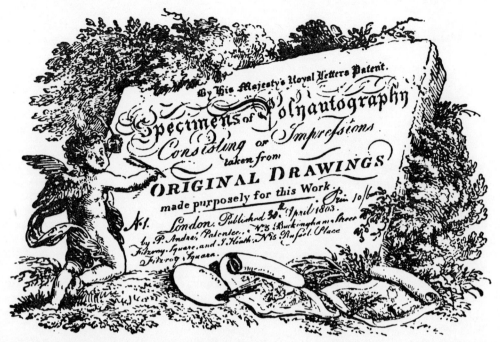

*Title page for the English publication of Polyautographs by André, 1803. This was the first publication, in any country, containing original artists' lithographs*

Gessner's (seven lithographs, of which five are in crayon), other painters were using the medium at the same time: William Delamotte, John Claude Nates and Thomas Hearne, as well as John Eckstein (1760–1802), who made a crayon drawing, a portrait of Philipp André, which was later reproduced as a copper engraving in the *Gentleman's Magazine* (March 1808) together with an article by Fisher on the early days of polyautography.

1802 brought André a rich harvest, as he received lithographs from a number of artists for his planned publication: several pen and ink landscapes from Richard Cooper, *Study of a Tree* by R. L. West (Benjamin's son), drawings by H. Corbould, Thomas Barker of Bath (1769–1847), and Charles Heath (1784–1848) (pl. 6). The first amateur lithographs were also done at this time: Lady Caroline Cawdor (1771–1848) made a small landscape with castle, P. Bayley several figure drawings. But by far the most important contribution in that year came from the Anglo-Swiss painter, Henry Fuseli RA (1742–1825), *A Woman Sitting by the Window* (pl. 8). Though this was not published until 1803, we can assume that Fuseli did this drawing in 1802 at the latest, since he had already treated the theme twice—as a drawing in 1800 and a little later as a painting.[1] Federmann says that the painter was engaged in lithography at the age of sixty, i.e. in 1801.[2]

Meanwhile Gessner continued to experiment with crayon, and Benjamin West did two drawings, using this technique, but they were not published.[3] When André edited his first portfolio, he had a good number of prints to choose from. However, he limited himself to twelve, all pen and ink drawings, which were issued to the public in two series of six prints each, under the title *Specimens of Polyautography*, in April 1803. All these prints were about the same size and were pasted on to a large piece of paper, with a frame, printed by aquatint, of a brownish-grey. Each series of six prints was issued in a paper cover with the imprint, at a price of half a guinea.

Though impressions of these lithographs exist (as published in 1803) in the British Museum, the Victoria and Albert Museum and the Philadelphia Museum of Art, no complete copy is known in its original state and bound as issued. The Victoria and Albert Museum in London has these twelve prints stitched together by a person unknown, in a stiff paper cover, on which has been pasted the cut-out title page from an original issue, shown above.

The twelve prints, the first artists' lithographs to be published anywhere, are by Benjamin West 1801 (pl. 2), Hearne 1801, Richard Cooper 1802 (pl. 4), Delamotte 1802, Corbould 1802, R. K. Porter 1803, Henry Fuseli (1802) (pl. 8), James Barry (1803) (pl. 7), Barker, Thomas Stothard (1803) (pl. 5), Warwick and Conrad Gessner (1801) (pl. 3).[4]

[1] Catalogue of exhibition, Kunsthaus, Zurich, 1926 and 1961.
[2] Arnold Federmann *Johann Heinrich Füssli* (Zurich, 1927) p. 63.
[3] Catalogue of Loan Exhibition of Lithographs at the South Kensington Museum, London, 1898, where the lithograph *This is My Beloved Son*, crayon lithograph, with signature B. West 1802, is mentioned as on loan by J. Pennell.
[4] The claim that *48 Bayerische Sprichwörter* by Ferdinand Schiesl, Munich, preceded this publication must be rejected. Ferchl dates this publication 1802. This date is however only an assumption, as there is no dated imprint. The most likely date for this publication is 1804–5—and other of Schiesl's lithographs are dated even later.

Though André had a number of crayon drawings on hand, he did not publish any of them, probably considering (probably correctly) that the penwork was more technically accomplished. His chief concern was to produce clearly drawn images as propaganda for the new method of printing. Though in some prints there was considerable crosshatching, the artists still being under the influence of etching and engraving, such artists as Fuseli, Barry (1741–1806), and Barker had already developed a free style and were delivering impressive work. The technical quality of the first edition of these prints shows that the proper inks were used for drawing and printing, and that the stones, made from the best material, had been properly prepared. The themes of these early prints were by no means limited: there are landscapes with and without figures as well as the allegorical drawings. It was André's intention to prove that the new method was suitable for artists in any style.

We would have little information about this first publication and the public reaction to it were it not for a contemporary article which described the novelty in all its details and which appeared in a German periodical entitled *Englische Miscellen*, published by Johann Christian Hüttner for J.C.Cotta in Tübingen in 1803. The article says:

A novelty to be regarded with extraordinary interest are the two first numbers of 'Specimens of Polyautography' consisting of impressions taken from original drawings on stone. It has already been mentioned before in the *Miscellen* that polyautography is an invention of Mr Aloys Senefelder, a German by birth, who had been granted a patent for Mr André. This German invention is of enormous importance. One makes a design on stone, which the patentee is said to get from Hungary. The stones are polished, and their price varies according to size from two to three guineas. A special liquid, similar to Indian ink is used, or if one prefers, a special kind of chalk. Both are especially prepared for the purpose of polyautography. Since the surface of the stone is absolutely flat, one can draw on it just as well as on paper.

As soon as the patentee receives the drawing, he makes the same indelible, by using a simple chemical procedure. After this, the stone is wetted with a sponge, in order to remove any dust. Then the printing ink is applied with the help of two printer's balls. Through the preceding chemical treatment of the stone, the ink adheres only to the lines of the drawing, and the intervals remain untouched. Now one lays on the sheet which is to be printed. The inventor uses a special press which is similar to a calender press. The impression obtained is identical to the original drawing, and contains all parts and particles and little dots of the same with such perfection that one cannot see the slightest difference between original and copy: also how would it be possible to see one, as the original is fixed to the stone? One can take impressions till infinity, the first is as good as the last, and each one contains the spirit of the original.

The speed by which all this is done is certainly not the least of its advantages. As soon as the drawing is made on the stone it is fixed chemically, and then within a few hours, and with costs negligible compared with those of copper engravings, the artist can have many thousand impressions of his drawing, and may justly call each impression his own work.

Addison says in *The Spectator* No. 166: 'The circumstance which gives an advantage to writers above all other great masters is the fact that they can duplicate their originals, or better they can make as many copies as they like, copies which are of equal value to the original.' Through this invention here, the advantage no longer belongs to the writer exclusively. The impression is taken from a plane surface, whereas with woodcuts, letter press, etc., the surface must be raised, so that the printers' ink adheres only to those parts which are elevated, just as one makes furrows for the same purpose when making engravings or etchings. Besides, the other graphic mediums require special training and discipline, and do not allow the freedom and spontaneity of drawing with pen or crayon. The impression taken from a plane surface also has the advantage that one can obtain a far greater number of prints than from a copper plate, which wears out gradually. From present experience one has reason to believe that one can take many thousands of impressions without doing harm to the stone, and since this is an enduring substance, one can store the same in an ordinary way for several years and then can have new impressions taken.

The Specimens, announced at the beginning, will be made up of six numbers, containing six prints, price being half a guinea. One addresses oneself either to the Patentee, P.André, No. 5 Buckingham Street, Fitzroy Square,—or to any printseller. In this collection one finds drawings by the following, generally famous masters: West, Barker,

Barry, Beechey, Boyne, Mather Brown, R. Cooper, Corbould, Cosway, de la Motte, Downman, Eckstein, Farrington, Flaxman, Fuseli, Gessner, Heath, Hearne, Hoppner, Laporte, Opie, D. Orme, W. Orme, Ker Porter, Pyne, Samuel, T. Stothard, Stubbs, Tresham, Westall, etc.

Among others one also finds some excellent drawings by the very skilled and charming Viennese artist Fisher, who in the course of this summer (1803) was in London. As this wonderful invention has not yet been properly launched, one must be glad that our enterprising compatriot R. Ackermann of the Strand has shown great inclination to buy the patent. His spirit of enterprise and his far-reaching trade contacts would, within a short period, procure for polyautography the renown this invention deserves.[1]

From this long and optimistic article, which was printed five months after André's first publication, it can be inferred that André's business in London was not prospering too well. In the list there also appear a number of artists who, as far as is known, never made lithographs. Probably André had sent them stones and material, but had had no response. Doubtless André would have liked to have as his partner Ackermann, the well-known printseller and publisher, but it would seem that Ackermann was extremely cautious and was awaiting the general public's reaction. However, recent research shows that Ackermann did do some business with André, for in 1803 he published some lithographs. André, as the patentee and only printer, must have been responsible for the printing. They appeared under the title: 'Twelve views in Scotland, delineated by a Lady (F. Waring) in the Polyautographic art of drawing upon stone. 1803 Publ. by R. Ackermann, London.'

All these lithographs are drawn with chalk on the stone; some are signed FW 1803 in the stone. They were printed on a thickish dark-brownish paper. Ackermann's imprint on the title page was printed from a copperplate. As art, made by an amateur, these drawings are not very important, but as an early work in crayon, published as an album, they are of the greatest historical interest. Their publication shows that Ackermann did have some interest in the new process, but unfortunately, as hinted at in *Englische Miscellen*, this interest did not bear fruit. Artists' lithography would have received a great boost, had a connection between Ackermann and André come about.[2]

Despite all these disappointments as far as business was concerned, André's activities in London must be judged of a certain importance in the development of artists' lithography, for they resulted in the first planned publication of its kind, and also produced in the years 1801 and 1802 examples of this new art which were made exactly to Senefelder's instructions. To realize their real merits, one must set them beside those produced on the Continent at the same time. France was the centre of the fine arts after the turn of the century, but early examples of French lithography are limited to a few by Bergeret in Paris and some by Frenchmen outside France. No important French painter produced a lithograph before 1815. In Germany, the country of the invention, incunabula, especially those produced before 1803, consist, with few exceptions, of more or less isolated, single attempts. The German artists had neither proper instruction, nor proper materials.

---

[1] *Englische Miscellen*, Vol. 13, p. 62, I./1803, published by Johann Christian Hüttner, Tübingen (for Cotta). Wagner notes that an article by Gotthelf Fischer, publ. in July 1804 in *Neues Allgemeines Intelligenzblatt für Literatur und Kunst*, Leipzig, is the first publication on Senefelder's invention and the only source to get information. Most likely the *Englische Miscellen*, published nearly one year before, were not known to him. The whole text of this publication was first published in English in Felix H. Man's *Lithography in England* (New York, 1962).
[2] In *Zeitschrift für Bücherfreunde* Leipzig 1899, III. Jahrg.1, the well-known collector Emanuel Kann mentions this excessively rare set of lithographs, which are neither in the British Museum nor the Victoria and Albert. Complete sets were sold at auction in October 1904 in Vienna (Kann collection), and on 8 March 1965 in London at Sotheby. There is no doubt whatsoever that the Waring prints are lithographs. Aufseesser, on the other hand, mistook four prints by Frz. Jos. Mannskirch, published by Ackermann, 1799 [*sic*], for early lithographs with crayon, an error which Dussler unfortunately repeats in *Inkunabeln der deutsche Lithographie*, even in the reprint. Mannskirch's prints were in fact vernis-mous etchings.

# 5 The first artistic attempts in Germany

The German artists from the very first instinctively used the crayon manner, one which after years of development proved to be the most characteristic of lithography. But while this style was in its infancy, Senefelder in London with Gessner was still experimenting with this method. The artists in Munich, Berlin and other places were hampered by imperfect technical facilities, for Senefelder's early success had been in the development of the pen and ink manner.

After obtaining the patent in Bavaria and setting up André's presses in Offenbach, Senefelder went to England for seven months towards the end of 1800. Shortly after his return to Offenbach in the summer of 1801, he parted from André and moved to Vienna where he spent the next five years. He handed over his presses in Munich to his brothers Theobald and George, who produced mainly music and technical prints, not having the technical know-how in the crayon manner to promote artists' prints in any very organized way. A former assistant of the two brothers, Franz Anton Niedermayr, who had worked with them for some time, had by 1800 opened an establishment in Straubing. But he infringed the privilege in the process and had to move his premises beyond the frontier to Regensburg. He too lacked sufficient technical knowledge.

For these reasons Professor Mitterer (1764–1829) was carrying out his experiments, together with Angelo Quaglio his pupil, with inadequate facilities, working without instruction merely on what he had heard of the process. It was Mitterer who played an important part some years later when the Lithographische Kunstanstalt der Feiertags-schule was founded in Munich. According to Dussler, the engraver Mettenleiter (1765–1853) had been working on the stone since 1800 [sic]. His lithograph in chalk, *Prelate Hupfauer*, dated by Ferchl 1802 (previously dated 1801 in the catalogue of the Brockhaus collection), had even been lithographed on stone without grain. For historical reasons one must mention Count Clemens von Toerring's two chalk drawings, *Wörthsee* and *View from Seefelder Lake*, both signed 'Clemens Comte de Toerring, Seefeld, delineavit anno 1800', printed without much success by Theobald Senefelder. In 1802 E.J. Aurnhammer designed twelve small landscapes in the crayon manner which were also printed by Theobald Senefelder in Munich. They lacked technique both on the part of the artist and of the printer, and suffered from the absence of proper materials. M.J. Bauer did a half-length portrait of Prince-Primate Carl Dalberg, dated by Ferchl 1802, and Francisca Schöpfer made a small crayon drawing, after Angelica Kauffmann, *Farewell to Music* (1803) (pl. 17), which must be regarded as the most successful of the early Munich lithographs.[1]

On the other hand, there were some prints from Offenbach which deserve attention. As Johann Anton André restricted himself to music, having little interest in artistic lithographic printing, his friend, the engraver François Johannot, ventured to develop this side. By 1802 what must be regarded as one of the very finest lithographs in the crayon manner had already appeared from his press in Offenbach. Powerfully drawn in black and white and showing a strong painterly effect, this print, *Landscape with Ruins in the Style of Piranesi*, by Matthias Koch (pl. 20), was printed '1802 bei François Johannot i. Offenbach. Kreide auf marbre' ('Chalk on stone').

Koch made two small drawings of trees in this same year, and these should be mentioned since they have the imprint 'marbre polyautographic', the first time this term had been used in Germany.[2] Koch also produced other lithographs, a study of plants after Phil. Hackert (1803), a rose in full bloom (1804) and some studies of trees.

Johannot, working closely with André, apparently made some effort to publicise the new art, and a number of early prints came from his press, such as the often mentioned *Withered Oaktree* by Johann Conrad Susemihl, who was active in Darmstadt, as well as several chalk drawings by the historian Professor Nicolaus Vogt, from Mainz, whose best known lithograph is of a woman playing the harp, *The Power of Music* 1803 (Dussler 6). It is worth noting that nearly all the prints from Johannot's press were chalk draw-

---

[1] The prints mentioned here are not supposed to represent a comprehensive list. This can be found in Dussler's *Incunabeln der deutschen Lithographie* (Munich, 1924). The date for the Schöpfer-Kauffmann drawing is taken from Ferchl. However, judging from the grain of the stone, the year 1805 seems most likely.
[2] The word 'marbre' must not be taken literally, though it can mean real marble. In these early days it was also used for Solnhofen stone. Koch probably, from the evidence of the quality of his work, used the real Solnhofen stone.

ings, while those from London were usually pen and ink. Philipp André did not consider the chalk manner sufficiently well developed, and he was correct in this opinion for, as all the early Johannot prints show, the grain of the stone was still coarse. The controlling hand of the inventor was clearly lacking, for work produced under his personal direction was of a much higher degree of technical perfection.

Prince Karl of Isenburg (1766–1820), patron of Johann Anton André, also made a lithograph in 1804, a portrait of Chrétien de Mechel, a drawing made from nature on 'marbre polyautographique', printed by Johannot (pl. 27).

In *Neues Allgemeines Intelligenzblatt für Literatur und Kunst*, July 1804, there is a contemporary report by Gotthelf Fischer von Waldheim (subsequently a Privy Councillor in Russia) under the heading (in translation): 'A word about Polyautography, an art for multiplying drawings and writings etc. by printing on stone, improved by Franz Johannot in Offenbach a.M.' In this article, which contains a number of errors, Fischer states among other things:

> Polyautography is the invention of a German, who discovered by accident [*sic*] that one can make drawings on marble instead of on copper in order to print them [Fischer then goes on to talk about Johannot and his enterprise.] 'With regard to these works of art, they are the works of Johannot alone [*sic*] . . . Besides several works which I had the opportunity of seeing at this very kind man's place, I possess through his generosity the following successful works of art: some hatched sheets by Mr Reuter and by the Professor and Librarian Nic. Vogt. . . . This method using black chalk and printing from stone seems excellent. In this style is a sheet showing a withered oaktree. This has been designed by the young Susemihl . . . An excellent work, a rose in full bloom with a bud and leaves . . . I regret that I have forgotten the name of the artist. If I am not mistaken it could be Koch, who also transferred a drawing of leaves and plants, by Ph. Hackert on to the stone . . . Anything that can be represented in black chalk can be produced in this manner. This is proved by 1. a fine historical painting by my learned friend Nic. Vogt showing the effects of music . . . 2. the portrait of Chrétien de Mechel by Karl Prince of Isenburg, a work of art executed in the true spirit of the original, granting the Prince a high rank among true artists . . . Mr Johannot invites all draughtsmen and painters to visit his institute when passing near Offenbach.

Fischer also mentions the Berlin painter, Wilhelm Reuter, who from 1801 was experimenting with lithography and whose activities in polyautography in Berlin will be dealt with later on.

# 6 Further development in England

While, in Offenbach, Johannot was making every effort to interest artists in lithography, in Munich the brothers Senefelder were doing the same; in Berlin Wilhelm Reuter and his circle of professors were preparing their first publication of polyautographs, Senefelder himself had gone out to win Vienna over to his invention, and Philipp André in London was continuing to collect material for further publications. In spite of the limited success of his first 1803 issue, he put all his energy into asking a great number of artists to try their hands at the new art, and encouraging those who already had some experience to improve their technical skill. First he concentrated on further improvements to the crayon style, and Gessner, who stayed in England till the middle of 1804, made definite progress in this method. His chalk-drawing *Horses at Cottage Door*, 1804 (pl. 11), a composition slightly influenced by Morland, is very satisfactory and probably his most important print. He also introduced the Viennese painter and engraver Joseph Fischer (1769–1822) to lithography. Fischer, on his tour of Europe, stayed in London in the summer of 1803. During his stay he made six lithographs using both pen and chalk methods. One of his extremely rare polyautographs is *Five Figures around a Table*, 1803, which is supposed to show Philipp André standing, surrounded by friends.

In addition to Gessner and Fischer, Richard Cooper (1740–1814), who was already represented in the first publication with some pen-drawings, was now experimenting intensively with the crayon method, and from the years 1804–6 there exists quite a number of fine landscapes from his hand in this manner; they can be accepted as good examples from both the artistic and technical points of view. Another artist, H.B. Chalon (1770–1849), made an important chalk-drawing in 1804, *Wild Horses* (pl. 12), and Fuseli's second polyautograph *The Rape of Ganymede*, had already been executed by (1804) (pl. 10).[1]

Looking at all these chalk-drawings one can see how the method gradually improved and how important a part the preparation of the stone and the refinement of the grain played.

Contrary to his original announcement, André had to abandon further publications in spite of the copious material he had on hand. The English public showed little interest in this new graphic art. We do not know if André could outweigh this loss by printing commercial products as did his brother in Offenbach.[2] We know that another scheme, dating back to 1802–3, for reproducing the great works of art in the Louvre by poly-autography, did not materialize either. This project, undertaken with another brother, Frédéric André in Paris, is described in a letter which Wilhelm Reuter, who had visited Paris in 1803, wrote on 13 December 1804 to H.E. von Hardenberg, trustee of the Berlin Academy.[3] This letter, kept in the Berlin archives, deals with a difference of opinion between the Deputy Director, Frisch, and the Rector of the Academy, Schadow, over the value of polyautography. Reuter wrote as follows (in translation):

At the end of last century [*sic*—1802–3] in Paris, Monsieur André, by the request of or in partnership with an art dealer, started to publish in monthly numbers the contents of the Musée Napoléon, paintings as well as antiquities. Monsieur Denon, Director General of the Musée has agreed to append to each number a 'raisonnement'. During my stay in Paris a drawing after Rubens, a burial of Christ, had just been finished; two other drawings after Poussin and Leonardo da Vinci had been finished earlier. The art dealer had only wanted pen-drawings,[4] and the print I saw was a perfect result. (pl. 36) Monsieur André, Frédéric, was very worried, as for seven months he had had no news from London, because all communications with England had been interrupted by the war. It appears that he did not want to run the risk of continuing alone, as he had no

---

[1] Ganz assumes 1805 as the latest date for this lithograph. But the grain of the stone is identical with those lithographs made in England in 1804, and the later crayon-drawings of 1805–6 were executed on a finer surface. Further research has shown that 1804 is the more likely date.

[2] Music printed by lithography is known in England from the year 1806 (published by Vollweiler).

[3] See Paul Hoffmann *Ein Beitrag zur Geschichte der Lithographie* (Berlin, 1924) and *Heinrich v. Kleist und Wilhelm Reuter* (Berlin, 1927).

[4] The art dealer was Mr Bell, Southampton Street, London who planned this enterprise together with Philipp André. An advertisement for it, designed by Pierre Nolasque Bergeret in polyautography and printed at 5 Buckingham Street, London, is in the collection of the British Museum (Gräff 6). As these prints had already been seen by Reuter in Paris in 1803, they must be dated before the *Mercury* of Bergeret from 1804.

knowledge nor judgement about art, and I am afraid this enterprise will be hampered by the war continuing. [This happened in October 1803] . . . Monsieur André in Paris mainly uses polyautography to print music.

This shows that the war had ruined a well planned enterprise.

In the end, discouraged by all these disappointments, Philipp André gave up, handing the London branch over to G. J. Vollweiler, a friend of the family, and returned to Offenbach in the first half of 1805. Vollweiler was well acquainted with the new method of printing. When he took it over, the firm changed its address and from then on the imprint found on the English polyautographs runs: 'Printed from a Pen and Ink drawing on stone at the Polyautographic Office, No. 9, Buckingham Place, Fitzroy Square.' Vollweiler also signed himself as 'Patentee', and he too sent circulars to artists and amateurs asking them to try their hand at the new art, offering instructions and material, and the loan of the stones at a moderate rate. One of the amateurs who responded was Antoine Philippe d'Orléans, Duc de Montpensier (1775–1807), brother of the Duc d'Orléans, an émigré from Napoleonic France.

By spring 1806, Vollweiler had about one hundred prints at his disposal and the time seemed ripe for trying another publication. At short intervals he published six numbers, each containing six polyautographs, hoping to win over the English public by emphasizing that polyautographs were original works of art and as such well worth buying. He had a number of impressions left over from André's first 1803 publication and he included twelve of these polyautographs in his new album. This meant that of the thirty-six prints which he published only twenty-four were new.[1]

All the prints were mounted on sheets of paper the same size as in the 1803 issue, but the borderline framing the prints was changed to a lighter colour. Each set of six prints was bound in a bluish-grey paper wrapper with the following imprint:

By His Majesty's Royal Letters Patent,
and
Under the Patronage of Her Majesty
and Their Royal Highnesses the Princesses
Specimens of Polyautography
Consisting of Impressions
taken from
ORIGINAL DRAWINGS
made on stone purposely for this Work Price 10/6
London
Published (May 1806) by G. J. Vollweiler, Patentee, Successor to Mr. André[2]
Buckingham Place, Fitzroy Square.

Neither the British Museum nor the Victoria and Albert Museum nor any other collection possesses the six parts in original wrappers as issued and the order in which the prints were bound can only be guessed at. Again the public remained indifferent; even excellent prints of high artistic quality in the crayon manner by Fuseli (pl. 10) or Cooper could not win them over. In August 1807, Vollweiler, disillusioned by these failures, gave up the effort and returned to Germany. Nobody was prepared to take over the patent and to continue the publications. All Vollweiler could obtain was a sum of £100 from the General Quartermaster's Office, who acquired a licence to print maps for military purposes. A printer named D. Redman, who had already worked for André and Vollweiler, was also taken over, as we know from a business card which has survived. These six years of the London enterprise cost André a considerable amount of money without any return; the only one to profit was Senefelder himself who received 3000 Guilders in 1801 when he sold the English and Scottish rights to André.

[1] This reissue in 1806 explains why a print dated 1801 or 1802 in the stone can have the paper watermark showing 1805 or 1806. For this reason Ferchl places the date in the stone in doubt, obviously without any justification.
[2] The arrangements as well as those taking part in this publication are described in detail in Felix H. Man *Lithography in England, 1801–1810*, (New York, 1962, by Print Council of America, and Hamburg, 1967, by Dr E. Hauswedell). The printroom of the State Collection in Munich possesses a complete edition with the thirty-six polyautographs. These, however, are not in contemporary binding and not in the correct sequence as published. The dates are inserted by hand.

In the British Museum collection there is another publication with some crayon-drawings, which, as it has Vollweiler's imprint, must have been printed in 1807 at the latest. Five of these drawings and the title (cut out from the whole sheet) have survived. They are by Peter Stroehling (1768–1826), born in Düsseldorf, who worked from 1803–7 in London, where he exhibited at the Royal Academy.[1] Though well-known art dealers such as Orme and Ackermann were connected with this publication, which had been announced as appearing in weekly parts, it was to share the same fate as Vollweiler's. It was a complete failure and only five drawings, mostly classical-figure subjects executed with crayon, printed on brown paper from issue No. 1, have survived.

While still in London, Vollweiler printed parts of a book, which had been compiled by an antiquarian, Thomas Fisher of Hoxton (1782–1836), who worked as a clerk at the India Office, and who was also an etcher of some skill. The book[2] consisted mainly of full-page illustrations of fresco paintings, which he claimed to have discovered in 1804 in a chapel at Stratford upon Avon. These frescoes were reproduced as lithographs (pl. 24), eighteen single and one double page, with the rubric: 'drawn 1804 and published April the 20th 1807, some July 22nd 1807'. They were printed by Vollweiler, and as such form the first book ever to be printed by lithographic techniques. It anticipates the prayerbook of Emperor Maximilian by Strixner after Dürer. After the first section had been printed, Vollweiler closed down, and etching had to be used for the completion of the work.

Fisher complains bitterly about this in an article in the *Gentleman's Magazine*, March 1808.[3] Not much information can be gleaned from this, and it contains a number of misinterpretations. Fisher tells us that André left England in 1805 and his successor, Vollweiler, failing to receive sufficient patronage, returned to Germany in 1807. 'Mr André imported the stones from Germany, although his successor assured me of nearly similar quality in the neighbourhood of Bath.' Then follows the description of the ink, the preparation of the stone and the transfer method.

'For crayon-drawing the stone must be made rougher.' Professor Mitterer in Munich is credited with the invention of the crayon method, and Strohofer as having invented engraving on stone—a method Fisher thought superior [*sic*]. The article continues with a review of the thirty-six prints published by Vollweiler; while Chalon and Fuseli are praised for their good work, some artists who had never lithographed or were not included in the publication like Spilsbury [*sic*], Flaxman, Westall, Wood, Nicholson and the Duke of Orleans [*sic*] are mentioned. The same applies to H.R.H. Princess Elizabeth, Mr Joseph Fischer and Mr Hergen Rodra, a German artist who is praised for minuteness nearly equal to the etchings of Hollar. (By Hergen Rodra he probably meant J.M. Hergenröder, son of the Offenbach artist.) Fisher ends his article by quoting the then celebrated painter Landseer, who warned the public 'not to be led astray by the false light of a spacious prospectus'. In short there is little new in Fisher's article, and the few facts he knows and tells correctly had been published a few years before in the *Englische Miscellen*.[4]

One more lithograph of importance was executed under Vollweiler's régime, *Job in Prosperity*—also known as *Enoch*—by William Blake (1757–1827) (pl. 9). We do not know the exact date of this great pen-drawing, but it can be assumed that this was done about 1806–7 as the paper and the size are identical to the Vollweiler publications. However, this polyautograph remained unpublished and only three impressions are known.[5] There can be little doubt that at that time Blake was the greatest British artist seriously occupied with the graphic arts.

[1] Thieme-Becker dates these lithographs 1810; this is wrong since the Vollweiler imprint does not exist after 1807 and Stroehling himself left London in the same year.
[2] *A Series of Antient Allegorical Historical and Legendary Paintings in Fresco, discovered in the summer of 1804 on the Walls of the Chapel of Trinity at Stratford upon Avon . . . publ. by Messrs G. and W. Nichols Pall Mall . . .* and by Mr Fisher, Hoxton 1807. Of this very rare book the British Museum and the Victoria and Albert, London, possess a copy coloured by hand; a third copy came to light some time ago at a London dealer. Uncoloured trial proofs, loose sheets, are in the F.H. Man collection.
[3] *Gentleman's Magazine* Vol. LXXVIII p. 193, March 1808.
[4] A second article by the same Fisher about lithography, as the process was then called, was printed in the *Gentleman's Magazine* in October 1815.
[5] One impression is in the British Museum, one in the collection of Sir Geoffrey Keynes, and one, only recently discovered, is in the possession of the Keeper of Prints and Drawings at the British Museum, Mr Edward Croft-Murray.

After Redman had taken over from Vollweiler, nothing of importance was produced in England. At first he printed for the Quartermaster's Office in Horse Guards, Whitehall, and later he opened his own printing press at 15 Bishops Walk, Lambeth. As English artists were not interested, Redman addressed himself to amateurs through a circular.

The prohibitive duty on the import of stones and the high cost of transport for this heavy material from Bavaria had led Vollweiler to look for a substitute in England, and the limestone found in the region of Bath proved quite useful. This may account for the fact that a number of amateurs, known as the 'Gentlemen of Bath', executed some lithographs which Redman published. He also printed for Hutchinson, Trench, Burgess, and for Sir Richard Colt Hoare, a gifted amateur, whose watercolours and designs were highly accomplished.

John and Cornelius Varley, both well known water colourists, came fairly late to lithography; while John preferred chalk, Cornelius mainly used pen between the years 1809 and 1811. Sketches and progressive lessons which P.S.Munn published prove uninteresting. As an art form in England, lithography which had made such a splendid start in 1801, was on the decline. In 1813, H.Banks published a small book about lithography, the first of its kind in the English language.[1] In 1813 Thomas Barker of Bath, who had been making lithographs since 1802, acted as his own publisher. Redman printed for him forty pen-drawings, *Rustic Figures*, obtainable through subscription. He followed up this book in the next year by *Thirty-two Lithographic Impressions from Pen Drawings of Landscape Scenery* (published at Bath, 1814, printed under the direction of Mr Barker by D.Redman) (pl. 22). These little-known drawings with the pen are of an exceptional quality and very rare.

Agostino Aglio, who became known as a lithographer after 1820, had much earlier tried his hand at a number of pen-drawings. Sir James Stuart, Baronet, lithographed very impressive compositions of horses in movement; W.Scott of Brighton did some landscapes with chalk. Of all amateurs, Lady Amalia Farnborough (Lady Long), who had been using the stone since 1810, was probably the most successful, making some very interesting chalk-drawings, while Princess Elizabeth, Landgravine of Hesse, was with her lithographs the leading 'Royal Amateur'.

But all these prints made later than 1810, like the early publications of André and Vollweiler, had no influence on the development of lithography. Lithography as an art in England was dormant until Ackermann and Hullmandel started the revival in 1818, but by that time, France, who had not played any part in the early days, had taken the lead, and Géricault had already produced some of his most famous prints.

---

[1] H.Banks *Lithography or the Art of Making Drawings on Stone* (Bath, 1813; Second Edition 1816).

# 7 Wilhelm Reuter and the Berlin Academicians

The first attempts of the painter and commercial artist, Wilhelm Reuter (1768–1834), Berlin, date back to the years 1800–1.[1] Like all the other artists in Germany, Reuter had neither the proper materials nor the proper technique, as can be seen in all his early attempts. These suffer from a certain technical deficiency. It can be assumed that Reuter had seen the trial-proofs of Gessner and other English artists, which André had taken to Berlin in 1802. We also know from letters that Reuter had travelled to Paris in 1803 and on his way visited Offenbach and Darmstadt. As he was a friend of the André family, one can also assume that they showed him the *Specimens of Polyautography*, which had just been published by Philipp André in London. In Paris he visited the third brother of the family, Frédéric André, who was trying to establish a lithographic press there, and who, with the help of the painter Bergeret, had printed some polyautographs, which Reuter describes in his letters.[2]

Reuter, without any doubt, had a very considerable influence on the introduction and on the further development of lithography in Berlin, and no other artist at that time applied himself with such zeal to this new art. However, there have been quite a number of incorrect theories about how Reuter became originally acquainted with lithography. A great-grandson of Reuter, Otto Sigfrid Reuter, wrote an article in *Monatsschrift, Niedersachsen*, Vol. 3, 1925, entitled 'Wilhelm Reuter, father of artists' lithography', in which he declared that Reuter had learned the new art neither from Johannot nor from André. As proof of this he named the prints, which Dussler listed by this artist, under the year 1801. He also referred to a letter by the Minister von Hardenberg, written on 8 October 1804, in which he stated (in translation): 'He [W. Reuter] claims to have learned the invention fifteen years ago in his hometown Hildesheim, from his teacher, Schrecker [*sic* 1789]'. This misleading statement is supported by Nora Keil in *Kunst-Chronik*, Munich, March 1956 and by Wilhelm Weber in *Saxa loquuntur*.[3]

Sufficient proof that this statement is misleading and that Reuter had not in fact produced lithographs twelve years before his first known prints is furnished by the two samples Dussler mentions for the year 1801, which are mediocre attempts artistically as well as technically. Even in 1802 Reuter only produced, according to Dussler, three prints and it was not until 1803, after he had been to Offenbach and Paris, that he produced results of any merit in this new art. Reuter was not only painter and draughtsman, he was also involved with commercial art. It is therefore understandable that he was interested in various methods of reproduction which could serve this purpose and it is quite possible that he experimented himself. As etching and later on also printing from stone was no secret, but had indeed been known for several hundred years and the method, as already mentioned, had even been revealed in books, it may well be possible that Reuter had etched stones as early as 1789. But this was either relief or intaglio printing; it was not lithography.

When in 1799 Senefelder obtained his privilege in Bavaria, it was published in a newspaper and in the same way that André got to know about this invention, Reuter may also have learnt about it; and, since, through various sources, the secret of the invention soon leaked out, Reuter probably derived some knowledge of the process, though, as we can see from his early examples, a very limited one. At that time he had neither the proper materials nor the proper stones and he used a kind of limestone from Rüdersdorf. From a letter written to Reuter by a Mr Schindel, from Solnhofen in Bavaria, we know that in August 1804 225 stones were sent to Reuter. The bill for these stones amounted to 165 Guilders, and in order to be able to pay for these he wrote to von Hardenberg requesting a loan of 400 Thaler. This request was granted for a six

---

[1] There is a small print by Reuter in the Senefelder museum in Offenbach, dated indistinctly in the stone; it could be 1800, but just as easily 1801. It is a trial, with the pen. If the date 1800 is correct, it is most likely December 1800, as all the other early attempts by Reuter are 1801.

[2] See Paul Hoffmann *Wilhelm Reuter, ein Beitrag zur Geschichte der Lithographie* (Berlin, 1924).

[3] In *Kunst-Chronik*, March 1956, Nora Keil criticized me for not giving sufficient credit to Reuter in my book *150 Years of Artists' Lithographs* by not mentioning the above article according to which Reuter got to know lithography in 1789. As this statement is incorrect I naturally left it out. Nora Keil also mentioned a hitherto unknown lithograph by Reuter of a still earlier date than 1801, to be published in due course, which would show Reuter as the very first artist to have lithographed. So far, fourteen years later, this mysterious print has not been forthcoming.

month period.[1] Reuter had good connections with the Prussian Court. At that time it was the custom for the nobility and the well educated to learn to draw and paint, and one of the most accomplished amateurs of these days was Goethe. Reuter was giving art lessons to Queen Louisa of Prussia and received the title of court painter. He was even sent by the court to Paris to copy paintings in the Louvre.

Reuter's importance (pl. 13) for artists' lithography rests not only on his own work as a lithographer. When he returned to Berlin in 1803 from his travels to Offenbach and Paris, he decided to start a publication of polyautographs, modelled on the English prototype of 1803, which he had seen on his journey. He approached the leading Berlin artists, and by September 1804 he was already in a position to publish his first series of prints under the title *Polyautographische Zeichnungen vorzüglicher Berliner Künstler* (Polyautographic Drawings of leading Berlin Artists). This was the first organized publication of lithographs in Germany for the general public. Besides Wilhelm Reuter himself, who contributed two works, the following, amongst others, took part: the sculptor Johann Gottfried Schadow (1764–1850), the Rector of the Academy, Friedrich Georg Weitsch, Professors Bolt and Niedlich and Carl Friedrich Hampe (1772–1848). This first portfolio contained fifteen prints. As Reuter did not get his stones from Bavaria before autumn 1804, all contributions to this first publication were made on marble or local limestone. Particularly notable are the contributions of Hampe (pl. 19) and Schadow (pl. 18). Schadow, the principal representative of the classical style in Germany, was not only the most important of those artists included, he was also an experienced graphic artist who had not only etched to a great extent but had also developed ideas for new techniques. In the years to come Schadow made nearly fifty lithographs, between 1804–37, including a number of portraits of a sculptural appearance, typical of the crayon of a great sculptor, and among the finest lithographs of the period (pl. 44).

Mackowsky, who catalogued Schadow's entire graphic work in 1936,[2] tells us about the experiments Schadow carried out using zinc-plates instead of stones. For this the sculptor recommends the following method:

> With chemical ink one makes a drawing on a paper with a grained surface, which then being moistened is transferred to a clean polished zinc-plate, using a press. After this the zinc is treated with acid and gum Arabic and prints are taken in the same way as from stone.

Schadow was already using this method in 1827.

The fact that the foremost members of the Royal Academy were participating in Reuter's publications caused the King to ask his Minister of State, von Hardenberg, to make a report on this new art. Though the report was very favourable to Reuter, the King refused to follow the advice of his minister, who had suggested 'having a medium-sized house built for Reuter where he could perfect his method'. Instead he made Reuter a present of twenty pieces in gold. As von Hardenberg would have preferred to get proper support for Reuter's enterprise, he asked the Rector of the Royal Academy, Professor Weitsch, for a detailed critique. Weitsch himself had participated in Reuter's first publication. This, however, did not prevent him from making an unfavourable report despite the protest of the two professors of the Academy, Schadow and Frisch. Consequently von Hardenberg could do no more than grant the 400 Thaler loan already mentioned.

From the start, Reuter had dedicated himself to this new art with the greatest enthusiasm and with short interruptions he remained faithful to it. Experiment followed experiment, starting with primitive small pen-drawings and attaining the technically advanced and artistic chalk-drawing *Bathing Nymph* (pl. 21), 1805, and the lithographs he made in several colours as trial proofs for paper money in the 1820s. His lithographs have a very special quality, present only in the work of a great artist.

---

[1] Letters written by Reuter to von Hardenberg 11/14 Dec. 1804 (in translation): 'I have succeeded with imperfect materials and the most primitive machinery to send to your Excellency some successful attempts . . . Nine months ago I ordered some stones from Hungary [*sic*] as I was convinced that the local material were useless . . . I shall be getting 225 stones of different sizes which will enable me to present to your Excellency drawings in the crayon manner . . . the stones cost more than 300 Thaler.'

[2] M. Mackowsky *Schadow's Graphik* (Berlin, 1936).

Altogether Reuter made more than 130 lithographs. His publication of *Polyautographische Zeichnungen* (Polyautographic Drawings) started in 1804, and continued till 1808, including in the later issues new names such as Leopold, Krüger, Hartmann, Müller, Meltzer, etc. Particularly impressive are the portrait in profile of King Frederick William III, drawn in chalk by Franz Leopold (1783–1823) in 1807 (pl. 30), and its counterpart, the portrait in profile of Queen Louisa, by Johann Gottfried Niedlich (1766–1837) (pl. 29), of the same year. These two prints are fine examples in the crayon manner, similar to the method of stipple-engraving. But in spite of all efforts, Reuter never had financial success. He was too much of an artist and he did not understand how to advertise himself. In 1808 his financial position became worse; he had to sell his own house, and in spite of his connections at the Royal Court he found no help, except that a room was assigned to him in the palace of the Margrave of Ansbach, in the Wilhelmstrasse, Berlin. Reuter also drew a number of portraits on the stone with pen and with chalk. These were at first sketchy attempts, but in the course of time his portraits in the crayon manner improved and stand out through their liveliness and lack of academic stiffness. It must be regretted that Reuter did not find the support he deserved, but times were difficult and the disorders of the Napoleonic wars gave Prussia other troubles to deal with.

Besides Reuter and Schadow, another pioneer of lithography must be mentioned: Friedrich von Schinkel (1781–1841), the great architect of the classical period, who was also a painter and designed some stage décor for Mozart's *The Magic Flute*. He lithographed a few designs which were printed by Decker in Berlin. His most important lithograph, a pen-drawing of a Gothic church behind an oak grove with tombstones in front, is one of the most important and impressive artist's lithographs of that time (1810) (pl. 34), and of a very large size. This print is not only perfect from the artistic and technical point of view, but succeeds in conveying the peaceful and romantic atmosphere of the old churchyard. According to Dussler, Schinkel lithographed eight prints, printed by Georg Decker. Decker, who was far more skilled in business than Reuter, developed his enterprise most successfully. He himself lithographed, using both chalk and pen.[1]

[1] Dussler records eleven lithographs by Decker. See also *Zeitschrift für Bücherfreunde* 1900, p. 288ff. (Aufseesser).

# 8 Munich: hometown of lithography

While Senefelder was in Vienna (1801–5), his brothers Theo and Georg made every effort to introduce 'this new art', and a number of prints, as already mentioned, came from their press. Besides the early attempts, there are some prints by Simon Klotz, drawn with chalk: portraits and landscapes as well as classical subjects. Ferchl dates the first lithograph by Klotz 1803, a Sybil in the crayon-manner. Johann Jacob Dorner (1775–1852) (pl. 25), who was already using the stone in 1803, lithographed some views in Upper Bavaria, which are noteworthy as early crayon-prints. They are superior to those of Wagenbauer, who started in 1804, and who is credited by Dussler with more than sixty lithographs. It is surprising that the Munich artists did not make more use of the pen, particularly as the crayon manner demanded special preparation of the stone. What is more, the exact composition of the lithographic chalk, as improved by Senefelder, was not known even to his brothers, for when, in 1804, during the inventor's absence in Vienna, his brothers Theo and Georg sold the invention to the Feiertags-schule in Munich, the school's technical director, Professor Mitterer, had to reinvent, through lengthy experiment, the composition of the chalk, since what information he had received from the two brothers was insufficient.

Professor Mitterer (1764–1829) had made his first attempts by 1801, when Nieder-mayr, who had worked for the inventor for a short time as printer, sold 'the secret' to him for three Louis d'ors.[1]

Aloys Senefelder in Vienna was ignorant of what was happening in Munich and the Feiertagsschule had no right to set up this printing press, nor to appoint the brothers Theo and Georg as 'Professors of the Art of Stone Engraving'. When in 1806 Mitterer even tried asking for a privilege, it was refused, for the brothers failed to produce a power of attorney from Senefelder.

On his return from Vienna, Senefelder started a new printing press in Munich, in partnership with Baron von Aretin, Abbot Vogler and Mr Gleissner. In spring 1807, Senefelder took out a writ in the Upper Royal Court against the activities of the Feiertagsschule. The dispute went on for some time until, as has been said, a settlement was reached in October 1809, and Senefelder became a Royal Inspector of Lithography. His partner, Gleissner, received a yearly salary. For the first time, Senefelder existed free from care, though he had to part from von Aretin who had been his close associate, but whose demand for compensation had been refused. Senefelder sold his newly-established printing works with all its contents to the director of the Royal Picture Gallery, Christian von Mannlich, and to the merchant Georg Zeller, who then proceeded mainly to print lithographic reproductions of paintings and drawings.

By the establishment of the lithographic section of the Feiertagsschule, lithography was exploited for the first time in an organized way in Bavaria. It was certainly to Professor Mitterer's credit that, at least as far as technical development was concerned, lithography took a big step forward. Mitterer asked six artists from Munich to collaborate, in order to bring out a joint publication of which the first issue, with six prints, appeared in October 1805, under the title *Lithographic Artworks*.[2] Up until September 1807 twenty-six issues were published altogether under this title. The artists were Inspector Jos. Hauber, Professor Andreas Seidl, Simon Klotz, Max Wagenbauer, Simon Warnberger and Max Mayrhofer. Professor Mitterer supervised the printing. The drawings, some with pen, some with chalk, represented flowers, landscapes, images of saints after famous models like Guido Reni and Poussin, and the representation of the twelve months after Sandrat, etc. Seen from the purely artistic point of view this publication was not very convincing, but at all events it was a step forward, and hastened the development of artists' lithography in Germany.

With two presses[3] working at Munich at the same time, production increased. Max Joseph Wagenbauer (1774–1829) used the stone in about 1806 to draw a series of land-scapes with animals, sheep in mountain districts, roes, stags, badgers and cattle on pasture etc., all in the crayon-manner (pl. 33)—no doubt an improvement. But the

---

[1] See Wagner *Alois Senefelder, sein Leben und Wirken* (Leipzig, 1914).
[2] *Lithographische Kunstprodukte*
[3] The press of the Feiertagsschule and the Senefelder-Arentin press, founded after Senefelder's return from Vienna in 1806.

chalk line was still timid, and there was still a gradation in the line similar to that in etching. The hand of the artist was limited through lack of experience and was not, as yet, capable of expressing colour in black and white. The animal was a principal theme in the numerous prints by Raphael Wintter, who had been using the stone regularly since 1805.

The best prints of Simon Warnberger are those with pen, landscapes from Upper Bavaria, *The Ridge near Lake Kochel* (pl. 32), and many others. Warnberger was not an important painter and the stroke of his pen sometimes appears slightly uncertain and hesitant, yet his lithographs have a certain quality and convey the inner reality of the subject.

The Quaglio family also belonged to the circle of early lithographers. Angelo Quaglio (1778–1815) had by 1800 already made experiments, with Professor Mitterer. His subjects were mainly landscapes and classical buildings. His brother Domenico (1786–1837) lithographed Gothic churches, cloisters and classical buildings (pl. 26). He was one of the first artists to use a tint on a second stone. There is also a lithograph by Domenico of 1813 (two versions exist), which demonstrates lithography as a quick medium for bringing news in picture: *View of Isar Bridge after the Flood*.[1] The flood and the collapse of the bridge happened on 13 September 1813, and the lithograph is dated 17 September, which in those days meant quick reporting of a topical event. Another Quaglio, Lorenz (1793–1869), lithographed the well-known portrait of Senefelder in 1818, which was published by J.G. Zeller in Munich (publ. in *Sammlung von Original-Handzeichnungen* 1807) (pl. 1).

Before he moved to Vienna, Johann Adam Klein (1792–1875), from Nürnberg, lithographed two small drawings, *Students from Erlangen out Riding* (pl. 28) and *The Ride*;[2] both of them are gems of the period.

High ranking foreign visitors staying in Munich, did not fail to pay a visit to the two rival printing presses, in order to study the new method of printing at its source. Throughout the Napoleonic campaigns, quite a number of leading personages from France came to Bavaria. In 1806 the Director General of the Imperial Museums, Baron Vivant Denon (1747–1825) paid a visit to the Feiertagsschule, though at the time he did not profit through his visit. In 1806, during a visit to the brothers Theobald and Georg, the French general, Louis-François Lejeune (1775–1848), adjutant of General Berthier, well-known painter of battle pictures and patron of the fine arts (who later became Director of the Museums in Toulouse), lithographed his famous *Cossack* on the stone (pl. 39). Within an hour one hundred prints of his drawing were presented to him.[3]

In 1807, the French colonel Lomet (1759–1826) lithographed in Munich *The Bearded Staininger*, a rather dull print. There is another lithograph of French origin, made, according to Ferchl, in 1805 in the Feiertagsschule. This is signed in the stone within L.N., interpreted by Ferchl as Louis Napoleon, with the title *Four Men of the Emperor's Guard*.[4]

By order of Napoleon, Vivant Denon paid a second visit to Senefelder's shop, accompanied by Marcel de Serres, who had the job of studying the condition of the fine arts in Germany and Austria. During this visit, Denon lithographed his well-known print *The Holy Family* (pl. 37).[5] Another artist, the painter Zix from Strasbourg, who travelled with Denon, made a print of similar content. A year later, in January 1810, the painter François Gérard came to the Bavarian capital and lithographed two portraits, one an officer in uniform and the other a half-length portrait of a lady.[6]

---

[1] *Ansicht der Isarbrücke nach dem Einsturz*
[2] *Der Spazierritt*
[3] There are three different states of *The Cossack*, the first one, with the imprint 'un Cosaque' is excessively rare. Lejeune presented the stone to the Ecole des Arts, in Toulouse, and in 1847 new impressions were taken after the following wording had been added to the stone: 'Munich 1806, Lejeune del.' In the third state the following had been added: 'Dessin original du Général Baron Lejeune, restauré par M.N. Joly'; from this an edition was printed.
[4] *Vier Mann der Kaisergarde*
[5] This print by Denon has the following imprint in lithography: 'Essai au crayon à la plume et à l'estompe. -Denon fecit, Munich 1809.' Further down: 'fait à la lithographie de Munich le 15 9ber 1809 Denon.'
[6] See Gräff pp. 80–3 and 121–2.

Electrina Stuntz (Baroness von Freyberg-Eisenberg), who worked in Strasbourg and Munich, designed an album of forty lithographs *My Lessons in Mythology* (pl. 14),[1] figurative drawings which are remarkable for their skilful use of a second stone for a tint. The imprint of the title page indicates that this publication could be bought in Paris, Munich or Strasbourg. The baroness was a versatile and gifted artist who had also lithographed quite a number of single prints. Two of these were included as examples in the French edition of Senefelder's textbook of 1819.

Though all the technical means were now available, the great artist needed to develop the new art to the limits of its possibilities was not forthcoming. Work produced in this field, though technically neat, was mediocre and of little importance from the artistic point of view. These prints were mere reproductions of drawings, accepted for their novelty. By such means one can trace the great progress of lithography in the commercial field and the prosperity of the Munich presses.

As the cheapest medium of reproduction in those days, lithography was used more and more to reproduce paintings and works of art in public collections. Consequently the professional lithographer came into existence, and Munich and other towns were flooded with the products of the 'new art'. Lithography as an original art form was finally driven into the background.

Many years before, André, in London and Paris, had already had the idea of reproducing famous works of art by lithography, but at that time he did not succeed. Now this became a great success. Senefelder himself had started by publishing the marginal adornments which Dürer had made for the prayer book of Emperor Maximilian, and he had asked Johann Nepomuk Strixner (1782–1855) to reproduce these designs on the stone. The book consisted of forty-three sheets, printed without text in red, green or violet ink. The reproduction was true to the original and demonstrated Strixner's skill. There was a title page, a reproduction of Dürer's self-portrait, drawn in 1500, and a preface autographed by Aloys Senefelder himself. Published in Munich in 1808, this book was highly successful and further editions followed, even an English edition in 1817, though in this some pages were redrawn by Electrina Stuntz. A glut of reproductions followed, the professional lithographer had been born, and the most important of these were Strixner and Piloty. Through the production of hundreds of large reproductions of the gallery masterpieces, lithography superseded some of the highest quality copper engravings and etchings as the medium for reproduction.[2]

As part of this scene Johann Christian von Mannlich (1741–1822), Director of the Royal Picture Gallery, must be mentioned, for a great number of these reproductions were made on his initiative. But as far as artists' lithography is concerned he could only work within certain limits—and a comparison with France shows the Bavarian artists in a poor light. In his memoirs Mannlich describes his activities in this field. We must, however, distinguish clearly between artists' lithographs and Mannlich's idea about the 'New Art'. Certainly, as he himself wrote, he experimented in improving the technique, since during Senefelder's absence from Munich many technical details were not accessible to him. And when crowned heads commended him for his progress, this was only just. However, strictly speaking, these commendations were for technical achievements, not for artistic ones. Senefelder himself already knew all about these techniques and had practised the same for a long time. Naturally, artists' lithography profited eventually from these improvements, particularly in France at a later date.

In the meantime the new invention became known outside Berlin, Munich and Offenbach. Since Senefelder had successfully obtained patents in other countries, it is surprising that he did not take any such steps in Germany. We only know of a privilege in Bavaria, and can well imagine that a number of people who had learnt the secret of lithography (more or less completely) were willing to reveal the method for a consideration. Apart from Niedermayr, who established himself first in Straubing and then in Regensburg (1801),[3] Strohofer, an apprentice of the two brothers Georg and Theo

[1] 'Mes Leçons de Mythologie composées et dessinées . . . par Electrina Stuntz . . . A Munich chez l'Auteur d'Anger. A Paris chez Armand König. A Strasbourg chez Armand König' (1810).
[2] *Les oeuvres lithographiques 1811–16—The book of tournament, Duke Wilhelm IV 1817—Des Lucas Müllers, genannt Cranach Handzeichnung 1818—Gemäldesaal München und Schleissheim 1817* etc.
[3] He also tried to establish a press in Paris for the music dealer Pleyel, 1803.

*Page from the Prayer Book of Emperor Maximilian, lithographed with the pen by Johann Nepomuk Strixner after the original design by Albrecht Dürer, published by Senefelder in 1808[1]*

[1] Dussler I. A second issue (Dussler II) appeared in London in 1817, *Oratio Dominica*, with some plates designed by J. B. Stuntz and Electrina Stuntz. (J. N. Strixner 1782–1855.)

Senefelder, was pre-eminent as a pirate.[1] By 1806 he had already tried to establish himself in Munich, but this was forbidden. He therefore went to Stuttgart, where he got to know the Aulic Councillor, Gottlob Heinrich von Rapp, at that time a well-known art enthusiast, who introduced him to the important publisher Johann Friedrich Cotta in Tübingen. As publisher of the *Englische Miscellen* he had been acquainted since 1803 with the theories of the process, and having for this purpose joined forces with Rapp, he asked Strohofer to set up a lithographic press (1807). But apparently Strohofer did not have sufficient knowledge to do this, for by the following year he had been sacked, while the Cotta-Rapp press continued to work. Rapp, who himself lithographed, wrote *Das Geheimnis der Steindruckery* (The Secret of Lithography), the very first book on the subject published by Cotta in Tübingen in 1810.[2]

How confused the law was at that time in Germany one realizes from the fact that though the pirates were not happy about using the invention without a licence, they did not hesitate to demand privileges for themselves. Gottfried Christian Hörtel, for instance, tried to get a privilege in Saxony in 1807; in Karlsruhe, Karl Wagner tried to set up a printing press in 1810; and in Gotha, Ernst Friedrich von Schlotheim did the same. In Berlin two presses were working, Wilhelm Reuter's enterprise and the printing works of Decker. In spite of all these attempts and the great technical advances, the real driving force which raised lithography to the same standards as the other graphic arts came only a few years later from France, where as late as 1810 there was no working lithographic press.

---

[1] Dr Platte reports that Karl Senefelder had sold the secret to Strohofer, which resulted in a protest to the authorities in Munich, on 11 December 1806. Wagner writes (p. 185) about a receipt in the archives of the Germanische Museum in Nürnberg, according to which Karl Senefelder, the third brother of the inventor, acknowledged receiving 50 Guilders and 45 Kreutzer for revealing the secret (23 Aug. 1806).
[2] Dr Platte says that Rapp published a lithograph as a supplement to the *Morgenblatt für gebildete Stände*, Stuttgart, 1807, the first artist's lithograph to appear in a newspaper.

# 9 Lithography in France before Géricault

The very first attempts to introduce the new art in France did not mature. Frédéric André, as he called himself, was granted a 'brévet d'importation pour une nouvelle méthode de graver et d'imprimer' (an import licence for a new method of engraving and printing) on 22 Pluviôse an X (11 February 1802). In rue de Berry, André printed music, and some drawings by Susemihl, animals and a portrait. In 1803 he moved to Charenton near Paris, and sold a licence to Madame Vernay in the same year. André himself returned again to Paris, where he worked at 24 rue St Sébastien.[1] It was here that Bergeret made the drawing in 1804 of his Mercury with the imprint 'Imprimerie lithographique'. All this is described in detail by Walter Gräff in his publication *Die Einführung der Lithographie in Frankreich*.[2]

Bergeret (1782–1863) made for André a number of pen, as well as crayon, drawings, which are today very rare. Gräff lists twenty prints by Bergeret. Since then a few more have been discovered which were unknown to Gräff. Among others Bergeret drew *Christ in the Manger*, *Execution of St John*, *The Burning of Troy* (pl. 35), *Dawdlers in the rue du Coq* (1805), *The Epitome of Current Good Form*[3] (the last two prints usually coloured by hand), and also some vignettes and title pages for music, such as *The Violinist*[4] (1804), and, as already mentioned, a circular for André in London, a mourning scene, with two oriental heads at each side. As we know, the composer Pleyel tried to establish a printing press in 1803, with the help of Niedermayr, who had arrived for this purpose from Germany. André protested, and this press had to close down. For the development of artists' lithography these early days in France are of no importance, and with the exception of the prints by Bergeret and Susemihl, there are hardly any lithographs made during the first years of the century. Times were unfavourable for the new art because of the Napoleonic wars, and Frédéric André left Paris in the winter of 1805–6 to return to Germany. Lasteyrie, who was already interested in lithography, bought some of the stones from André.

In 1806–7, François Johannot, previously working in Offenbach, started the second printing press in Paris for André, and André himself returned in 1807. There were, however, no works from this press which had any influence on the development of the art, and it can only be regretted that neither Fragonard nor David lithographed.

For the four volumes and one atlas *Voyages dans les départements du midi de la France* by Louis-Aubin Millin, Paris 1807–11, André printed some lithographs (in some copies all the illustrations are engravings). Far more interesting than these drawings are the twelve illustrations, printed on six sheets, which Susemihl lithographed in 1807 for the third edition of *Tableau de l'Espagne moderne* by J.Fr.Bourgoing. These were drawn with pen and illustrated a bullfight.

In 1807–8, André sold the secret to the composer Choron and to the architect Louis-Pierre Baltard (1764–1846), some of whose lithographs are known from the years 1816–17. Choront mainly printed music. In 1809 André gave up for the second time and sold a licence to the painter Guyot-Desmarais, who circulated a prospectus, drawn by Charles Johannot (son of François), with the imprint 'par Brevet d'importation Imprimerie lithographique de Guyot-Desmarais'. Gräff is of the opinion that André only leased the fittings of his shop, as in 1816 these were auctioned by Knecht, a representative of André. During the years 1810–15 no lithographic press of importance existed in Paris. In spite of the fact that quite a number of important personalities became acquainted with lithography in Munich, the new process could not gain a foothold in France. Senefelder had hoped that, with the help of Baron von Aretin and with the support of the gallery director von Mannlich, who had sent trial-proofs of Strixner and Piloty to the Académie des Beaux Arts, an Imperial Institute in Paris would be founded when Denon returned from Munich. But circumstances ruined this plan, as had happened before in the case of André's establishment in 1802 and 1807, that of Niedermayr in 1803 and that of Johannot in 1806.

[1] Another address was 48 rue St Sébastien (1805).
[2] *Die Einführung der Lithographie in Frankreich* dissertation by Walter Gräff (Heidelberg, 1906)—and a contribution by Gräff with the same title publ. in the periodical *Gesellschaft für vervielfältigende Kunst* (Vienna, 1904).
[3] *Le Christ à la Paille, Décollation de Saint-Jean, L'Incendie de Troyes* (pl. 35), *Les Musards de la rue du Coq* (*1805*), *Le Suprême Bon Ton Actuel*
[4] *Le Joueur de Violon* (see p. 13)

Thanks to two Frenchmen, Gottfried Engelmann of Mulhouse (1788–1839) and Count Charles-Philibert de Lasteyrie (1759–1849), lithography was finally introduced into France. In 1812 the Count had gone to Munich for three months to learn about the process. However, forced back by the Russian campaign, he had to return to Paris. In 1814 he paid a second visit to the Bavarian capital, and he studied lithography with Senefelder himself. He worked as an ordinary printer and learnt every detail like grinding and polishing the stones in preparation for printing, and how to pull trial-proofs. When he returned to Paris, he again had to postpone the establishing of his printing works, for Napoleon had returned from Elba and another campaign had started.

Gottfried Engelmann, who had studied *Das Geheimnis der Steindruckery* (The Secret of Lithography), published in 1810 by Cotta in Tübingen, experimented in Mulhouse. In the end he too went to Munich in 1814 where he got to know Strixner and Piloty, though it cannot be said with certainty that he became a pupil of Senefelder. He then opened his first printing-press in Mulhouse in 1815, and in October of the same year sent seven proofs to the Société d'Encouragement in Paris, demonstrating the various methods, pen, chalk, transfer and music prints. The Commission of this society, of which Lasteyrie also was a member, judged them favourably.

Lasteyrie had sent for skilled workmen from Munich and started his printing press in Paris in April 1816 at rue du Four. Soon afterwards, Engelmann came to Paris and established a branch at 18 rue Casette (1816). While at first Lasteyrie restricted himself mainly to reproductions, Engelmann addressed himself at once to leading artists such as Vernet, Regnault, Denon (pl. 38) and Mongin, and presented the fruit of their work to the Institut de France. After this, a special commission was appointed with the task of judging the artistic merits of this new process. Pierre-Narcisse Guérin (1774–1833), a pupil of Regnault, who had been appointed a member of the Commission, learnt to lithograph, in order to be able to pass judgement, and he designed his three well-known prints with chalk on the stone *The Idler* (pl. 41), *The Vigilant One* and *The World Stands Still* (1816).[1] These three lithographs are, however, still of a delicate silvery grey, somewhat hesitant, and the scale of tone is limited, but as drawings these neo-classical creations stand among the finest lithographs of the early period in France.

In the meantime Lasteyrie also started to print artists' lithographs, and soon afterwards another printer named Delpech opened up, first in Sèvres then on the Quai Voltaire in Paris. Without giving a complete list, some of the most important prints from the early days in Paris are the three lithographs by Guérin, *Lancer* (pl. 40), by Horace Vernet, some portraits by Denon, the three lithographs presented by Engelmann in April 1816, *Mounted Cossack*[2] by Carle Vernet, *Study of a Head* by Regnault, *The Blind Man's Dog*[3] by Mongin, the portrait of *Coupin de la Couperie* (pl. 45) by Girodet (1767–1824) and a landscape drawn with pen (pl. 51) by Bourgeois (1767–1841). Already by 1817 a great number of further prints had appeared and new artists joined. Of these Baron Gros (1771–1835), a pupil of David who glorified in his paintings the Napoleonic campaigns from the pyramids to Prussian-Eylau, was outstanding. His two lithographs *Leader of the Mamelucks*[4] and *Desert Arab* (pl. 52), both of 1817, are accomplished drawings. They are slightly academic but show some progress. Looking at these two prints one can see that the technical side of lithography was by now completely developed and that only a great master was needed to create something really important in this new graphic art, by allowing lithography its own inherent character. Overnight artists' lithography as a new branch of art had arrived in France. Artists and amateurs made use of it, and the public willingly accepted it. Production became so extensive that soon new printing works were started: Motte, Gihaut and Lemercier.

An important work of the early days by a Frenchman whose authorship, however, is disputed, was made by the painter Jean Dominique Ingres (1780–1867), in Rome, where he lived for many years, and where he designed in 1815 four portraits (pl. 43) on one stone. These lithographs by Ingres are masterpieces of his classical drawing in all its delicacy and assurance. They are lithographed portraits, a genre hardly repeated

[1] *Le Vigilant* and *Le Repos du Monde* (1816)
[2] *Cosaque à Cheval*
[3] *Le Chien de l'Aveugle*
[4] *Chef des Mamelucks*

until Degas did his experiments on stone. However, the possibilities of lithography were by no means exhausted in these chalk drawings of the members of an English noble family, and here we must not forget the date of their origin. The authority of these lithographs is mainly disputed by some Paris dealers, and by Heinrich Schwarz in the *Gazette des Beaux Arts*, December 1959. Their theory is that Ingres drew four members of the noble family in Rome in 1815, and that the drawings were copied on to the stone in London by Richard Lane (1800–1872).[1]

We know with certainty that Dall'Armi, who arrived in Rome in 1807 in company with the painter Raphael Wintter, received a licence on 4 January 1808, and opened a lithographic printing shop there. From this press came, among others, a lithograph by Joseph Anton Koch (1768–1839), a landscape, of which, however, only two copies survived. This means that the necessary materials were at Ingres' disposal.[2] It is generally acknowledged, even by those who dispute the lithographs, that the four portraits of the noble family on one stone were printed in 1820, or 1821 at the latest, by Hullmandel in London. At that time Richard Lane was still an apprentice with the engraver Charles Heath and had never done any lithographs. In later years, Lane became a versatile copyist who in 1825 copied Gainsborough's sketchbook using lithography, with his name as large as that of Gainsborough underneath, for Lane was very vain and all his copies bore his name. As Lane remained with the engraver Heath, it is out of the question that he copied the Ingres drawings. And if Lane was not the copyist in England who else could have done it so perfectly? For there was nobody in the country at that time with such technical skills. Besides this, a professional lithographer would have traced the drawings exactly and certainly not in such a way that the prints reversed, with the men's suits buttoned up the wrong way. There are also a number of differences between the original drawings and the lithographs. For instance the measurements do not correspond everywhere with the drawings and the signature on the portrait of Sylvester Douglas is 'Rone 1815' instead of Rome, all differences which a professional lithographer would never have allowed himself. The transport of the stone to London would not have caused any difficulties nor would the stone have lost its quality as a printing surface during these five years.[3]

[1] See my article in *Düsseldorfer Handelsblatt* No. 135, Kunstbeilage, from 16–17 July 1965: 'Das Rätsel der Ingres-Lithographien'.
[2] Giuseppe Fumagalli in *Rivista della Stampa* (Rome, 1937), and Leandro Ozzola *La Litografia Italiana* (Rome, 1923), as well as Augusto Calabi *Saggio Sulla Litografia* (Milan, 1958). It is mentioned that Dall'Armi printed for Ingres which may be possible but cannot be proved.
[3] Delteil mentions these four portraits only in a cut-up condition. They are catalogued by him with LD 2, 3, 4, 5. Other lithos by Ingres are *Les Quatres Magistrats de Besancon*, *Odalisque* and *Portrait of Baron Norvin*.

# 10 The first great days of lithography

Towards the end of 1817 lithography became a prosperous business in France, quite a number of printers and publishers had made contact with the foremost artists, and large editions were being sold to the public. Carle Vernet (1758–1836) (pl. 42), and his son Horace (1789–1863), both popular painters in France, produced over the years a great number of lithographs, admired at the time, but nearly forgotten today. An important document, a kind of diary kept by the wife of Horace Vernet, reveals to what extent the income of a well-known artist was influenced by lithography, if he was in favour with the public. This diary contains an exact account of Horace Vernet's income from the time he married in 1811 until his death in 1863.[1] Some extracts are:

| | |
|---|---|
| 1817 Mars 7. Un dessin lithogr. pour M. de Lasteyrie | ....Frcs. 120 |
| 1818 Fev. 18. Une lithogr. pour M. Delpech | ....Frcs. 600 |
| Juillet 29. Une lithogr. pour Mme Delpech | ....Frcs. 800 |
| [and the same year, in November] | |
| Une lithogr. pour M. de Forbin | ....Frcs. 1000 |

By 1822, his price for a lithograph had risen to Frcs. 1500 each, and his income from lithography alone in 1822 was Frcs. 9000 in gold, a large sum in those days. Hunting and horses, both loved by the Vernets, were the themes of their lithographs. A contemporary, N.H.Jacob, is to be remembered for his lithograph, *The Genius of Lithography encourages Art*, in which he pays homage to Senefelder. This print was included in the French edition of Senefelder's book. Jacob, pupil of David, never attained the popularity of Nicolas-Toussaint Charlet (1792–1845) (pl. 57), whose lithographic output, beginning in 1817, went into several thousands. Soon a great number of adherents appeared, taking advantage of this new source of income, but their work was of little artistic merit.

The genius who made such an impact on nineteenth-century painting, Théodore Géricault (1791–1824), pupil of Guérin and friend of Delacroix, influenced artists' lithography very decisively. Géricault, a painter of exceptional gifts, had already received at the age of nineteen a gold medal for a painting, and with him, the dominating influence of David was broken. Vivid creations of passionate movement replaced the balance of David's classicism, a change noticeable also in his use of colour. Until Géricault, French lithographs were competent drawings of a silvery grey without much depth. Even Ingres, in his early lithographs, did not exploit the medium. Géricault's first stone is dated 1817. By 1818 he had lithographed some of his masterpieces. In these he not only created space on a flat surface, but by free and daring strokes of the chalk he managed for the first time to produce a colourful effect in black and white. By this masterly power Géricault transformed a mere technique into a new artistic medium of expression, and this before Goya's time. In 1818 he lithographed *Two Horses Fighting in a Stable, Mounted Artillery Changing Position*[2] and *Mameluck Defending a Wounded Trumpeter* (pl. 50), masterpieces acknowledged as such even in the present day. Another lithograph *Boxers*, and those which he made later during his stay in England, are of equal excellence.

No such progress was made at the same time in England after the promising beginnings of 1801–7. Though H.Banks had published a booklet in London in 1813, *Lithography or the Art of Making drawings on Stone* . . . , and a second edition appeared in 1816, none of the important artists, not Constable nor Turner, lithographed, nor did Blake repeat the one attempt he made in 1807. In England, lithography was regarded as second best, and it was only after Charles Hullmandel, who had studied the process with Senefelder in Munich, had established himself in London, that lithography had a revival in England. Having published his album *Twenty-four Views of Italy* in 1818, Hullmandel founded his own printing shop in 1819, the year in which Ackermann published the English edition of Senefelder's own book.[3]

The first artist of merit to use Hullmandel's printing shop was Géricault, who came to England in 1820 together with his friend Charlet, from whom he had gained part of his knowledge of the technical side of lithography. His famous painting, gigantic in size, *Medusa's Raft*,[4] was shown in public, an important event. (At that time London did not

[1] Armant Dayot *Les Vernets* (Paris, 1898).
[2] *Deux Chevaux se battant dans une Écurie, Artillerie à cheval changeant de position*
[3] A.Senefelder *A Complete Course of Lithography* (London, 1819).
[4] *Le Radeau de la Méduse*

have a public gallery, the National Gallery was not founded until 1824.) The entrance fee was one shilling; each visitor received a small reproduction, a lithograph drawn with the pen, a joint work by Géricault and Charlet. Géricault's share in the takings was 17,000 shillings, quite a respectable sum in those days.

During his stay in London Géricault designed twelve lithographs on stone for Hull-mandel, *Various Subjects drawn from Life on Stone* (pls. 53 and 54), published by Rodwell and Martin, February–May 1821. At the same time, he used Senefelder's latest invention the 'Carton Lithographique', a substitute for stone, on which he made seven designs with the pen (pl. 55).

While in the English capital, Géricault met the painter James Ward (1769–1859), whose work he admired. Ward, painter of animals, of the forest, wild horses and bulls, and partly influenced by Rubens, was a gifted painter. Under the influence of Géricault's *English Set*[1] he shortly afterwards made a series of fourteen lithographs, *Celebrated Horses* (pl. 56) which he himself published in 1823–4. These works are among the best produced in England during the 1820s.

After returning to Paris, Géricault did two large lithographs on Napoleon crossing the Alps, and some series of horses in a small size. They are, however, not as important as his early work. His death in 1824 at the age of thirty-three, through a riding accident, brought his career as an artist to a premature end.

At about the same time, Richard Parkes Bonington (1801–1828), British by birth, who spent most of his life in France, made a number of lithographs for Baron Taylor's mammoth publication, *Voyage Pittoresque en France*; some of these were printed in England by Hullmandel. Bonington, a pupil of Gros, was a close friend of Delacroix. His lithograph *Rue du Gros Horloge, Rouen* (pl. 60), 1824, is, in its delicate gradation of tone, his masterpiece. When he died in 1828 at the age of twenty-eight he left behind seventy lithographs.

Baron Taylor's *Voyage Pittoresque* was the largest publication ever produced in lithography. Started in 1820 it continued for forty years, but finally had to close down, in spite of the fact that it was subsidized by the State, and artists like Isabey, Vernet, Charlet, Géricault, Prout and even Ingres and Delacroix contributed to it. Inspired by this work, Hullmandel issued similar folios—Prout's *Rhine, Foreign Views* and *Britannia Delineata*. In 1824 he also published a textbook, *The Art of Drawing on Stone*, in which he gave an account of the difficulties lithography had to overcome in England:

> When lithography first appeared in Germany the French Government sent two agents to that country to examine the merits of the new discovery and to endeavour to introduce it into France . . . On the other hand, when the infant art was introduced into England an almost prohibitive duty was laid on the very material, viz. the importation of stones . . .

Another passage reads:

> Prints of every description find purchasers in France amongst those classes of society which in England views them with as much concern as they would hieroglyphics . . .

David Octavius Hill (1802–70), Scottish painter and past master of photography, lithographed a number of landscapes in the 1820s. They are, however, not as important as his famous photographs. In short nothing produced in England during this time stands comparison with the work of the artists in France of the same time.

---

[1] *The English Set* must not be confused with the French repetition by Léon Cogniet and Jos. Volmar, produced in reverse later in France.

An artist whose prints are of great merit was Jean Baptiste Isabey (1767–1855), famous also as a painter of miniatures. In 1818 he published with Engelmann *Divers Essais Lithographiques*, and in the same year with Lasteyrie some single prints of a very small size which are remarkable for their delicacy and their near pointillist conception. They are landscapes (pl. 49), interiors and 'portraits en miniature' (pl. 48).

Pierre Paul Prud'hon (1758–1823), 'Correggio of the Empire', lithographed three prints towards the end of his life. However, only one of these, *Reading* (pl. 62), is characteristic of the art of this painter. Prud'hon, who in his paintings knew so well how to show a seductive smile on the faces of his beautiful women, such as only Leonardo had achieved before, succeeded in creating a similar atmosphere in this lithograph, which, however, must be seen in an early state.

From Géricault the line of succession leads directly to Delacroix (1798–1863) his friend and heir. Though Delacroix had previously made some drawings on stone (some caricatures for *Le Miroir* and *Le Nain Jaune* between 1817 and 1821), these were of no artistic importance, and not until 1823 did he occupy himself seriously with artistic lithography. His *Médailles Antiques*, technically perfect drawings (1825) already show that he was an outspoken graphic talent. But the further development of his graphic talent was influenced by Goya (1746–1828), the great Spanish painter and etcher who in 1819, when he was an old man, had started to lithograph. At that time his extensive graphic work, the etchings and aquatints, which later made him world-famous, was already completed. Even *Los Proverbios*, the set with fantastic dream fantasies, had been etched by 1819 when he touched the stone for the first time. With more than 260 engravings completed, the experience gained stood him in good stead, as can be seen even in his early small lithographs. While in voluntary exile in Bordeaux he executed his masterpieces, his set of four stones *The Bulls of Bordeaux* (pl. 66). These four lithographs are superior to any other lithographic work of the century.

Without sketchiness Goya used daring, free strokes for the lively forms of his raving bulls, toreros and matadors, surrounded by spectators in a mystic twilight. In this manner he created on the stone an exciting scene of the interplay of lights, in shades from the deepest black to the purest white.

M. Matheron describes in his biography of Goya how in Bordeaux in 1824 the artist, then seventy-eight years old, worked the stones from memory in his studio (in translation):

> When working on his lithographs Goya would rest the stone on his easel as though it were a canvas. He handled his crayons as if they were paint-brushes, and never sharpened them . . . He would usually cover the whole stone with a uniform grey and then use his scraper to take off the parts he wanted lighter . . . Then he would take up his crayon again to darken the shadows, emphasize bold strokes and to indicate the figures and give them movement.

By the same method he lithographed the portrait of M. Gaulon. The *Bulls of Bordeaux* were published by Gaulon in an edition of one hundred. Today these prints are excessively rare; a number were lost, and what remained are nearly all in public collections. It is interesting to observe that Goya's art began during the period of Rococo. When he was born, Fragonard was fourteen; and when he died, the Romantic movement in art had begun and Daumier was already in his twenties.

When Delacroix in 1827 made his seventeen lithographs for *Faust*, Goya's masterpieces were well known to him, and he even had two prints of the bullfights, the portrait of Gaulon fils and *Spanish Dance* (pl. 65) in his possession. He had seen in 1824 at the Paris Salon Constable's (1776–1837) *Hay Wain* and had been deeply impressed. In 1825 he travelled to London, where Eugène Isabey, Monnier, Lamie and Bonington were already staying. There he went to see Shakespeare at Covent Garden and Drury Lane—*Richard III*, *Othello* and *Hamlet*—and also Goethe's *Faust*, which made a deep impression on him. This later proved a fruitful stimulus for his famous series of lithographs. His seventeen full-page prints for *Faust* (pl. 67), with a portrait of Goethe, was published in 1828 by Motte. Of these masterly lithographs Goethe said, 'I must admit that M. Delacroix exceeds the ideas I had in my mind about the scenes I had written.' However, these lithographs had no success with the public. Compared with the *Odalisque* by Ingres, neatly and over-carefully drawn on the stone in a somewhat academic manner,

this *Faust* set was much too advanced in its conception for the general public. Delacroix, painter, lithographer, writer and art-critic must be regarded as one of the most important representatives of his time in intellectual France.

Besides *Faust* he also made lithographs for *Götz*, *Macbeth* and a series of sixteen prints for *Hamlet*, as well as a good number of single lithographs. His larger pieces, *Lion d'Atlas* and *Tigre Royal*, both technically brilliant, are often regarded as his 'chef-d'oeuvres'. His small lithograph, *Young Tiger Playing with its Mother* (pl. 68), a theme he also painted, vies with his large prints in quality. His entire lithographic output was about 100 pieces. During this romantic period lithography rose to first place in France among the graphic arts and was of much greater importance than etching. This may have been because colour played a more important part than line at this time.

A painter who made only three lithographs, though of outstanding quality, was Théodore Chassériau (1819–56), a pupil of Ingres and an admirer of Delacroix. He knew how to lend a nymph-like grace to the classical beauty of his elongated and slender female figures, combining the severe calm of an Ingres with the passionate romanticism of a Delacroix. His *Venus Anadyomène* (pl. 78), and his *Apollo and Daphne* are in their purity of form and graceful bearing both masterpieces. They have, however, to be seen in contemporary impressions. A premature death at the age of thirty-seven brought the work of this gifted artist to a sudden end.

As usual in times of political decline the glorification of the past served as a consolation to the French bourgeoisie. Lithography was used as a medium for spreading political propaganda and glorifying the legend of 'La Grande Armeé de Napoléon,' the life of the soldiers and the battles. Large numbers of such lithographs were eagerly bought by an enthusiastic public. Nicolas-Toussaint Charlet, Hippolyte Bellangé and August Raffet were the principal representatives of this genre of print. With the exception of a few prints by Charlet and Raffet they were of little artistic merit. Charlet (1792–1845), a pupil of Gros, started to lithograph in 1817. His entire lithographic output amounts to more than 1200 pieces; his best, however, were done before 1825. He was a technician of great virtuosity and some of his large lithographs are brilliant drawings with chalk, such as *Grenadier at Waterloo*, *The French Soldier* (pl. 57), *The Cuirassier's Death*, and *Defending the Flag*.[1] But the bulk of his work does not rise above the illustrative. He was also one of the first to produce images from the tinted stone by scraping only. While Charlet mainly depicted the happier side of a soldier's life, Raffet (1804–60) also depicted the horrors of war in all its reality, illustrating for the public great moments from the days of the 'Corsican'. Later he even joined the troops himself, taking part in the siege of Antwerp and in the battles in North Africa, in order to report historical facts (pl. 72).

Contemporary habits and customs were described by Henri Monnier (1805–77), mostly as lithographs with the pen, afterwards coloured by hand, and also by Eugène Lami and Victor Adam, while Louis Boilly (1761–1845) became popular through his series of ninety-six lithographs *Les Grimaces*, published by Delpech between 1822 and 1826. Achille Devéria (1800–57) was the most important exponent of portrait lithography. His *Alexandre Dumas Père* (pl. 61) and his *Victor Hugo* are fine examples of his art.

Eugène Isabey (1803–86), son of Jean Baptiste, lithographed mainly seascapes, ports, ships and the cliffs of the Normandy. His *Cahiers des Marines*, powerfully drawn with chalk, was published in 1833 by Morlot in Paris, by MacLean in London and Baily in New York (pl. 70).

Romantic landscape was represented by Paul Huet (1803–69), who in his lyrical conceptions used chalk in a delicate way (pl. 69). The few lithographs by Jules Dupré (1811–89) were all published in the early numbers of the periodical *L'Artiste*. They are interpretations of his paintings in another technique, though not copies (pl. 71).

Another painter, Diaz de la Pena (1807–76), who worked in the forest of Fontainebleau, designed a few figurative scenes on the stone (pl. 97). Though his figures wear contemporary clothes, one notices his affinity with Prud'hon, but the prints have a certain atmosphere of sensuality, bordering on trash, but without its offensive quality.

---

[1] *Le Grenadier de Waterloo*, *Le Soldat Français* (pl 57), *La Mort du Cuirassier*, and *Le Drapeau Défendu*

Another artist also painting occasionally in the forest of Fontainebleau, the sculptor Antoine-Louis Barye (1796–1875), made a small number of lithographs which were mostly published in *L'Artiste*. His drawings of animals, tigers, bears, stags are monumental and three dimensional, a quality often found in the drawings of sculptors. Jean François Millet (1814–75), the master of Barbizon, made only three lithographs of which *The Sower*,[1] 1851, is the best known. Gustave Courbet (1819–77), whose realism had such a strong influence on painting even beyond the borders of France, lithographed only twice. The prints as such are of no great importance.

[1] *Le Semeur*

# 12 Daumier and the caricaturists

Only rarely has an artist been involved in the political happenings of his time to such an extent as Daumier, without losing his artistic identity and falling into a merely tendentious art.

When Daumier grew up, France was suffering under the maladministration of the Bourbons who had made a comeback after the fall of Napoleon. Louis XVIII was followed in 1824 by Charles X. After the revolution of July 1830, Louis-Philippe d'Orléans succeeded to the throne. Successful at the beginning with his reforms, he soon succumbed to the temptation of filling his own pockets, a trait soon emulated by his ministers and officials.

To fight these grievances, Charles Philipon founded in November 1830 his satirical periodical *La Caricature*, with Balzac as writer and the twenty-two-year-old Daumier as his principal draughtsman.

Originally Honoré Daumier (1808–79) had been sent by his father as assistant secretary to a clerk of the court. When he revolted, it was intended he should become a bookseller, but finally he got permission to become a draughtsman. He received his first instruction from the Chevalier Alexandre Lenoir. As his only job was copying plaster casts he left. Asked for advice, a friend of the family recommended that he should learn lithography, a proposition he accepted with enthusiasm. At that time lithography was at its zenith in France, and all the famous artists were using this medium. In 1829 Achille Ricourt had founded his periodical *L'Artiste* in which he published mainly lithographs. Professional lithographers were reproducing the famous works of art; in short, lithography had advanced far since Engelmann and Lasteyrie had started fifteen years earlier. Charles Ramelet, a professional lithographer of great experience, taught Daumier his *métier*, and so he was well prepared for his start with Charles Philipon.

Philipon himself had lithographed, but being only a mediocre draughtsman he gave it up and turned to politics, founding the political, satirical weekly *La Caricature*, with topical contents and lithographs. Daumier's colleagues were Grandville, Monnier, Raffet and others. *La Caricature* was not the first magazine to print lithographs; this technique had been used already at the beginning of the 1820s and later on by *La Silhouette* and *La Mode*, since it had proved to be the quickest and cheapest at that time.

Daumier, working first under the pseudonym of Rogerlin, became a permanent contributor in 1831. Having insulted King Louis-Philippe with his drawing *Gargantua*, he was sentenced to six months' imprisonment and a fine of 500 Francs. In *La Caricature* of 30 August 1832 the following appeared (in translation):

> Even as we were writing this, M. Daumier was arrested (before the eyes of his parents, for whom he provided the sole support) and sentenced to six months' imprisonment for his *Gargantua* caricature.[1]

In 1835 *La Caricature* had to close down as the new law prohibited political caricature, and a severe censorship was enforced. Daumier's most important contributions were portraits: *Guizot, Bring Down the Curtain* (pl. 88), *The Wobbling Head, The Phantom*[2]—ninety-one lithographs altogether.

In order to be able to print lithographs twice the size of those in *La Caricature*, Philipon had started in 1834 *L'Association Mensuelle*, in which *Le Ventre legislatif, Ne vous y frottez pas, Enfoncez Lafayette, Rue Transnonain* (pl. 89) appeared. Daumier's early lithographs are conceived as sculpture, and indeed at that time he modelled his heads and figures before he drew them on the stone; and from 1830 to 1832 he modelled thirty-six small sculptures of political personalities from memory.

Philipon had already founded another periodical in 1832, *Le Charivari*, and Daumier had to change his subjects, when political caricature was banned. As a contributor to *Le Charivari* he described the life of the petit bourgeois in his banal surroundings, the officials of the law in their pomp, the bohemians of Paris, the gluttonous life of the spendthrift and the commonplace fellow during his leisure hours. His most important

---

[1] *Au moment où nous écrivions ces lignes, on arrêtait sous les yeux de son père et de sa mère, dont il était le seul soutien M. Daumier condamné à six mois de prison, pour la caricature de Gargantua.*
[2] *La Tête Branlante, Le Fantôme*

contributions to *Le Charivari* were his series *Women Bathers, Actualities, The Bohemians of Paris, Respectable Citizens, Robert Macaire, The Judiciary, Les Pastorales, Anything You Like,*[1] lithographs of a painterly quality. But Daumier was not only an artist. His journalistic instinct and his exceptional gift of obversation enabled him to discover in ordinary happenings the extraordinary, which he then transformed into brilliant compositions tinged with slight irony. His entire lithographic output consists of nearly 4000 pieces. In order to appreciate his work one has to view the proofs on thick paper without text on the reverse. What makes his work so overwhelming is the fact that he does not distort nor does he make the mistake of many other caricaturists of bringing the grotesque into the foreground. Daumier was more than a master of the caricature; as an artist he stood among the leading ranks of his time.

Of those working besides Daumier on *Le Charivari*—Grandville, Andrieux, Traviès, Beaumont, Cham and Gavarni—only the latter survived. Gavarni (1804–66), an artist of great ability, who originally, as a contributor to the magazine *La Mode*, specialized in fashion drawings, started to work for *Le Charivari* in 1837. His lithographs give an insight into the manners and morals of his time; they are real documents of the day. Using every technique in a brilliant way he described the social life of the upper classes, of the stage and in particular the habits of the Parisian of the 1840s and 1850s. His work consists of more than 2700 lithographs, series such as *Lorettes, Actresses, Les Enfants Terribles, Paris in the Morning, Paris by Night, Carnival, Masks and Faces,*[2] not forgetting his own creation, *Thomas Vireloqué*, the tramp. (pl. 93)

For nearly twenty-five years these artists were the only creative lithographers in France. As once before in Germany, lithography had been taken over by professional lithographers who exercised their craft in making reproductions. Though photography had been already invented it was still some decades before a practical and mechanical method of reproduction came into use. Even *L'Artiste*, originally founded to publish artists' original lithographs, had ceased to offer its readers originals and opened its columns to the professional lithographer.

---

[1] *Les Baigneuses, Actualités, Les Bohémiens de Paris, Les Bons Bourgeois, Robert Macaire, Les Gens de Justice, Les Pastorales, Tout ce qu'on voudra*
[2] *Les Lorettes, Les Actrices, Les Enfants Terribles, Paris le Matin, Paris le Soir, Carneval, Masques et Visages*

# 13 Further development in Germany and other countries

In the motherland of the invention, Germany, nothing was comparable to the French success. During the nineteenth century Paris dominated the visual arts. The Romantic movement following Classicism in Germany did not bring forth painters of the calibre of Géricault or Delacroix. Moreover artists like Rethel, Schwind and Richter preferred the woodcut for illustrating books.

Only a few artists' lithographs, made in the 1820s and 1830s, are worth mentioning—scenes from the war of liberation by Peter Hess, published by Zeller in Munich 1819, and the works of Franz Krüger and Carl Blechen in Berlin. Franz Krüger (1797–1857) was the official court-painter of the still somewhat provincial Prussian Court. The first fiacres had just crossed 'Unter den Linden', recently paved. It was the Berlin of Wilhelm von Humboldt, Schinkel, Schadow, Rauch and the Brothers Grimm, as well as of Heine, before his emigration to Paris. The Royal family promenaded daily in public in the Tiergarten. *Schorn's Kunstblatt*, published by Cotta since 1820 in Stuttgart as a supplement to the *Morning Gazette*, was eagerly studied by art enthusiasts. Krüger, portrait painter (pl. 46) of the Royalty and the nobility as well as of horses (pl. 58), made more than eighty lithographs between 1815 and 1830. These must not be confused with those lithographed by others after his drawings after 1830.

One of the most interesting painters in the Biedermeier period was Carl Blechen (1798–1840), who made a small number of lithographs with chalk or with pen. Blechen is best known for his landscapes. He was a friend of Schinkel and worked for some time (1824–27) as a scene-painter at the Berlin Royal Theatre. This activity had some influence on his lithographs, which are of an exuberant romanticism with an almost stage-like effect. However, he was a fine lithographer and avoided sentimentality (pl. 75).

The lithographs by the Munich artist family Adam are of greater interest for their documentary value than for their artistic quality. In a somewhat dry manner they depict the life of the soldier, battles and hunting, but do not stand up to the prints of a Raffet.

Of greater importance, and artistically of a higher level, are the approximately 600 lithographs by Theodor Hosemann who illustrated many books. These book illustrations, drawn first with pen, later on with chalk, were afterwards coloured by hand. To some of the prints a tint was added. This, though it accorded with the taste of the time, was not always to their advantage, as his chalk lithographs with their velvety blacks did not need such adulterations.

The 1830s in Germany were, however, rich in publications on the new printing process. The important book by the Parisian printer Engelmann[1] was translated into German and a number of other books appeared in Germany. Besides giving information on technical advances in the process at that time, they contain details about the social conditions of the printer in Germany. In his book, J. M. Dunst, lithographer and proprietor of a printing works in Bonn wrote (author's translation):[2]

> The ordinary working hours in the spring are from 6 a.m. to 12 noon and from 1 p.m. to 7 in the evening. During the hot months in the summer it is advisable to work from 4 a.m. to 10 a.m., and in the afternoon from 2 p.m. to 7 p.m. In winter the printer has to work from 7 in the morning till midday and from 1 p.m. till 8 in the evening.
>
> A lithographer should have a scientific education, know spelling as well as a compositor . . . but most important are good lessons in drawing. The apprentices who want to become lithographers must, in establishments where there is no 'boots', keep the premises clean. They must dust the tables, heat the stoves in winter, light the lamps, in short they have to do any work available. They must be obliging and polite and obedient and must not gossip about things happening on the premises. Also no apprentice is allowed to appropriate proofs or take them out of the printing shop.

In 1848 the *Düsseldorfer Monatshefte* appeared, published by Arnz, and modelled on the French *Le Charivari*. In 1851 Wolfgang Müller published the *Düsseldorfer Künstleralbum*, for which Andreas Achenbach did some lithographs, seascapes influenced by Eugène Isabey. At the beginning of the 1820s a printing press had been opened in Karlsruhe by

[1] Godefroy Engelmann *Manuel du dessinateur lithographe* (Paris, 1822).
[2] J. M. Dunst *Praktisches Lehrbuch der Lithographie & Steindruckerkunst* (Bonn, 1836).

Müller for which Ernst Fries designed some lithographs of Heidelberg Castle. His series of lithographs, *Neuburg Convent*,[1] are among the best made in Germany at that time.

It is to be regretted that the principal exponents of German Romanticism, Phil. Otto Runge and Caspar David Friedrich did not lithograph. The only nineteenth-century German artist to produce some masterpieces was Adolph von Menzel (1815–1905), a painter and draughtsman of exceptional gifts and great diligence. He started as a professional lithographer as his father's pupil, helping him in his lithographic business as a boy. When he was seventeen his father died, and Adolph had to support his family by making commercial lithographs. In this way he became acquainted with the technical side of the process, which was rare for an artist. His talent for illustration came early to the fore, and the publisher Louis Sachse asked him to lithograph twelve cards for the New Year. After a short term at the Berlin Academy he drew for the same publisher a series of six lithographs, *Künstlers Erdenwallen*, pen drawings 'componiert und lithographiert von A. Menzel'.

In the twelve lithographs, the *Reminiscences*,[2] which followed in 1836, Menzel overcame the somewhat dry style of his youth. He was now a painter with chalk and surpassed his French models in battle scenes. His principal works as an illustrator *History of Frederick the Great* by Kugler (1840–2) and his illustrations to *Works of Frederick II* (1846–9) had to be published as woodcuts, because of popular taste.

His major lithographic work, the six lithos he created as a mature artist in 1851, *Experiments on Stone with Brush and Scraper*,[3] are his best, though they are not all of equal quality. In some of these prints the technical achievement outweighs the artistic, while others like the *Bear Pit* (pl. 77) or *The Persecution* (pl. 76) are masterpieces of the highest order. Here the genial draughtsmanship of Menzel reveals itself; chalk, brush and scraper are triumphant. To do these prints justice they have to be seen without the second printing of tone which was added later, or still better they should be seen in the first state with the little drawings in the margin.

Menzel's largest lithographic work, started in 1834 and finished in 1851, was published in 1855 in three volumes under the title *Die Armee Friedrichs des Grossen*. These 453 lithographs were drawn with pen and coloured by hand, but only thirty copies were printed.

A final word should be said about Eugen Napoleon Neureuther's (1806–82) marginal drawings for Goethe (ballads) and for other classics, as well as for the songs from the Bavarian mountains which Cotta published in 1831 and 1834 in Tübingen.

With Menzel, artists' lithography in Germany ceased to exist for the next forty years.

[1] *Kloster Neuburg*
[2] *Die Denkwürdigkeiten*
[3] *Versuche auf Stein mit Pinsel und Schabeisen*

# 14 Lithography in Austria, Switzerland, Russia and the United States of America

Senefelder's early failure in Vienna did not deter him from making another attempt in 1816, with the printer Karl Gerold. Of Senefelder's first stay in Vienna, 1801–6, which he describes in his own book, there is little to report on artists' lithography. In his workshop, the K.u.K. privil. Chemischen Druckerei, it was mainly music that was printed. Sometimes the title pages had decorations which were usually drawn by Karl Müller, who had been taught by Senefelder. These had the imprint 'Imprimerie chymique, Rue Paternoster'. When Senefelder left Vienna, his shop was taken over (1805–6) by Steiner and Krascniczky, who printed among other things a few landscapes with the signature 'Steinböck fec. 1808', and in 1812 produced a booklet of views. In 1812, Johann Adam Klein (1792–1875) from Nürnberg, who had lithographed there before, designed some scenes with men on horseback for Georg Mansfeld in Vienna.

When Senefelder returned to Vienna in 1816 further attempts were made in the artistic field. Disputes between the printing works of Gerold and Steiner & Krascniczky over the patent hampered progress. Another enterprise was founded in 1817 by Adolph Kunicke for whom artists who had moved to Vienna, like Olivier and Alt, worked. Count Pötting opened the Lithographische Institut which became famous through the colour prints by J. Lanzedelly about whom something will be said later.

The most important artists' lithographs about that time in Vienna were those by Ferdinand Olivier (1785–1841), *Seven Views of Salzburg and Berchtesgaden* (pl. 31), published by Kunicke in Vienna 1823. The lithographs were done over a period of several years. Some sketches for these prints had previously been made, with the date 1818. These fine and sensitively drawn lithographs have the same fragrant lightness as his drawings; they are the finest examples of the art of drawing as practised by the 'Nazarener'.[1] A series of representations of Saints preceded these landscapes.

Another of Kunicke's leading contributors was Jakob Alt (1789–1872), born in Frankfurt. He designed in chalk a travelling report of 200 lithographs, *Views on the Danube*, a collection far surpassing the usual traveller's descriptions (pl. 74).

At the same time a young artist who later became famous in Berlin, was using lithography as his medium for illustrations for the Viennese publisher Trentsensky. Moritz von Schwind (1804–71) made pen-drawings on the stone, albums each of six prints, which were published from 1824 onwards, when Schwind was a mere twenty years old. They depict the life of knights, the tournament, sagas and German poetry. Apart from these rather dry drawings, Schwind lithographed with chalk in 1823 the small but fine and delicate portrait of the actress Sophie Schröder (pl. 73). In later years, with a few exceptions when he lithographed versions of his own paintings, Schwind's drawings were reproduced by a professional wood-engraver.

The lithographed portrait was particularly favoured in Vienna. Joseph Kriehuber (1800–76) started in the 1820s to draw for Trentsensky personalities from the nobility, and leading lights in music, painting etc.—Beethoven, Schubert (pl. 47), Paganini—altogether more than 3000 prints, of which an almost complete collection is in the Albertina in Vienna. The early examples were outstanding, but later he was in so much demand that his work became more or less mechanical, and he even allowed his pupils to assist him. Sometimes the portraits were not drawn from life. His contemporary, Franz Lieder, born in Potsdam, and working in Vienna from 1812, worked on similar lines, sometimes with even more painterly perception.

Generally speaking, until the 1850s portrait lithography was 'en vogue' but was then superseded by photography which was becoming popular.

In imitation of French models such as *La Caricature* and *Le Charivari*, periodicals appeared in Austria. The drawings in these papers looked so much like those of Gavarni and his contemporaries that they could be mistaken for their work. Carl August von Pettenkofen (1822–89), lithographing genre scenes and war pictures of Hungarian motifs in a pre-impressionist style, excelled in this method. His lithographs, military action pictures like *The Assault on Ofen*, are remarkable.

In Zurich, in June 1807, a certain Karl Theodor Müller from Breslau had offered to reveal 'the secret of drawing on stone' for a consideration of 120 Guilders. Twelve members of the art society in Zurich, under the leadership of a certain Mr Füssli,[2]

[1] 'Nazarener'—a society of painters in Rome, 1810–30, with idealistic principles looking to Dürer and Raphael as prototypes. Overbeck, Cornelius, Schnorr v. Carolsfeld, etc.
[2] This Mr Füssli is not the same as the painter H. Füssli (Fuseli), who at the time was living in London and had been lithographing since 1802. A publication for the 50 years' Jubilee of the Society of Swiss Proprietors of Lithographic Establishments, Berne 1944, is incorrect in making this connection.

decided to delegate four members to learn the method. One of these, Heinrich Meyer, made a report on this six-day lecture course. A few proofs made at that time with chalk and with pen are preserved in Zurich at the Kunsthaus (pl. 79). However, nothing materialized and the real introduction of lithography came after 1818 in Geneva when Gabriel Charton printed vignettes and caricatures, and Ludwig Albrecht Haller, whose son Emanuel had studied with Senefelder, started a printing press in 1819 in Berne. Franz Leopold, professor of drawing at the Institut Fellenberg at Hofwil near Berne, is regarded as the first artist-lithographer in Switzerland, and he taught his pupils the new art. Leopold was an experienced lithographer and had already lithographed in 1807 in Berlin. His portrait of *King Fredrick William III* of Prussia (pl. 30) is one of the finest portraits from the days of German incunabula. As the most important artist-lithographer of the early days in Switzerland, Franz Niklaus König (1765–1832), (pl. 81), who had studied with Engelmann in Paris, left many lithographs of quality. Other artists were Lory, father (pl. 80) and son, who designed smallish prints, landscapes and rural scenes, and Joseph Volmar, who lithographed mainly horses. In Zurich Brodtmann opened a printing-shop where Julius Arter lithographed some views of glaciers. In the 1820s all the large towns in Switzerland, Geneva, Basle, Lucerne, had lithographic establishments, but such artists as they had in France were not forthcoming.

In the 1830s, simultaneously with Hosemann in Berlin, Rodolphe Toepffer was working in Switzerland. Goethe had given high praise to a sketchbook with drawings by Toepffer which Eckermann had sent him from Geneva, and these autographic pen-drawings were published as lithographs. Toepffer's pen-drawings such as *Dr Festus*, *Monsieur Pencil* and *Histoire de M. Jabot*, are spontaneous sketches, in spite of a certain dilettantism, and are works of the highest quality. Some were autographed by Freydig in Geneva after Toepffer's designs.

In Russia lithography started a little later than in west and central Europe. Although a press existed in St Petersburg (Leningrad) in 1815, it was only used to duplicate documents. Alexander Orlowski (1777–1832), Polish by birth but settled in Petersburg, was the first painter to concern himself with lithography. His earliest attempts are dated 1816 and are *A Turk from Turkestan* and *Three Horsemen from Kurdestan*. Soon afterwards the Baltic Baron G. von Schilling, who had studied with Senefelder in Munich, established himself as a publisher of lithographs in St Petersburg, and Orlowski now came forward with lithographs of an outstanding quality drawn with chalk to large dimensions. These prints give us an insight into the life of town and country in Russia. He also drew soldiers in picturesque uniforms, roaming through this vast country. Orlowski was not only an exceptional draughtsman, but he also knew how to handle his material. Considering this early date (1819–20) these lithographs are an extraordinary achievement (pl. 59).

Lithography was introduced into the United States of America at about the same time as in Russia. The first artist to experiment in this field was the painter Bass Otis (1784–1861), who in 1818 drew a portrait of The Rev. Kneeland on the stone, which was used as the title page for a book. In the same year *The Analectic Magazine* of Philadelphia,[1] published an extract from the *Edinburgh Magazine* describing Senefelder's invention. Soon afterwards a second notice appeared[2] with the following interesting comment:

> Aloys Senefelder, who, which is seldom the case, may be called both the inventor and perfecter of the new art, desires now to have it called by the name of 'Chemical Printing', instead of lithography . . . because other materials such as brass, copper, tinfoil, prepared paper, are used in it in many cases instead of stone.

In July 1819 *The Analectic Magazine* printed a small lithograph drawn with chalk by Bass Otis (pl. 82) and a six-page article. This lithograph was 'made on a stone from Munich, presented to the American Philosophical Society, by Mr Thomas Dobson of Philadelphia . . . but the art has been successfully tried on a specimen from Frankfort in Kentucky'. In 1820, another article appeared in the same magazine, illustrated with a small lithograph by Bass Otis, this time drawn with the pen (pl. 83).

The first lithographic establishment in the United States was started in New York by Barnet & Doolittle in 1822–3. Henry Stone began in the same year in Washington and William S. Pendleton started one in association with the engraver Abel Bowen in

---

[1] *The Analectic Magazine*, 1818 Vol. IX, p. 163.
[2] *The Analectic Magazine*, 1818 Vol. XII, p. 350 and 1819 Vol. XIV, p. 67ff.

Boston in 1825, while Peter Maverick opened in New York. The *Journal of the Franklin Institute* published a detailed description of the process and in 1827 offered a prize for the best lithograph made in the United States. The winner was Rembrandt Peale (1778–1860) with his portrait of George Washington (pl. 84). He also received a silver medal. Other American artists of these early days were Thomas Cole and Thomas Doughty. Doughty, born in 1793 in Philadelphia, contributed forty-eight lithographs to the book *Cabinet of Natural History*, published in 1830 in Philadelphia. Professor Christian Schusele, born 1824 in Gebweiler in Alsace, who studied lithography in Strasbourg, came in 1848 to Philadelphia, where later he became Professor of the Academy of Fine Arts. He made a number of fancy prints and took a great interest in chromolithography. The important American painter Winslow Homer became an apprentice in a lithographic establishment, went as a reporter for *Harper's Weekly*, and took part in the Peninsular Campaign (1862–3). From his war sketches he made six lithographs.

The first American firm to achieve commercial success was William S. & John Pendleton, who started in Boston in 1824. A fifteen-year old apprentice, Nathaniel Currier, began in this shop in 1828. In years to come this young man was to be responsible for lithography's popularity in the United States. Currier founded his own business in 1835 in New York at 1 Wall Street. In 1852, J.M.Ives entered his business and became his partner a few years later. The new firm was called Currier & Ives,[1] and published over many years several thousand lithographs. A woman named Fanny Palmer (1812–76), who had already worked for Nathaniel Currier, became their most important contributor. Between 1849 and 1868 she made more than 200 lithographs of which *A Midnight Race on the Mississippi* (1860) (pl. 85), *Landscape, Fruit and Flowers* (1862), *American Express Train* (1864) and *The Rocky Mountains, Emigrants Crossing the Plains* (1866) are her finest. The prints were coloured by hand as was then the custom, and consequently black and white prints are excessively rare.

Fanny Palmer, born in Leicester, England, in 1812, emigrated with her family in 1844. She settled in New York and together with her husband, who was a lithographer, tried to start a business, but without success; N.Currier eventually took over the firm.[2]

For the anthropologist, the lithographs of George Catlin, depicting the life of American Indians, are of interest.

But none of these prints had any influence on the development of lithography as an art. This was left to those artists of American origin who spent the greater part of their lives in Europe: Benjamin West, J. M. Whistler, Mary Casatt (pl. 110), John Singer Sargent (pl. 114) and Joseph Pennell.

In Holland, the first lithographic press was established in 1809 by Niedermayr for Ludwig Plattner. The Rijksprentenkabinet in Amsterdam has a lithograph, a landscape with a half-withered tree in the foreground and a steeple on the right in the distance, signed on the stone S.Petit, drawn with chalk. An added note states: 'Un Graveur de Rotterdam a présenté à M.Twent ministre de l'Intérieur en 1809, cette épreuve come [*sic*] nouvelle invention.' (A Rotterdam engraver presented this print as a new invention to M.Twent minister of the Interior in 1809.)

In Brussels, Carl Senefelder founded a press in 1817. Impressions are known with the imprint 'Ch. Senefelder, Bruxelles 1817'.

The printing press in Rome, founded by Andreas dall'Armi in 1808 has already been mentioned in connection with Joseph Anton Koch's only lithograph. At the same time De Werz opened in Milan where G.Longhi (1776–1831) lithographed a bust of a young woman and the painter Levati (1739–1828) in 1808 did a romantic landscape, a bridge across a torrent in the mountains. Both prints, in spite of the somewhat coarse grain, are impressive. In 1807 the Florentine Antonio Fedi (1771–1843) drew with the Stamperia Salucci the bust of a small boy. Other Italian artists of the early days are Migliara, Corneo and Bossi. Though all these prints are of historical interest and well drawn, they did not have much influence on the development of the art (pl. 23).[3]

[1] Harry T.Peters *Currier & Ives*, 2 Vols, 1929 and 1931; Harry T.Peters *America on Stone* 1931.
[2] Mary Bartlett Cowdrey 'Fanny Palmer, an American Lithographer' in *Prints* (New York, 1962).
[3] Detailed information about the early days in Italy are found in Augusto Calabi *Saggio sulla Litografia* (Milan, 1958).

# 15 Manet and the renaissance of artists' lithography in France

Having some years before been responsible for reviving etching in France, the publisher Cadart tried to do the same for lithography. In 1862 he asked a number of artists who worked for the firm Cadart & Chevalier, rue de Richelieu, Paris, to draw some lithographs, and he sent stones to Manet, Ribot, Fantin-Latour, Legros and Bracquemond. The most important artist of this group, Manet (1832–83), designed *The Balloon*; Ribot drew *Reading*, and Fantin-Latour a scene from *Venusberg*. Manet, who as an experienced print-maker had made quite a number of etchings, found the soft chalk to his liking. Though *The Balloon* was never published, he made altogether twenty-four lithographs in the years to come, including a large poster, *Le Rendez-Vous des Chats*, for the book *Les Chats* by Champfleury, This poster, placarded all over Paris, is now practically lost. The influence Manet had on painting was considerable. Though he was not an Impressionist in the strict sense, colour and light played an important part in his work. He profited from the progress of the open-air school, using pure and brilliant colours without neglecting composition.

In his prints, in particular in his etchings of the early days, he was influenced by Velasquez and Goya and later on by the art of the Far East. But the hard and somewhat brittle material of the copper-plate did not suit his style as a painter. The stone, on which he could express his fine feeling for colour much better, was the better material. His lithograph *The Execution of Maximilian* (1867) is a good example of his painterly conception. But his early style of graphics changed, and in the two scenes from the Civil War of 1871, *The Civil War* and *The Barricade*[1] (pl. 86) of which Manet was an eyewitness, he developed a new and more graphic conception, which is even more noticeable in the lithograph *The Race at Longchamp*.[2] This lithograph, 'nearly written down in shorthand', as Curt Glaser observed, is an attempt to describe quick movement in a new way. The event, unfolding itself in a few seconds, is in this print interpreted in a masterly way. The public, not understanding the artist, refused to accept it.

In the meantime transfer paper, originally invented by Senefelder, had been greatly improved. When in 1874 Manet illustrated Mallarmé's translation of the *Raven* by Edgar Allen Poe, he used this method for the six lithographs he executed with the brush. These lithographs for *The Raven*[3] (pl. 90) are more than mere illustrations. The poet's thoughts and imagination are here expressed with the help of another medium. They are new creations able to exist in their own right. Apart from Daumier, Manet was the first important painter since Delacroix to concern himself with this new art. He must be regarded as the true father of modern lithography as well as of modern book illustration. As *The Raven* was not a success, Lesclide, the publisher, had to abandon further projects. The influence of Japanese art on Manet and his friends of the Café Guerbois now becomes visible. Artists' and collectors' interest in Japanese colour prints began with the World Exhibition of 1867 in Paris, where a large number of colour prints were shown. In lithography this is clearly visible in *The Raven* and later in the French colour prints of the 1890s.[4] The much improved transfer paper offered Corot (1796–1875) the medium which appealed to his temperament. By this method he succeeded in transferring his fairylike landscapes to the stone (pl. 91). They are made with the same mastery and economy as his drawings. Though they did not exhaust the technical possibilities of lithography, these small chalk lithographs are real gems. They vibrate by their lively line, and at the same time breathe an enchanting calm.

As far as output is concerned, Henri Fantin-Latour (1836–1904) was a most prolific lithographer, with 147 pieces to his credit. Though Fantin was a pupil of Courbet, hardly any of his master's realism is evident in his work. On the contrary, Fantin allowed his fantasy free reign and many of his lithographs, though technically well executed, lack taste and are merely illustrations of a literary character. The bulk of his prints are illustration cycles to Wagner, Berlioz and Brahms. Besides these series for

---

[1] *La Guerre Civile* and *La Barricade*
[2] Guérin dates *La Course à Longchamp* 1864, as this print is related to a watercolour made in that year. Moreau-Nelaton gives as date 1872, as Manet painted an oil of the same subject in that year. It can be assumed that both these paintings precede the lithograph as the whole conception and the exceptional stroke of the chalk corresponds more with his style of the 1870s.
[3] *Le Corbeau*
[4] Manet's only colour lithograph, *Le Polichinelle*, will be dealt with later in the colour section.

music, Fantin-Latour made some lithographs of the highest quality—nudes, women bathing or doing embroidery, and one single flower piece, *Bouquet of Roses* (pl. 92). These masterpieces are very much sought after today. Fantin nearly always used transfer paper, but having transferred his drawing to the stone, he continued his work with chalk and scraper, so creating the finest variations of tone.

One of the most important graphic artists of his time, who was very much ahead of his contemporaries, was Odilon Redon (1840–1916). Redon, often referred to as a Symbolist, was a friend of the circle formed by the Impressionists. However, he thought that the aim of the Impressionists to express in their painting the effect of light on colour and the impression of the moment was not enough. His ambition was 'La beauté humaine avec le prestige de la pensée' (Human beauty enhanced by Thought). He did not only paint the visible form but the inner life of his objects, and this can be seen even in his flower paintings. It would be entirely wrong to regard his lithographs as literary; they do not tell stories but transmit inner realities, often bordering on the world of dreams. In his journal[1] he wrote: 'Rien ne se fait en art par la volonté seule. Tout se fait par la soumission docile à la venue de l'inconscient' (Nothing in art is accomplished simply by the Will. Everything is accomplished by gentle submission to the Unconscious)—and in fact the vision dominates in his vast graphic work. Lithographs he made before 1890 could have been made in the 1920s. In his ideas he went beyond the programme of the Symbolists and was a pioneer of what we call today Surrealism.[2]

His first album, *In Dreams*,[3] was published in 1879. From 1883 to 1889 he gave up painting entirely in favour of lithography. Among his important prints are *Closed Eyes*, *Winged Horse*, *Pegasus Captured*, *Head of Christ* (pl. 94) and the series *Homage to Goya* and *Temptation of St Anthony* (pl. 95).[4]

Not all Redon's contemporaries judged his work favourably. In his book on lithography, H. Bouchot even wrote a dismissive criticism: 'In a thousand little prints, which have their own special côterie of admirers, Redon reveals his own vague, fantastic dream. Personally, I find it quite impossible to understand. Those eyes open upon the firmament, those faded marshland plants, those strange distorted bodies, only give you feverish nightmares; they contribute nothing to the art of lithography.'[5] Such was the rash criticism of Bouchot, who at the same time praised Fantin-Latour for his lithographs illustrating Wagner—judgements now reversed.

But Redon himself had his likes and dislikes, even as far as the young Symbolists, meeting regularly at the Café Voltaire, were concerned. He describes the paintings of Carrière as 'sale et neutre', but was enthusiastic about Gustave Moreau and Puvis de Chavannes. Eugène Carrière (1849–1906) painted a number of portraits of famous contemporaries in brownish colours, nearly monochrome, a conception most suitable for lithography. Some of his forty lithographs done in this manner, his Verlaine (1895), his Edmond de Goncourt and Marguérite Carrière (1901) (pl. 98) belong to the best of portrait lithography. Puvis de Chavannes (1824–98) made only a few lithographs of which his *Poor Fisherman*[6] is the best known.

A lonely figure was Rodolphe Bresdin (1822–85) teacher of Redon. His fantastic landscapes, virgin forests peopled by figures and skeletons of the same fantastic appearance, are the work of an individualist. His more than thirty lithographs are worked to the last detail and some could be nearly mistaken for etchings. His most important lithographs are *Comedy of Death* (1854) (pl. 99), *Rest in Egypt* and *The Good Samaritan* (1861).[7] He was the original for the novel by Champfleury *Chien-Caillou*. Among the few who admired his art were Redon and Baudelaire. Towards the end of his life he lived from the sale of vegetables grown in his small garden—now his lithographs fetch hundreds of pounds.

[1] Odilon Redon *A Soi Même* (Paris, 1929).
[2] Symbolism means: a. to express an abstract idea through line and colour, or b. to represent an object through a symbol. The Symbolist movement was originally founded in 1889 by Emile Bernard and Paul Sérusier.
[3] *Dans le Rêve*
[4] *Les Yeux Clos, Cheval Ailé, Pégase Captivé, Tête de Christ* (pl 94), *Hommage à Goya* and *Les Tentations de St Antoine* (pl 95).
[5] Translated from Henri Bouchot *La Lithographie* (Paris, 1895).
[6] *Le Pauvre Pêcheur*
[7] *La Comédie de la Mort* (1854) (pl. 99), *Repos en Egypte* and *Le Bon Samaritain* (1861)

One of the most important artists of the last century, Edgar Degas (1834–1917), loved to experiment. He saw printmaking as a medium in which each method (wood-cut, etching, lithography) had its own special characteristics. His aim was to extract the typical from every graphic technique, accidental happenings included. For his lithographs he invented his own working-process.[1] He would draw with ink and brush on copperplate, taking from it an impression on transfer paper. Having then transferred his drawing to the stone, he continued to work with chalk, ink, brush and scraper, taking trial proofs from time to time, so creating the various known states. By applying these different techniques and materials he managed to obtain new graphic effects. Remembering the advice Ingres had given him in his youth, 'Dessinez, jeune homme, dessinez' (Draw, young man, draw!), his tendency in his lithographs was more that of a draughtsman than of a painter—unlike Manet or Renoir.

He found the themes for his prints in the circus, the 'variété', in the dressing-room and the bath. To arrest movement at the fertile moment was to him the important task. He invented new compositions whereby he used (for this time) astonishing cuts. He also came under Japanese influence. His lithographs show the hand of a master (pl. 104).

As the graphic arts always run parallel to painting, two painters, whose creations made a deep impact on the following generations, Gauguin and van Gogh, must be mentioned here, though they had little influence on the development of lithography. Gauguin (1848–1903) is better known for his exciting woodcuts, which opened new horizons for this art. Having outgrown Impressionism, he published in 1889 a series of eleven lithographs done with chalk, printed from zinc (pl. 102). They were exhibited the same year at the Café Volpini in Paris, together with works by Émile Bernard, Schuffenecker, Laval and Anquetin, described as *Le Groupe Impressioniste et Synthétiste*. The lithographs were scenes from Martinique, Arles and Brittany and the original edition of fifty sets was printed on a yellow paper of strong colour. A reprint was made later on *simili Japon*. When Gauguin returned to Paris in 1894, between his two stays in Tahiti, he executed *Manuo Tupapau* for Vollard's album *L'Estampe Originale*, a lithograph in chalk after his 1892 painting of the same name. The proofs are signed and numbered in ink, one hundred altogether. Another lithograph he did on zinc was *Je Vous Salue, Marie*, the Annunciation in a Tahitian surrounding. Forty copies were printed on Japanese paper in blue, green or black.

The few lithographs by van Gogh (1853–90) all belong to his early period. They are still somewhat clumsy, not yet showing the grandeur of his art displayed a few years later, when he drew with a light hand and could strongly express himself by a few lively lines and dots. His best known lithograph is *Sorrow* (1882), another print, from the year 1883, shows a peasant digging, while *The Potato Eaters*, an interior scene which he also painted and drew, falls into the Nuen-period and is dated 1885 by De la Faille. Van Gogh, who lived on the support by his brother Theo, was hoping to use his lithographs and drawings as illustrations for English periodicals. It is to be regretted that a few years later when his art had matured he no longer used the stone.

---

[1] This process is described in *Degas à la Recherche de sa Technique* by Denis Rouart, Paris 1945.

# 16 Lithography in colour

Since the time of Manet and the Impressionists colour has dominated painting. Yet until that time colour did not play an important part in the original graphic arts of the West, with the exception of the wood engravings in chiaroscura of the sixteenth century and the coloured etchings of Hercules Seghers (1585–1645). It was different in the Far East, where the Chinese and the Japanese woodcut in colour was an important medium of expression for the artist. As already mentioned, these prints became known in Europe through the World Exhibition of 1867, making a great impact on the artist in the West.

The idea of using colour in lithography is nearly as old as the process itself and Senefelder himself worked on this problem at an early date. But at first he was concerned with the improvement of his materials and finding a substitute for the heavy stone. Besides, the trend in artists' graphic work then was still for quite a while towards monochrome.

The first step towards colour was to use a second stone with a flat colour to bring out the highlights. Senefelder himself called the print *Madonna with Child* by Strixner, published in 1808 in Munich in his *Musterbuch über alle lithographischen Kunstmanieren*, a first attempt in this direction.[1] Before using a second stone an attempt was made to obtain a tint by smoke, those parts which were to remain white were covered beforehand.

Ferchl gives us some hints about the beginning of colour lithography. He writes about a drawing by Cesari, the head of an old man with beard, drawn with two chalks, black and red, which Senefelder had transferred on to two stones, to get a facsimile of the original. The black parts of Cesari's drawing were transferred to one stone and the red parts to another. The printing of the second stone was done with great care on paper which had been imprinted by the first stone, so obtaining a replica of the original.[2]

The first book printed in 1808 by the inventor with plates in two colours, red and black, *J.v.Stichauer, Sammlung Römischer Denkmäler in Bayern* (according to Nagler and Dussler drawn by F.Schiesl), was published by the Royal Academy in Munich.

To overprint with a second stone as a tint soon became commonplace, much to the detriment of the final appearance. There are a few good examples of this technical novelty, in particular by Angelo and Domenico Quaglio, and by Electrina Stuntz (pl. 14),[3] but soon this method degenerated and the black and white prints from that period are to be preferred. However, the problem of printing in colour was still smouldering and Senefelder himself made further trials. A very good example of three-colour printing is to be found in his book of 1818 (pl. 15). As well as in Munich, such experiments were made in Berlin and Vienna and Wilhelm Reuter used colour lithography for the trial proofs of his bank notes in Berlin in the early 1820s.

The colour lithographs which Joseph Lanzedelly, the elder (1774–1832), made between 1819 and 1823 are little known. Though these prints are not originals, they are very remarkable, from the technical angle, printed from up to nine stones, using chalk, pen and scraper. If they had become more widely known they might have inspired creative artists. Lanzedelly jointly worked on his colour prints with a painter, Peter Fendis, in Vienna. His series *Jahrmarkt in Siebenburgen*, after Neuhauser, was printed in nine colours in 1819–20. A further idea was to reproduce Freydal's book on tournaments in nine colours, even using gold.[4] However, only one print *Mummery from the 'Theuerdauk'* (pl. 16), a miniature drawn originally for the emperor Maximilian, was completed and printed in the Austrian Institute in Vienna about 1820. This print shows that Lanzedelly recognized that colour lithography's strength was not the imitation of another technique like oil painting, and he adopted the principle of clear flat colours without overprinting.

At about the same time Franz Weishaupt, foreman in a lithographic printing shop in Munich, was working on similar principles and printed some illustrations in colour for the first volume of *Reise in Brasilien* by Dr Joh. Bapt. von Spix and Dr Carl Friedrich von Martius.[5] In 1833 the publisher Hildebrandt in Berlin brought out a book with the

---

[1] Dussler also mentions under Senefelder No. 40, a print *Stammtafel* for Feyerbach-Gönner *Allg. Bürgerl. Gesetzbuch für Bayern* as the first lithograph printed in colours in 1808.
[2] Franz Maria Ferchl *Übersicht der einzig bestehenden, vollständigen Incunabeln-Sammlung der Lithographie* (Munich, 1856) pp. 54, 55.
[3] Electrina Stuntz *Mes Leçons de Mythologie* (Munich, 1810), forty lithos with a tint.
[4] This design is wrongly ascribed by O. Weigmann to Schwind, *Moritz von Schwind* 1906, p. 8.
[5] Dr Joh. Bapt. v. Spix and Dr Carl Fr. v. Martius *Reise in Brasilien*, 3 Vols (Munich, 1823, 1828, 1831) & Atlas.

heraldic emblems of various States in colour lithography, using ten to fifteen plates, and in 1837 another work was drawn on the stone and printed in colour, dealing with *Ornaments of all Classical Periods*.[1] The printer Storch in Berlin pursued similar ends.

Heinrich Weishaupt, professor of drawing at the Königliche Feiertagsschule in Munich, gives us a description of all these proceedings in his book on colour lithography, published in 1848.[2] Weishaupt, himself an experienced lithographer, wrote: 'After many years of trial I finally succeeded in 1835 in producing results, the first being a Head of Christ by Hemling, printed in the three colours red, yellow and blue. In such a way I succeeded in mixing and imitating every shade of colour in the painting.' Further prints in colour by Weishaupt are *Mater Dolorosa* (1835) after Glink, a *Madonna* after Raphael, and *Jesus as a boy* after Carlo Dolce. However, Weishaupt did not pursue his experiments, and it was only when in 1837 he noticed in a magazine an announcement that Engelmann of Mulhouse had invented a new process for printing lithographs in colour that he became convinced of the importance of his own invention, and, indeed, realized that Engelmann's process and his own were based on the same principles. Engelmann, who in December 1836 presented his first proofs in colour printing to the Committee of the Fine Arts in Mulhouse, asked the Préfecture du Département du Haut-Rhin for a patent on the 15 January 1837, and it was granted to him for ten years. La Société d'Encouragement had offered a prize of 2000 Francs for the invention of an economical process for printing lithographs in colour. The process must be capable of producing at least 1000 impressions. This was a condition, and Engelmann received the reward in 1838.

Engelmann had based his invention on the discovery made by Sir Isaac Newton, towards the end of the seventeenth century, that the three primary colours red, blue and yellow, when properly combined, would produce any other colour. Jaques-Christophe Le Blon had already made use of this knowledge at the beginning of the eighteenth century, when he produced his colour prints by mezzotint and etching. As he was not really satisfied with the result he added a fourth plate, black, making a four-colour process, for the reproduction of Old Masters and for his portrait-prints. About fifty prints are known by Le Blon, of which three bear his signature.

Engelmann's invention was actually a process of colour reproduction by which oil paintings and watercolours could to a certain extent be reproduced. This is why the samples from his album published in 1837 are reproductions after oils and watercolours by Thomas Lawrence, Greuze (pl. 63) and others.[3] These reproductions are very fine and successful and show a technical progress. Considering that even today, with the technical perfection of photography, colour separations do not always yield the desired result, this being dependent on the right combination of basic colours, one can understand why artists did not adopt the Engelmann method. The principal of colour lithography in art, as used fifty years later by Toulouse-Lautrec, Bonnard, Vuillard and Signac, is based on the use of flat and clear colours, without the four-colour combination, similar to the art of the Far East, and it remains the same to the present day.

Other printers were trying to solve the problem at the same time as Engelmann. In an article published in 1839 in *Le Lithographe*,[4] Jules Deportes wrote that a M. Garsons had already attempted to make colour prints with several stones in 1833–4. In the two volumes by Léon de Laborde, *Voyage en Orient*, 1837–9, we find besides Engelmann and Graf as printer the name L. Letronne—'Imprimeur'. The majority of the plates in this work are printed only with one tint, the few in colour have no artistic value. But there is a note of interest. 'J'appellerai l'attention des amateurs des arts sur la planche de Costumes de cette livraison. Elle est executée entièrement d'après un procédé nouveau que l'on doit aux recherches assidues de M. LETRONNE [*sic*]'. (I should like to draw the attention of art enthusiasts to the *Costumes* plate in this publication. It has been pro-

[1] *Ornamente aller klassischen Kunstepochen n.d. Originalen in ihren eigentlichen Farben dargestellt* by Wilhelm Zahn, Kgl. Preuss. Professor. 1 Vol., August 1831. Colour printed by C.G. Herwig, from stone drawn by H. Asmus.
[2] Heinrich Weishaupt *Theoretisch-praktische Anleitung zur Chromo-Lithographie oder zum lithographischen Farbendruck* (Quedlinburg & Leipzig, 1848).
[3] *L'Album Chromolithographique, un Recueil d'essais du nouveau procédé d'impression lithographique en couleurs. Inventé par Engelmann père et fils à Mulhouse. Brevet d'invention 1837*.
[4] *Le Lithographe*, Journal des Artistes et des Imprimeurs, 1838–9.

duced by a new method which is the result of the painstaking research of M. LETRONNE [*sic*].) This is a strange notice, considering Engelmann's patent of 1837. Gustave von Groschwitz,[1] in the *Gazette des Beaux Arts*, 1954, and *Marsyas* Vol. 6, 1954, gives priority to a colour print by Auguste Bouquet and Émile Lessore of 3 September 1837 as a true colour lithograph. Only one impression is known, in the Metropolitan Museum of Art, New York. It should be noted that in *Le Lithographe*, 1839, Jules Desportes wrote in relation to colour prints by Lessore: 'Lessore has treated his impressions in colour not as a lithographer but far more as a painter. The method of M. Lessore is a special way of colouring: there is painting in his impressions.'[2]

Whether this remark also applies to the unique print mentioned by von Groschwitz, can only be decided by inspection.

Almost at the same time, Charles Hullmandel in London presented his new process of lithographic colour printing with the album 'Picturesque Architecture in Paris, Ghent, Antwerp, Rouen etc., drawn from nature on stone by Thomas Shotter Boys, London, published 1839 . . . Printed entirely in Colours by C. Hullmandel, London'.[3] In the field of artists' lithography in colour this was the decisive deed. These were not reproductions of some odd drawings but truly original creations by the painter and draughtsman Shotter Boys (1803–74). They were not three- or four-colour printings in imitation of another technique by printing colours on top of one another, but artists' lithographs with each colour standing on its own, separated and balanced, a principle used some decades later by Chéret and Toulouse-Lautrec. Boys himself wrote in the preface to his work that it was unique, and the process by which it was printed entirely new to the public . . . and that all drawings in this volume were produced by the medium of lithography only and taken from the press in exactly the same state as presented. He then continues 'these are pictures drawn on stone and printed in colour, whereby every single stroke is a work of the artist'.

The album (26 pp.) consists of twenty-nine drawings, including the title page. The colours are used as flat tints; occasional spots of colour like green window shutters, the Tricolor and some red dresses of the townfolk are reminiscent of the Bonington school. Though Boys was a friend of Bonington he was not his pupil. Particularly interesting in this set are *Notre Dame, Paris from the Quai St Bernard* (pl. 64), *Pavillon de Flore*, a version of the *Panthéon* in Paris in moonlight and *Byloke, Ghent*. These are artistic creations of great unity and the colour shows no spottiness.

King Louis-Philippe sent him a letter of congratulation and presented him with a ring, but the portfolio was not a commercial success and Boys did not repeat this great performance. *London as it is* (1842) was lithographed by Boys in black and white only. Originally a tint in brown was used, but coloured copies are all hand coloured.[4]

For more than twenty-five years, colour lithography as an art was forgotten. Manet made one attempt in 1876 with his *Polichinelle*, but it is probable that he only drew the black stone, colouring one impression by hand as a pattern for the printer—or it may be that the colour stones were made after his oilpainting of 1874.

Colour lithography finally came into its own through the poster. Jules Chéret (1836–1932) who had in 1866 seen posters in colour in London, designed a poster *Le Bal de Valentino* and also *La Biche au Bois*, his first posters to be printed in colour lithography (pl. 96).

Through poster-printing the technical aspects of colour lithography progressed, finally yielding a satisfactory result—satisfactory also from the artistic point of view. The first colour lithograph by Henri de Toulouse-Lautrec (1864–1901)[5] was a poster for *Moulin-Rouge* (1891). Preceding this, however, was a poster by Bonnard, *France Champagne* (1889), printed by Ancourt in colour. The success of his first poster caused Lautrec to draw his

---

[1] *Gazette des Beaux Arts*, 1954, p. 243.

[2] *Lessore n'a pas traité l'impression en couleur en lithographe, mais plutôt en peintre. Le genre de M. Lessore est un coloris à part; il y a de la peinture dans ses impressions. Le Lithographe*, Vol. 2 p. 201.

[3] 'Picturesque Architecture in Paris, Ghent, Antwerp, Rouen etc., drawn from nature on stone by Thomas Shotter Boys,' London, published 1839 by Thomas Boys, Printseller to the Royal Family, 11 Golden Square, Regent St, Printed entirely in Colours by C. Hullmandel, London.

[4] Gustave von Groschwitz *The Prints of Thomas Shotter Boys* with a catalogue raisonné, in *Prints* (New York, 1962).

[5] An illustration for a song of Aristide Bruant had been lithographed by Lautrec in 1885.

colour lithograph *La Goulue and her Sister*[1] directly on to the stone, a method which he permanently adopted. The same year saw *Englishman at the Moulin-Rouge*,[2] to be followed in 1893 by *Le Coiffeur, Box at the Mascaron Doré*,[3] *Miss Loie Fuller* and many others, altogether more than forty-five prints in one year (pl. 100). While at first his themes dwelt on variety, cabaret stars, dancers (pl. 107) and singers, he later included animals, horses and racing. His favourite printer was Ancourt, where he preferred to work with Le Père Cotelle, an old printer who was depicted in 1893 on a cover for *L'Estampe Originale*,[4] standing in short sleeves at the press. In later years the printer Stern pulled off his lithos (pl. 101). While the majority of his prints in those years served a special purpose and were used as posters, programmes or book covers, he proved in 1896 with his series *Elles* that colour lithography could exist as an independent work of art. This set of ten prints in colour with frontispiece and cover was published in an edition of 100 copies by Gustave Pellet. His friend Maurice Joyant has described how Lautrec watched a scene in the theatre from the stalls, twenty, sometimes even fifty times, making sketches, until he found his conception. Yet sometimes he made his design first shot directly on the stone, without any correction. Among the finest interpretations of animals are his *Histoires Naturelles*, a volume published in 1899 by Floury, with twenty-two full-page lithographs in an edition of 100.[5] Though Lautrec was to a certain extent under the influence of Utamaro and Hokusai whose woodcuts had taught him the use of clear, flat colours, he completely assimilated this Japanese influence. His refined sense of economy of material and his superb combination of colour made him one of the great masters of artists' lithography.

Artists' lithography was still in 1898 a subject disputed by the critics, and even the critic of *Le Temps* declared colour lithography only suitable for advertising; but the opposite view, the one of Gustave Geffroy, Roger Marx and Charles Maurice prevailed.[6] At the same time as Lautrec, the young Bonnard was occupying himself with colour-printing from stone. Other painters followed and lithography had a veritable renaissance. A number of publications were founded with the sole purpose of bringing lithography to the general public, and in these the publisher Sagot, Kleinmann, Pellet and Vollard played a part. In 1893 Marty founded *L'Estampe Originale* to which Roger-Marx wrote an introduction, Vollard started the *Peintres-Graveurs* and *Les Peintres Lithographes*. The brothers Natanson founded the art magazine *La Revue Blanche*, literary contributors were Mallarmé, Verlaine, Nietzsche and Tristan Bernard; artistic ones, besides Lautrec, les Nabis.[7] The Nabis, founded in 1889 and baptized by the poet Cazalis, mainly exercised their influence in the field of graphics. Their members were Bonnard, Denis, Vuillard, Vallotton, Sérusier, Roussel, Ranson and Ibels.

*L'Escarmouche* came into being in 1893 and *L'Estampe et L'Affiche* was founded in 1897 by André Mellerio, who in 1898 published a booklet on original lithography in colour with two originals by Bonnard.[8]

The art dealer Vollard, in whose small gallery in the rue Laffitte in Paris Cézanne had his first one man show (1895), soon realized the possibilities a publisher might seize from the rise of lithography and he asked nearly all the famous artists to work for him—Lautrec, Bonnard, Vuillard, Signac, Cross, Luce, Gauguin, Renoir, Pissarro, Cézanne, Denis, Redon, Whistler and others. They all lithographed for Vollard whose first *Album des Peintres Graveurs*, in an edition of one hundred, was published in 1896 and contained twenty-four prints. The second had appeared by the following year with thirty-two originals, while the third album, planned for 1898, remained unpublished. In his desire to include artists of repute who had no experience in colour lithography, he persuaded Renoir, Cézanne and Sisley to lithograph in colour. But these artists designed only the black stones of their prints, and left it to the master printer Clot to execute the

---

[1] *La Goulue et sa Soeur.* [2] *L'Anglais au Moulin Rouge.* [3] *La Loge au Mascaron Doré*
[4] *L'Estampe Originale*, published by André Marty, with a preface by Roger-Marx, came out in 1893, 1894, 1895, with original lithographs in colour.
[5] Jules Renard *Histoires Naturelles* (H. Floury, Paris, 1899).
[6] Lautrec's more than 350 lithographs are catalogued by Loys Delteil in *Le Peintre-Graveur Illustré* XVII (Paris, 1920) and by Jean Adhémar.
[7] The Nabis was an association of artists founded in 1889, close to the Symbolist and Rose+Croix movements.
[8] André Mellerio *La Lithographie Originale en Couleurs* (Paris, 1898).

colour stones after a black and white print they had coloured by hand. Such a process comes nearer to reproduction than to an original lithograph.[1]

Alfred Sisley (1839–99) himself made only one original lithograph in 1896 in one colour, *Bord du Loing*. Of the lithographs of Cézanne only his self-portrait is an original. Rodin's lithographs are also doubtful; these were, as Delteil confirms, made partly by Clot after drawings by Rodin.

Pierre Auguste Renoir's (1841–1919) prints play only a minor part in his entire *oeuvre*. His etchings were mainly intended as supplements for books. He lithographed a few portraits, of which his Richard Wagner, who posed for him in Palermo in 1882 for half an hour, is a lively study drawn with the brush, only surpassed by his Cézanne. His big lithographs in colour like *Hat with Pin, Child with a Biscuit* and *Children Playing Ball*[2] were executed in co-operation with Clot and are not originals—the serious collector should only buy the black proofs. Renoir's small lithograph *Odalisque* (pl. 108) intended as the title page of a book, but never published, is a masterpiece *en miniature*. For an album published by Vollard, Renoir made twelve lithographs with the brush.

Of the Impressionists, who were more interested in colour, only Camille Pissarro (1830–1903) occupied himself seriously with prints. Besides a great number of etchings, he left many lithographs. His first twelve lithographs (1874) are made with transfer paper and drawn with pen and chalk. Not until 1894 did he take up this technique again, at a time when his art had outgrown the impressionistic conception of his early days. By then he knew Seurat and Signac and was stimulated by their theories. The experience of a lifetime and a more constructive conception are reflected in these lithographs, of which his *Market at Pontoise*[3] as well as his series of *Bathers* (pl. 103)[4] are remarkable. They are real gems of lithography. Altogether he made sixty-seven lithographs, the last ones, about 1900, were *Port of Dieppe* and *The Plough*.[5]

The Neo-Impressionists, sometimes not quite accurately called Pointillistes (Seurat, Signac, Cross), a group denying the naturalism of the nineteenth century made important contributions to colour lithography, Seurat excepted. 'Le Néo-Impressioniste ne pointille pas, mais divise . . .'[6]

Their method of absolute division of colour was well adapted for lithography, and the colour prints of Signac and Cross are amongst the finest specimens of colour lithography. Paul Signac's (1863–1935) colourful prints are mostly scenes from ports, from Holland and the Mediterranean. His print *Evening*[7] was published in 1898 in the German Art magazine *Pan*, at the same time as a colour lithograph by Henry-Edmond Cross, *Les Champs Elysées*. Maurice Denis (1870–1943), though a painter, was at the same time an experienced writer and the spokesman of the Nabis. He took great interest in colour lithography, using fine and delicate colour. His prints (pl. 143), long neglected, are now making a comeback and are a valuable contribution to this art. His colleagues from *La Revue Blanche*, Bonnard, Roussel, Vallotton, Vuillard and others all worked in this medium.

Though originally belonging to the Nabis, Bonnard (1867–1947) treated their dogma more freely. Strongly influenced by Japanese colour prints, he developed his own style in colour lithography, his first important work in that line being published by Vollard in 1899 (though probably executed a few years before). This set of twelve lithographs in colour, *Some Aspects of Parisian Life*,[8] depicts scenes from Paris and shows that he had freed himself from the influence of the Nabis. He also lithographed a number of posters and contributed to *L'Escarmouche, La Revue Blanche* and Vollard's *Peintres-Graveurs*. In 1900 the German *Insel* published a brilliant street scene in colour, *The Boulevards* (pl. 105). Bonnard succeeded here with a few precise spots of colour in violet, grey, green and rose to paint an atmosphere full of life. *The Little Laundry Girl* (1896) and *The Child with a Lamp* (1898)[9] are his most sought after prints. For the publisher Frapier, Bonnard made some brilliant black and white lithographs with chalk for an album *Maîtres et Petits Maîtres* (1923–5).

Thanks to Vollard, artists took up original book illustration again, a genre neglected since the days of Manet—apart from one book illustrated by Redon, *Le Juré* by E. Picard,

[1] See André Mellerio *La Lithographie Originale en Couleurs* (Paris, 1898) p. 22. [2] *Le Chapeau Epinglé, L'Enfant au Biscuit* and *Enfants jouant à la Balle*. [3] *Marché à Pontoise*. [4] *Baigneuses*. [5] *Port de Dieppe* and *La Charrue*. [6] Paul Signac *D'Eugène Delacroix au Néo-Impressionnisme* (P. Floury, Paris, 1911). [7] *Abend*. [8] *Quelques Aspects de la Vie de Paris*. [9] *La Petite Blanchisseuse* (1896) and *L'Enfant à la Lampe* (1898)

published in Brussels in 1887. He asked Bonnard, Vuillard, Redon, Denis and others, and later on Rouault and Chagall, to illustrate books with original graphics. For *Parallèlement* by Verlaine (1900) and *Daphnis et Chloë* (1902), Bonnard made some striking lithographs with chalk.

His contemporary and friend Edouard Vuillard (1868–1940), highly gifted as a painter, first lithographed in black and white with Ancourt (where he met Lautrec and Bonnard). For the albums published by Vollard, he did some colour lithographs of which *Le Jardin des Tuileries*, a beautiful work, proves his fine sense of colour (1896). In 1899 Vollard published the album *Paysages et Intérieurs*, a set of twelve lithos in colour by Vuillard, printed by Clot in 100 copies. Here Vuillard shows himself a master of colour who understood how to create space with a few flat tints, at the same time observing a sound linear construction. *Interior in Pink*[1] and in particular *La Pâtisserie* (pl. 106), both from this set, are absolute masterpieces. In 1896 he contributed *Maternity* to the luxury edition of the German art magazine *Pan*, and in 1900 *A Gallery at the Gymnasium*[2] to the German portfolio *Insel*, both in colour. For the cookery book *La Cuisine* he made six lithographs in 1935.

As mentioned before, Maurice Denis liked tender pastel colours, which he also used in his lithos. His exquisite series of twelve prints, *Amour*, was published by Vollard in 1898. K. X. Roussel, a minor talent, preferred themes of mythological character. The Swiss-born Felix Vallotton (1865–1925) was happier with the woodcut, but his colour lithographs for *The Butter Dish*[3] (Special Issue March 1902), *Crime and Punishment*, is of great interest.

Th. A. Steinlen, also Swiss-born (1859–1923), an excellent draughtsman, lithographed street scenes (pl. 109) and interesting types of people. Some of his prints show social commitment. He also illustrated and made posters in colour. He deserves a somewhat higher regard than he receives.

In connection with the renaissance of lithography, Alexandre Lunois must be remembered for his considerable contribution to the development of the technique, lithographing mainly in colour with brush and tints, a process called lithotint.

A painter of international standing, born in America, domiciled in England, but working frequently in France was James McNeill Whistler (1834–1903). Whistler, strongly influenced by Eastern art and the Japanese colour print, exhibited with Manet, Pissarro and Cézanne at the Salon des Refusés. He became world famous as an etcher for his series the *Thames* (1871) and *Venice* (1880–6). In the years 1878–9 he made about a dozen lithographs including those virtuoso improvisations of the River (pl. 113), which are remarkable, since they were painted on the stone with a brush in fine silver-grey tints, a technique which Whistler mastered to perfection. He had found an excellent printer in London, Thomas Way, who later catalogued his lithographs. It can only be regretted that Whistler gave up this technique and did not touch the stone again until the turn of the century. He then made more than 150 lithographs normally using transfer paper, limiting himself to a few sketchy strokes of the chalk. Some of these were published in the art magazine *Studio* in London.

At one time Whistler was very friendly with Walter Richard Sickert (1860–1942), born in Munich, who painted in an impressionistic style without adopting the French colour scheme. Sickert was an excellent draughtsman and it is to be regretted that he only did about half a dozen lithographs (pl. 111). When the attempt was made in England to revive artists' lithography, magazines published originals. For *The Neolith*, Sickert made a beautiful lithograph, *Woman with Hat*. Though many other artists made efforts to popularize lithography in England, such as the Frenchman Legros, William Strang, William Rothenstein, Ricketts, Brangwyn, Shannon, Conder, Wilson Steer, Jackson, and the Americans Sargent (pl. 114) and Pennell (pl. 112), they did not succeed. The Senefelder Club was founded in 1909, and classes for lithography were introduced in the schools of the London County Council. But no masterpieces were produced as in France. Only Augustus John, who had made a name for himself outside the British Isles as a painter, designed a few pieces of quality.

In Switzerland Ferdinand Hodler (1853–1918) (pl. 156), painter of international fame, lithographed, and so did Otto Meyer-Amden (1885–1933), who however has only one print to his credit (pl. 157).

[1] *Intériéur aux Teintures Roses,* [2] *Une Galerie au Gymnase,* [3] *L'Assiette au Beurre*

# 17 The new start in Germany—some French artists

The great success lithography had in France in the 1890s among artists and public did not fail to have its effects in Germany where, since the lithographs of Menzel, this art had fallen into oblivion. The important art periodical *Pan*, a lavish quarterly, which published original prints had been founded in Berlin in 1895 and offered German artists the opportunity to occupy themselves with lithography, and to have their work published in this high class magazine, to which the leading French artists also contributed (Toulouse-Lautrec, Vuillard, Signac, Denis, Cross).

In Leipzig, Otto Greiner had tried his hand at lithography, as did Hans Thoma (1839–1924), son of a peasant from the Black Forest in the south. Thoma had studied in Paris with Couture and was at that time still under the influence of Courbet. In 1892, when he was fifty years old and mature as a painter, he developed a great interest in lithography. He even experimented with a kind of substitute, an apparatus called 'Tachograph', on which he printed his brush drawings in a few copies only, often on yellow or green coloured paper. Sometimes he coloured these 'Tachographs' by hand. But soon he changed over to colour printing in lithography, using opaque colours. When in 1897 a certain Mr Scholz from Mainz invented aluminium plates as a substitute for stone, a process he named 'Algraphie', Thoma made use of this invention, which appealed to him. His subjects were motifs from the Black Forest, life and work in the countryside. As they were of a large format they were intended to adorn walls. They should not be confused with the Karlsruher *Steinzeichnungen* (stone drawings) of a still larger size, which were lithographed commercially after Thoma's originals.

In 1890 in Berlin Max Liebermann (1847–1935), often called 'the German Impressionist', started to lithograph and contributed to the magazine *Pan* from 1896 onwards. His early lithographs, with few exceptions (pl. 115), are of minor interest, but his later work showing horses in motion and bathers on the beach are full of life, drawn fluidly in an impressionistic manner.

The true revival of lithography in Germany came through Max Slevogt (1868–1932), who also worked in Berlin. Supported by Bruno Cassirer, publisher and art dealer in Berlin, he became a book illustrator on a large scale and his entire lithographic work comprises more than 2000 drawings. His first important series was published in 1906–7, *Achille*, an album of fifteen lithographs for the *Ilias*. Some of his most striking works are illustrations to *Sindbad the Sailor*, James Fenimore Cooper's *Story of Leatherstocking*, *The Island of Wak-Wak*, *Benvenuto Cellini*, *Don Giovanni* and *Macbeth*. He was a master draughtsman who managed to elicit all the secrets from the soft chalk, the brush and the pen. His illustrations were not merely interpretations, they were creative. Apart from his illustrations he lithographed a considerable number of single plates and he continued to work on the stone until his death in 1932 (pl. 116).

Lovis Corinth (1858–1925), probably the most important painter of his time in Germany, used the stone only in later years when, as a painter, he had found his own grand style. His form, often baroque, reveals great force without being forceful; and the stroke of his chalk is similar to that of his brush, covering the stone with great speed, without becoming sketchy. While Liebermann in his prints always remained rational, Corinth followed the impulse of the moment. His late landscapes from *Walchensee* and Switzerland are among his best lithographs. His colour lithographs are more or less coloured drawings and are only satisfactory as trial proofs (pl. 120).

A contemporary of these three painters was Käthe Kollwitz (1867–1945), a pupil of Stauffer-Bern. Her fame rests on her graphic work, etchings and lithographs, depicting the suffering of the proletariat, the poverty of the worker, social themes of an accusatory strain. Her masterly ability, presenting itself through her personal and artistic expression, prevents her work degenerating into propaganda. Her numerous self-portraits designed on stone are highly impressive (pl. 117).

With the Paris World Exhibition of 1900, Impressionism and Post-Impressionism had advanced to 'Art Officiel'. However, Cézanne, van Gogh and Gauguin had, each in his own way, set free movements which were now becoming noticeable all over Europe. At the same time, the new pioneers, Matisse, Picasso, Braque and Léger were attracting the interest of the art world.

Though in Germany the nineteenth century had produced Romantic artists like

Schwind and Richter, the German-Swiss Böcklin, the idealist Feuerbach with his theatrical classical paintings as well as the genial Hans von Marrées, none of these painters had any influence on the further development of visual arts.

When Menzel died in 1905 at the age of ninety, Liebermann, Corinth and Slevogt were the principal representatives of progress in Germany. But as with the Fauves in France, some young painters began to form groups which opposed the inheritance of Post-Impressionism and were searching for new ways. But before these groups can be discussed the work of the Norwegian painter Edvard Munch (1863–1944) must be mentioned, for he stands as a connecting link between Paris and Central Europe and exercised a decisive influence on German art.

On the two occasions when he stayed in Paris, from 1889–92 and from 1895–7, Munch had not only acquainted himself with the art of Pissarro, Seurat, Signac and Van Gogh, but also with the exciting woodcuts of Gauguin, which were in every way novel. In his painting Munch sometimes faced the dilemma of developing linear values at the expense of tone. This may have been an influence on the fact that he expressed himself to such a great extent through the medium of graphic art, in which for him lithography finally dominated.

When Munch first busied himself with print making, he was already over thirty years old and had reached artistic maturity. He had learnt the technique of lithography in Paris, his first lithograph dating from 1895.

Munch's whole life was influenced by the grim realities he experienced in his youth. Through the activities of his strict father, a medical doctor in Oslo's poor district, he came into contact with the darker sides of life, and these influenced the development of this very sensitive youth. His secret fears 'The coming into existence', 'To be', and 'To pass away' did not only appear in his 'mood of life' but also in his art, his paintings and his graphic work, though the theme of his work is never purely realistic and never literary. He was also a great portraitist, both with brush and on the stone. What he had to say is the outcome of the experience of a tortured soul transformed into a perfect artistic form. The tension between the sexes permanently renewing itself—*The Kiss, Jealousy*—but also abstract themes like *The Shriek* (pl. 121), *The Fear* were the themes of some of his lithographs. Other important lithographs of the early days were the *Self-Portrait with the Skeleton hand, Death in the Sickroom* and *Tingel-Tangel* (pl. 123). His lithograph *Madonna* also belonging to the year 1895 is, like his lithograph the *Sick Girl* of 1896, printed in colour. After a nervous breakdown which forced him to stay in a sanatorium in Copenhagen (1908–9), his themes change to more realistic subjects such as *Streetworkers, Lion Tamer, Conflagration*, as well as numerous portraits (pl. 122). His cycle *Alpha and Omega* (1909), a fantastic story of a human couple in which a bear and other animals play a part, proves that Munch could treat a literary theme without becoming literary.

Munch met his first success in Germany, where he lived for many years and where he had the backing of Meier-Graefe, Gustav Schiefler and the brothers Cassirer. Among the younger generation of painters, Munch found enthusiastic admirers in Germany. The founders of 'Die Brücke' in Dresden chose him as their model.

This group of artists was founded in Dresden in 1905, when some students of architecture and some painters joined in friendship—Kirchner, Bleyl, Heckel and Schmidt-Rottluff. A year later Cuno Amiet and Emil Nolde joined, Max Pechstein and Otto Müller followed in 1910. But the self-willed Nolde could not adapt himself to the group and left them in 1907. Dissatisfied with Post-Impressionism, they once again stressed line and painted in original, strong colours, using the complementary colours red and green to define light and shade. Like Cézanne they abandoned scientific perspective and renounced detail when representing an object. This simplification automatically led to printmaking, especially to the colour woodcut, and left its mark on lithography.

The strongest personality of Die Brücke was without doubt Ernst Ludwig Kirchner (1880–1938), whose graphic work is by far the most prolific. To him printmaking was never a sideline but as important as his painting. He never regarded lithography merely as a means of reproducing his drawings but as a medium for new creations. The stone provoked him to experiment and he was the first to use turpentine to make the colour 'pearl' on the surface. In his colour lithographs he restricted himself to a few expressive tints and he often used coloured paper for printing. He found his own expres-

sive style towards the end of 1908 and the colour lithographs he produced during the next few years are of exceptional quality and beauty. Kirchner had his own printing process, using only one stone for several colours. He did his own printing, which accounts for the small editions. The circus, dancers, life in the cafés, the 'tingel-tangel' (pl. 127) and nudes were his themes, though he also did scenes from town and country. (pl. 126)

His delicate and sensitive constitution caused him in 1917 to retire to the mountains, to Davos, where the pine forests, animals and the peasants gave him new inspiration. Though he continued to lithograph, the woodcut now became predominant.

Karl Schmidt-Rottluff (b. 1884), like Kirchner and Heckel a student of architecture in Dresden, introduced lithography to 'Die Brücke'. At first orientating himself on Post-Impressionism (pl. 134), he soon freed himself and his lithographs, portraits, views of Dresden and of public parks, were drawn without adopting the forms of Jugendstil then predominant. After 1910 he preferred the woodcut and only in 1923 did he again take up lithography, making a set for the Kestner-Gesellschaft in Hanover about the life of fishermen. For Erich Heckel (1883–1970) printmaking was most important; he produced more than 1000 prints. His woodcuts in colour are his predominant output. His lithographs, in which he showed himself a first class technician, are superb. Like Kirchner he often did his own printing; his themes were portrait landscapes, bathing scenes and nudes, some in colour. Though he lithographed to the end of his life, the exciting period of his expressionistic graphics came to an end with his portraits in the early 1920s (pl. 131).

Max Pechstein (1881–1955) had lithographed a poster in 1906 for the first exhibition of Die Brücke in Dresden, strongly influenced by 'art nouveau' and printed in blue on pink paper. Pechstein, who moved to Berlin in 1908, found his inspiration in the music-hall and in bathing scenes on the beach at Nidden on the Baltic, where he used to spend the summer months (pl. 133). When in 1912 he joined the old Berlin Sezession his membership with Die Brücke ceased, and his best period came to an end.

The work of Otto Müller (1874–1930), who joined Die Brücke in 1910, is less harsh than that of his friends. Though basing his art on the same principles, he was of a lyrical temperament, and for this reason showed little interest in the robust technique of the expressionistic woodcut. He preferred lithography and the pliable chalk. His themes were slim nudes (pl. 119), youthfully fresh, out of doors and in, bathing, playing, resting, whom he drew with a few precise strokes, sometimes using a second plate as a tint. His series of large lithographs, printed in colour, depicting the life of the gypsies, are of the greatest artistic value.

Emil Nolde (1867–1956) did not find his own style before the turn of the century when he shook off the academic tradition. Nolde's main gift was colour. His inspiration came from nature, which he transformed into exciting glowing colours which enhanced his abstraction. He was a born graphic artist of an inexhaustible imagination, who started to etch in 1898. His first lithograph dates from 1907. In his early days he used the brush (there is one exception), and the four lithographs *Tingel-Tangel* made in 1907 are excellent examples of his brush technique. Before 1912 he used transfer paper for his lithographs, and the colour is not yet used in its own right but overprinted to heighten the effect. Only when Nolde started to work directly on the stone did he create those magnificent colour prints such as *The Three Kings*, *Dancer*, *Russian Woman* and *Young Couple*. Large landscapes and seascapes in glowing colours followed these figurative prints. In these Nolde often took only a few impressions and then varied the colour combination, using strong contrasting colours (pl. 167).

In the course of time all the members of Die Brücke went their own way and the association dissolved in 1913.

In Munich, the art centre of Bavaria, artists like Kandinsky, Klee, Jawlensky, Marc and Macke had also broken with the old tradition. But before this very important development can be examined, one must see what was happening in Paris, where a new generation of artists, Matisse, Picasso, Braque and Léger, had come to the fore.

Having overcome Impressionism, Henri Matisse (1869–1954) had similar aims in his use of colour as the Expressionists in Germany. Though he used colour as an independent factor, he always applied it in a refined way. But even so, having exhibited together with

Derain, Vlaminck, van Dongen and Manguin in 1905 in the Salon d'Automne in Paris, he was also called one of the Fauves. Though colour was predominant for Matisse in his painting, he had developed his own characteristic style in his drawings, to express himself concisely, a style he often used in his lithographs. His first lithographs date from 1906, about a dozen prints, heads and female nudes. A few more followed in 1914. Then he lithographed again in 1922, having reached technical perfection; and the main period of his production, 1925–30, shows him an absolute master of this technique.

In his lithographs he used two different styles: one, where he drew mostly in line (pl. 139) without any shading; and a second, using tones of every gradation, from the finest grey to the darkest black (pl. 140). As in his paintings, he often applied purely decorative elements such as vases, fruit, flowers and oriental ornaments. His themes were dancers, odalisques, mostly female heads and nudes. After 1930 he preferred etching and wood engraving for book illustrations. In 1950 he made a few lithographs for the chapel du Rosaire in Vence and in 1949 he lithographed a self-portrait. It is to be regretted that such a great colourist as Matisse did not lithograph in colour. Those lithographs printed in colour are only reproductions after his cut-outs of his later years.

The artist who influenced the arts in Paris for more than half a century, the Spaniard Pablo Picasso (b. 1881), did not lithograph before 1919 and there are no examples of his early cubist period in lithography. Cubism, influenced by Cézanne, developed by Picasso, Braque and Léger and adopted by Gleizes, Metzinger, Delaunay, Gris, Marcoussis and Archipenko, influenced printmaking many years later. Some of the few lithographs by Delaunay, who in 1908 became friendly with Picasso and the painters in the Bateau-Lavoir in Paris, are examples of Cubism. These lithographs produced in 1926 are close interpretations of his 1909–10 Cubist paintings of the Eiffel Tower and of St Séverin. Alexander Archipenko (1887–1964), born in Kiev, came into contact with the Cubists in Paris in 1908. He is mainly known as a sculptor and inventor of the 'Hole' which he brought into relationship with the surrounding space. In the 1920s he made some lithographs of figures and a still life (pl. 159) under Cubist influence. Picasso also lithographed in 1926 a Cubist design, *Interior Scene*. Apart from this, in the 1920s he lithographed a number of prints in a neo-classicist manner which were published by the Galerie Simon in Paris; (pl. 147). With the lithograph *The Painter and His Model*[1] of 1930 his first period of lithography came to an end and for the next fifteen years he did not touch the stone. His really great lithographic period started in 1945 and will be described later. (pl. 151)

One of the most influential French painters, Georges Braque (1882–1963), lithographed in 1921 a still-life in colour, a fine example of late Cubist style, also published by the Galerie Simon in an edition of 120 copies (pl. 149). He also devoted himself intensively to the stone after 1945. The same applies to Fernand Léger (1881–1955), who in his early days made only a few prints. Another Cubist, Juan Gris (1887–1927) has six lithographic portraits and some book illustrations to his credit (for Galerie Simon). André Derain (1880–1954), originally belonging to the Fauves, came under the influence of the Cubists and Picasso, but his later development was less uniform. The few lithographs he drew on the stone, a number of *Visages* drawn with chalk, are remarkable. Raoul Dufy (1871–1953), originally orientating himself towards Matisse and the Fauves, found his own way later, in which colour played a great part. His importance as a graphic artist is mainly based on his wood- and lino-cuts which he used not only for illustration but also for textiles commissioned by the creator of fashions, Poiret. He illustrated some books with lithographs and there are a few single prints in colour from his hand. It is a pity that in later years he signed a number of lithographs which are nothing but reproductions of his paintings.

Georges Rouault (1871–1958), who in 1905 had exhibited with the Fauves, very soon pursued his own bent, adopting some expressionistic tendencies. In 1914 the art dealer Vollard gave him a commission for his first prints. The best known are his aquatints in colour, and his large set *Miserere et Guerre*. With these prints a photographic process was used, thus denying them the description of 'Original'. His pure lithographs, however, are original lithographs, which he made directly with brush and chalk on the stone, continuing the work with a scraper. They are portraits, clowns (pl. 146), and religious

[1] *Le Peintre et son Modèle*

subjects, very impressive prints in black and white, mainly published by the Galerie des Peintres-Graveurs (Frapier), stamped with the 'timbre sec' and sometimes signed in pencil. Some early states of these magnificent lithographs are excessively rare.

Maurice de Vlaminck (1876–1958), originally belonging to the Fauves and later, flirting with Expressionism, made a number of landscape lithographs, villages, a still-life and some portraits which are fine examples of his romantic-expressive and intuitive art. His few colour lithos (pl. 145), are pleasing, but not of the same power as his black and white prints. The small number of lithographs by Utrillo (1883–1955) are town views, buildings in Paris, Montmartre, boulevards and suburbs in black and white. With him also the colour lithographs must be regarded with caution as in some cases they are mere reproductions.

# 18 Germany up to the Second World War

Shortly before Die Brücke disbanded, some artists in Munich founded the 'Blaue Reiter'. Their spokesman was Wassily Kandinsky; Franz Marc and Kubin were founder members; Klee, Campendonck and Gabriele Münter joined them. Kandinsky (1866–1944), born in Moscow, came to Munich in 1896, and studied there at the Royal Academy under Franz von Stuck. Originally influenced by art nouveau and Russian folklore, a short period of expressionistic painting in glowing colours followed. His first abstract watercolour matured in 1910.[1] From the very beginning Kandinsky was interested in print making, and in 1913 he illustrated his poems *Klänge* for the publisher Piper with woodcuts in colour. Shortly after his return in 1921 from Russia to Germany, he was appointed professor at the Bauhaus in Weimar by Gropius, and there in 1922 he did his first lithograph. While at the Bauhaus he wrote his second book (1923–6), *Punkt und Linie zu Fläche*,[2] which contains a special chapter on prints.

> Lithography—of all the graphic arts the one invented last—offers the greatest flexibility and elasticity in its manipulation.
>
> The great speed with which it can be performed corresponds completely with the 'spirit of our time', offering at the same time an indestructible solidity of the plate. Point, line and plane, black-and-white and colour—all this can be reached with the greatest economy.
>
> The flexibility in the treatment of the stone, which means the easy laying on with any tool and the nearly unlimited possibility of making corrections—especially the removal of faults, which neither woodcut nor etching like to endure—result in the possibility of starting without absolutely defined plans (for instance, when experimenting). This corresponds to the highest degree with the necessity of today, not only the external but also the internal.

and elsewhere he says:

> Lithography offers the chance of throwing off an unlimited number of prints in quick succession by a purely mechanical method, and emulates paintings by the increasing use of colour, so creating a certain substitute for the painted picture. Through this, the democratic nature of lithography is clearly established.

In 1922 the Propyläen Verlag in Berlin published his portfolio *Small Worlds*,[3] twelve original prints, including some lithographs in colour. He also made a number of single lithographs in colour (pl. 144), architectural constructions, lines, curves, triangles, and planes, related to his paintings from the same period. His disposition for simplification prevented him from making full use of the technical possibilities of lithography and some of his colour lithographs are similar in character to his colour woodcuts, lacking the texture typical of the stone.

His compatriot, the Constructivist El Lissitzky, also lithographed in colour. His best known are the series *Victory over the Sun*,[4] published in 1923 in an edition of seventy-five copies. His lithographs, like those of the Hungarian, Laszlo Moholy-Nagy, another Constructivist, resemble his paintings.

The Russian Jawlensky (1864–1941) lithographed some drawings of nudes and some heads in the manner of his 'meditations'.

Franz Marc (1880–1916), co-editor of the almanac *Der Blaue Reiter*, published by Piper in 1912, has a few lithographs to his credit (1908–9) still under expressionistic influence. Alfred Kubin (1877–1959), who had made a name for himself as a draughtsman and illustrator of the bizarre and ghostly, made some hundreds of lithographs drawn with the pen and closely related to his drawings.

Like Kandinsky, Paul Klee (1879–1940), also pupil of Franz von Stuck in Munich, had a great influence on the development of modern art.[5] Originally influenced by

---

[1] The ideas which turned him to abstract painting are described in his book *Das Geistige in der Kunst*, (Piper, Munich, 1912) (*Concerning the Spiritual in Art*, New York, 1947).
[2] Kandinsky *Punkt und Linie zu Fläche* Bauhausbuch 9 (Albert Langen, Munich, 1926).
[3] *Kleine Welten*. [4] *Sieg über die Sonne*
[5] Klee, often called a Swiss artist, was the son of a German musician living in Berne, where Paul Klee was born. His mother came from the Jura. His main education as an artist and his main activities took place in Germany, where he was a professor in Weimar, Dessau and Düsseldorf. During the war he served from 1916–18 in the German army. Dismissed from Düsseldorf by the Nazis, he returned in 1933 to Switzerland and died in Muralto-Locarno in 1940, without ever having become a Swiss citizen.

Kubin and animated by the work of Redon, Ensor and Goya, Klee gained independence when in the spring of 1914 he travelled with Macke and Moillet in Tunisia. In Kairuan, Klee discovered not only the colour-richness of the country but also the mosaic-like build-up of the ornamented tiles in the forecourts of the mosques, influences which were reflected from this point in his watercolours. The graphic art of Klee plays an important part within his entire oeuvre, and his more than 150 prints are no casual by-product. Having etched quite a number of plates, Klee made his first lithograph in 1912 *View over a River*,[1] published in Munich in the *Sema-Mappe*. His best known colour lithographs, and those most in demand, are *Rope Dancer, Hoffmanesque Scene, Saintly Woman*,[2] as well as the black and white lithograph *The Witch with the Comb* (pl. 124) (lithographs made from 1921–3). Klee was an outspoken graphic talent whose pictorial language was his own (pl. 125).

Besides Die Brücke and Der Blaue Reiter there were a few individualists working in Germany, such as the Austrian born (1886) Oskar Kokoschka. In his early youth an admirer of Klimt and the Austrian Jugendstil, he soon developed into an 'avant-gardiste' of Expressionism with a very personal note (about 1910).

His interest in lithography started early and it suited him better than any other graphic medium. He drew on the stone just as unaffectedly as on paper, using the chalk with the sure touch of a great draughtsman, who knows how to abstract the essence with a few spontaneous and passionate strokes. Even when illustrating he remained creative without becoming literary. Kokoschka's lithographic work is very extensive. In 1913 he made eight lithographs for *The Chinese Wall*[3] by Karl Kraus; in 1914 eleven prints *Bach Cantata*. His twelve lithographs to his own poem *Columbus in Chains*[4] were published in 1916 by Fritz Gurlitt, in Berlin; in 1916 Paul Cassirer published the six prints *The Passion* (pl. 129), and in 1917, fourteen lithographs to Kokoschka's own drama *Job* (pl. 128).[5] A born portrait painter, he lithographed many portraits, the majority before 1918. With the beginning of the 1920s the great phase of lithographs came to an end. Only after the Second World War did he take to the stone again, lithographing a number of self-portraits and series depicting travels to Greece and North Africa. His portfolio *Hellas* (1964), his forty-four lithographs to the *Odyssey* (1965), nine lithographs *London from the River Thames* (1967) and his suite of forty-one lithographs *Saul and David* (1969) were published by Marlborough Fine Art in London. For a text in French by Marcel Jouhandeau *Le Bal Masqué* (1967) he made a number of colour lithographs.

Another individualist, but of smaller stature, was Carl Hofer (1878–1955), pupil of Hans Thoma, who lithographed a number of figurative designs. Of far greater importance are the prints of Max Beckmann (1884–1950), whose first lithograph, *Eurydice's Return*,[6] dates from 1909. This was followed by six prints for the New Testament (1911) and a number of single lithos, views, cafés and in 1912–13 illustrations to Dostoievsky's *Letters from a Dead House*,[7] published by Bruno Cassirer, Berlin, in *Art and Artists*[8]—all lithographs with an impressionistic touch. In the following years, he neglected lithography in favour of etching, only to take it up again seriously in 1919 with his series of ten prints, *Hell*,[9] followed in 1920 by six prints, *City at Night*,[10] poems by Lili von Braunbehrens, and in 1922 by his ten lithographs *Berlin Journey*,[11] as well as a number of portraits and single prints (pl. 130). His last series of fifteen lithographs, *Day and Dream*, was published in 1946 by Curt Valentin in New York. Already in his illustrations to Dostoievsky certain expressionistic influences are visible, which take a definite form of their own in the *Hell* set. His line is now becoming strong and expressive and the composition of his allegories unusual, angular and of a certain realistic content, though in his last works his conception softens.

Otto Dix (1891–1969), Professor at the Academy in Dresden, 1927–33, produced, besides his etchings (of which the *War*[12] set has become famous), a number of lithographs in colour and black and white of prostitutes (pl. 138), and portraits. In later years he abandoned these erotic scenes and lithographed prints of religious content, landscapes and portraits.

Georg Grosz (1893–1955), a brilliant draughtsman, knew how to express himself

[1] *Blick auf einem Fluss.* [2] *Seiltänzer, Hoffmanneske Szene, Die Heilige vom Innern Licht.* [3] *Die Chinesische Mauer.* [4] *Der Gefesselte Kolumbus.* [5] *Hiob.* [6] *Euridykes Wiederkehr.* [7] *Aus einem Totenhaus.* [8] *Kunst und Künstler.* [9] *Die Hölle.* [10] *Stadtnacht.* [11] *Berliner Reise.* [12] *Krieg*

sparely and dynamically. His lithographs, mostly in line, are documents of his time, artistically valuable but of a cruel realism (pl. 135).

The best-known German sculptor, Ernst Barlach (1870–1938), representative of Expressionism, designed his monumental compositions of precise shapes on the stone, using strong contrasts of light and shade. His entire lithographic work comprises nearly 200 prints, portfolios, series and single lithos. They are powerful witnesses of his art (pl. 137).[1]

In the 1920s there developed a real boom in printmaking, only comparable with the same phenomen in France at the turn of the century. During the war, in 1914, Paul Cassirer had already started in Berlin *Die Kriegszeit*, followed in 1916 by the *Bildermann* (pl. 129), a weekly with text and illustrations in lithography. Artists such as Barlach, Heckel, Kirchner, Kokoschka, Liebermann, Zille and others contributed original lithographs to this popular periodical. In Munich, *Das Zeit-Echo* (1914–15), and the *Münchner Blätter für Dichtung und Graphik* had original lithographs by Klee (pl. 125), and Kokoschka; the periodical *Genius* (1919–21) also published prints. The most important art journal of the period, *Das Kunstblatt*, under the editorship of Paul Westheim, and published by Kiepenheuer in Weimar, was enriched during the years 1917–19 with original prints by Nolde, Heckel, Feininger, Kokoschka, Rohlfs and many others. The yearbook *Ganymed* (1919–25) included prints and the Ganymed portfolios, as well as the collection of prints which appeared under the title *Die Schaffenden*, published lithographs of the highest quality. The Gurlitt-Press and many others printed single lithographs, portfolios and books illustrated with originals and the Bauhaus, started in 1919 by the architect Gropius in Weimar, brought out a number of portfolios under the title *Neue Europäische Graphik*, with contributors like Klee, Kandinsky, Feininger, Severini, Prampolini, Schlemmer, Baumeister and many others. However, many publishers exaggerated, and not everything they published kept its value. To satisfy the demand of collectors, 'states' were manufactured, luxury- and super-luxury editions signed and unsigned, marked as A, B, C, D, editions were fabricated. Then towards the end of the 1920s, this enthusiasm to publish ceased in the face of the approaching economic crisis.

[1] *Ernst Barlach, Werkverzeichnis II 'Das graphische Werk'* (Dr E. Hauswedell, Hamburg, 1958).

Two painters, the Spaniard Picasso and Russian born Chagall, have occupied themselves more with lithography than any other contemporary artists. Their prints are an important part of their entire work. After his early attempts (mentioned above), Picasso (b. 1881) entered the workshop of the world famous master printer Fernand Mourlot in Paris at the beginning of November 1945 for the first time. He became involved with lithography to such an extent that for the next months he worked from nine in the morning till eight in the evening, not being satisfied until he had mastered every technical possibility for the process. Stone, zinc, transfer paper, ink, chalk, scraper, brush, turpentine—in short he used all variations and during these months he lithographed eighty sheets heads, nudes, fauns, pigeons, rams (pl. 152), bulls and still-lifes, a few in colour (pl. 162) and many in different states. After a short interval, new and complicated compositions followed; in 1947 he created ten different states after Lucas Cranach's picture *David and Bathsheba*, which differed to such an extent, that, what had been white in the first state became black in the final state, and what had been black, became white. In 1948 he made his Faun lithographs (pl. 153), five in number, which are among his finest lithographs drawn with the brush. *The Dove* and *The Toad*[1] followed in 1949, as well as series of portraits of women including *Françoise*. The years round 1952 were happy times which Picasso spent with his children Claude and Paloma in Vallauris, and are reflected in his lithographs. *The Saltimbanques*, *Nude Models*, *Studio at Cannes* and a number of portraits of Jacqueline, Kahnweiler and *Bachanales* follow. To the astonishment of the world he continues to lithograph masterpieces to the present day.

The virtuosity of Picasso has no limits. Everything he regards as suitable he subjugates to his creative genius. Already sixty years ago Kandinsky was writing about the phenomenon Picasso:

> Torn by the need for self-expression Picasso hurries from means to means. When a gulf appears between these means then Picasso leaps, and to the horror of his innumerable and bewildered followers he has reached the other side. Just when they thought they had caught up with him he has already changed once more.[2]

Unlike Picasso, the painter-poet Marc Chagall (b. 1887), one of the great graphic artists of our time, has not limited himself mainly to black and white but, as a great colourist, has used colour freely in many of his lithographs.

On his return from Russia in 1922 when he stayed in Berlin for a short while the famous teacher of graphics Herrmann Struck taught him the secrets of printmaking. In Berlin he drew more than thirty lithographs, published by Cassirer. *Man with a Goat, Man with a Samovar*[3] and *Le Juif à la Thora*, to name only a few. *The Trough* (pl. 141), drawn in Berlin, was printed in 1925 in Paris where he had returned in 1923.

In the following years he gave up lithography in favour of etching. During the Second World War he emigrated to the United States, where in co-operation with Albert Carman, the New York printer, he illustrated *Tales from the Arabian Nights* with twelve (thirteen) lithographs in seven or eight colours.

His great period of lithography began in 1952 with Mourlot in Paris, having returned to France in 1947. The Gallery Maeght in Paris offered him great chances of making colour lithographs, *The Red Cock, The Brown Horse* (1952)[4] *Paris* (1954), published in *Derrière le Miroir* and others; and for *Edition Verve* he made in 1953 *Vision de Paris* and a great number of colour lithographs for the Bible, Vol. I and II.

His numerous single lithographs in black and white and in particular his set *Cirque* (pl. 142), (1956), seven large lithos in black and white and one in colour (pl. 150) prove his mastery as a draughtsman and lithographer and must be counted as the most important prints of his graphic work. His art as a lithographer is best explained in his own words:

> One may be a good draughtsman without feeling this special urge in one's hands to lithograph, as this is a matter of an inner motive. One should add that each stroke of the

1 *La Colombe* and *Le Crapaud*
2 Wassily Kandinsky *Über das Geistige in der Kunst* (R. Piper, Munich, 1912).
3 *L'Homme à la Chèvre, L'Homme au Samovar*
4 *Le Coq Rouge, Le Cheval Brun* (1952)

chalk ought to radiate this very particular spirit, which has nothing to do with skill or method of work.[1]

In 1957 he executed fifteen lithographs for the book by Jacques Lassaigne to be followed by forty-two in colour for Edition Verve for *Daphnis et Chloë*. Countless single prints, further work for *Derrière le Miroir*, colourful posters and many charming small greetings cards complete his lithographic work, adding up to nearly 500 pieces from this remarkable personality who, in spite of his age, still continues along these lines.

Colour lithography, most popular with the public after the war, induced Braque also to use this medium frequently. His several still-lifes with teapots (pl. 148), his series *Helios Théogonie*, and his various lithographs on the theme *Char*, as well as a number of book illustrations, mostly quietly coloured lithos, are outstanding compositions of a sensitive quality, which his later lithographic work has not always equalled. It is a pity that Braque, like Picasso and Chagall, agreed that some sketches and gouaches should be reproduced by lithography in colour and numbered and signed in pencil by the artists.[2]

The few original lithographs in colour by Fernand Léger (1881–1955), in particular those he made in 1948 for the Gallery Louise Leiris in Paris (Kahnweiler), are typical and first class examples of his art (pl. 168). They demonstrate his particular gift for the decorative in flat colours. His sixty lithographs for *Cirque* were published in 1950 by Tériade. Further colour lithographs were published by the Gallery Leiris in 1952–3. There also exist reproductions of works by Léger made up as lithographs in colour.

Max Ernst born in 1891 in Brühl near Cologne, living since 1922 in France, has lithographed on many occasions (pl. 163). With Hans Arp and Masson he belongs to the movement known as Neosurrealism. In 1923 Arp's (1887–1966) plain abstractions were printed from stone under the title *Sieben Arpaden*. Masson (*b.* 1896), has constantly changed his style, as is evident in his prints.

In connection with the Surrealist movement, the Spaniard Salvator Dali (b. 1904), a painter and graphic artist of great virtuosity, must be mentioned. Dali has made a number of lithographs, sometimes of a sensational character, sometimes strongly erotic, sometimes in a religious vein. The latest contribution in the field of lithography by this brilliant draughtsman is his cycle *Alijah*, a set of twenty-five prints, 1967–8, about the State of Israel. In this set he expresses himself in a classical way using colour in a tachistic manner.

The well-known Catalan painter, Joan Miró (b. 1893), (pl. 166) has a great deal of lithographic work to his credit. His graphic symbols, often of a surrealist character, are a pictorial language of his own invention; his well balanced compositions are enriched by his vivid colours.

[1] Preface by M. Chagall in *Chagall Lithographe* Monte Carlo, 1960 (translation).
[2] The expert recognizes such prints at once as mere reproductions—not so the general public. As works of art such reproductions have no value.

# 20 The United States of America and modern developments

A number of external influences caused America's entry into the realm of the visual arts as an influential factor in her own right. The attitude of the Nazis towards the arts, and the following World War made New York the centre of modern art. The great exodus from Europe brought a number of important and influential artists to the United States: Josef Albers, Piet Mondrian, Lionel Feininger, Naum Gabo, Walter Gropius, Marcel Breuer, Mies van der Rohe, Amédé Ozenfant, Fernand Léger, Marc Chagall, Georg Grosz, Laszlo Moholy-Nagy, Max Ernst, André Masson and others.

The wife of Max Ernst, Peggy Guggenheim, acted as a go-between and introduced the newcomers to the American artists. Her tremendous collection, gathered in Europe with the advice of Marcel Duchamp, formed the basis for her Gallery-Museum, 'Art of this Century', which she opened in New York in 1942, and where she then showed the younger Americans: Jackson Pollock, Robert Motherwell, Mark Rothko, Adolph Gottlieb, Hans Hoffmann and others.

While literature and poetry had already made a home in America during the nineteenth century, painting and sculpture still looked for some while to Paris, where most American artists lived temporarily. Within this summary, details regarding these developments cannot be given in full, but two events of outstanding importance responsible for starting this modern movement must be mentioned: the activity of Alfred Stieglitz[1] who from 1908 acquainted New York with the works of the École de Paris; and the Armory Show, staged in 1913, an exhibition of more than 1500 works, from Ingres to Picasso. Cubism had arrived in the United States and the first germ of an independent art in America—demonstrating itself later in the creations of Gorky, Rothko, Gottlieb, de Kooning, Pollock, Motherwell and others.

When after the war the emigrants returned to Europe, a new generation had grown up and abstract art had become dominant. Though at first still based on experiences of nature, the new trend soon became non-objective, a development readily taken up by the young Americans. Abstract expressionism, action painting, pop art, op-art, multiple art, underground art—one movement followed the other in quick succession. 'Art is dead', 'Long live Anti-Art'. The space-age introduced new conceptions, art-critics used a new language hardly to be understood and the artist who did not produce something entirely new at least every second year was regarded as passé.

A great number of lithographs were produced, a real boom started, and since many painters did not take the meaning of the term 'original' seriously, the Print Council of America was forced to publish a definition of the term 'Original Graphics'.[2] Nonetheless, in the last twenty-five years lithographs of high quality and importance have been made.

In France, a number of artists made a name for themselves after the war. The sculptor, Alberto Giacometti (1901–66), whose elongated figures have a parallel in Etruscan art, was just as important as a painter and draughtsman. To him drawing was most essential. With his nervous line, often an immense number of lines, he does not give an exact outline, yet succeeds in conveying an enormous feeling for space and the essence. His lithographs, about thirty in number, some published in *Derrière le Miroir*, are excellent examples of his work (pl. 154).

The lithographs of Bernard Buffet (b. 1928) are in the same sombre tones as his paintings. The abstracts of Alfred Manessier (b. 1911), based on visual experiences, often of a mystical religious character, are in glowing colours and related to stained glass windows. Belgian-born Gustave Singier (b. 1909), a competent colourist (pl. 190), has

[1] Alfred Stieglitz (1864–1946). Also known as an important photographer, showed in his Fifth Avenue gallery in 1908 and in the following years the works of Matisse, Toulouse-Lautrec, Rousseau, Picabia, Picasso, Brancusi, Severini, as well as the then avant-garde of American artists.

[2] The producers of multiple-art state that printed graphics are multiple-art as several copies exist. This is a mis-statement. Original graphics have their own characteristics, prints have an individuality, as every single copy has its origin in the work of the artist. An original lithograph is not a mere reproduction of a drawing or a gouache; it has the characteristics of its own process. Artists who regard printed graphics only as a medium for reproducing their own works prefer these days screen printing, a process nearer to a mechanical process of reproduction where the artist does not himself execute the forms.

lithographed abstractions, while the prints of Roger Bissière and of Maurice Estève are purely abstract and those of Georges Mathieu calligraphic in style.

Le Corbusier (1887–1967), one of the leading architects of the twentieth century, whose paintings are only now properly valued, left a number of lithographs, abstractions in colour related to his paintings. In an exceptional position is Jean Dubuffet (b. 1901), (pl. 161), whose art is shaped by Klee and Art Brut, and who worked extensively with colour lithography.

American by birth, but living mostly in France, Alexander Calder (b. 1898), often hailed as a pioneer of Kinetic Art, is best known for his Mobiles. His abstract lithographs in colour, with a preference for red, blue and black, are for the greater part made in France (pl. 185).

Particular interest in the promotion of lithography was shown by Nesto Jacometti, who in 1949, with Pierre Cailler in Geneva founded *La Guilde de la Gravure*. In 1954 Jacometti left, and founded *Oeuvre Gravé*, Paris and Zurich. Altogether he published nearly 600 prints by the most important artists of the younger generation in Europe.

In Paris itself numerous publishers and dealers brought out lithographs, such as the well known Galerie Simon (Kahnweiler), the dealer and publisher Maeght (*Derrière le Miroir*), Tériade in his publication *Verve*, not forgetting the activities of Fernand Mourlot, the premier establishment for lithography, and of Desjoubert, the printer with whom many well-known artists worked. The periodical *XXième Siècle*, which had published original prints before the war, continued this activity in its new series. The house of Kornfeld & Klipstein in Berne invited artists to lithograph, and in Zurich the printing works of Emil Matthieu gained special praise by observing the principle of accepting from artists only work which deserved the name 'original'.

In Britain, where, since the days of Whistler and Pennell and the master-printer Way, no skilled printer was forthcoming. Though Paul Nash (1889–1946) (pl. 158), official war-artist, in 1917 drew a series of war lithographs on the stone, and the Senefelder Club induced Augustus John (1878–1961) to make lithographs, lithography was not taken up again seriously until 1946. In 1948 Rex de NanKivell (Redfern Gallery, London) founded, together with Mrs Stamper and Miss Lucas, the Society of London Painter Printers. More than fifty artists took part, including Graham Sutherland, John Piper, Jankel Adler, Robert Colquhoun, Victor Pasmore. Important exhibitions of prints in the Redfern Gallery and the Leicester Gallery continue up to the present day, making a valuable contribution towards getting lithography acknowledged in England as a true work of art. Today there exist in London alone more than twenty galleries dealing in modern prints.

The lithographic work of Graham Sutherland (b. 1903), one of the most important British painters since Constable and Turner, comprises more than sixty prints. Sutherland, a born graphic artist of exceptional gifts, started as an etcher, somewhat under the influence of Samuel Palmer. When intensively occupied with painting in the 1930s, he began to invent his own forms (pl. 164), which, however, derived from nature. His lithographic work is always close to the themes of his paintings and the majority of his prints are in colour. Besides a great number of single lithographs his set *A Bestiary* (pl. 179), published as colour lithographs in 1968 by the Malborough Gallery in London, is a striking example of his graphic art, and it should be mentioned that Sutherland makes the colour separations himself, without any help from a professional.

The sculptor Henry Moore (b. 1898), who as no other sculptor has influenced the development of his art, lithographed a number of prints related to his drawings. In his far-reaching abstractions, Moore has proved himself a great inventor of new combinations of forms, which, however, have their basis in nature (pl. 175).

Another British sculptor, Reg Butler, (b. 1911), has lithographed most seriously. Originally an architect, he is also an outstanding draughtsman, who knows how to abstract the essential from the human body. His lithographs in black and white are strongly expressive and monumental. As in his sculpture, he faces two problems in his lithographs: the human body in movement in abstracted form, and the theme of the tower in space (pl. 165). He prefers stone and has his own printing press.

John Piper, internationally known for his stained glass, is also a lithographer. Victor

Pasmore, who had made a splendid start as a figurative painter, later lithographed purely abstract prints. Alan Davie, a born colourist, William Scott, Ceri Richards, to name only a few, as well as all the younger artists in England, have used the stone.

Pop-Art and Op-Art coming from America pointed the direction for many younger artists in Britain and on the Continent. Allen Jones (pl. 191), Peter Blake, Eduardo Paolozzi, Howard Hodgkin belong to this group. The digestion of visual stimulation to create space through illusion is of the greatest interest to the Hungarian-born Victor Vasarely (b. 1908), who, however, prefers screen printing. An outspoken graphic talent amongst the younger artists is David Hockney (b. 1937) (pl. 189), who found his own style in representational art. His drawings are of great fluidity and at the same time have complete technical control. A number of publishers such as Editions Alecto, Curwen Prints, Marlborough Graphics and Petersburg Press have brought out lithographs. Stanley Jones, himself 'peintre-graveur' and teacher at the Slade School of Art in London, has, as a master printer with Curwen Prints, a part in the present-day success of lithography in art in Britain.

After the war Germany also had a renaissance in printed graphics. The woodcut, preferred in the days of Die Brücke, was neglected and lithography came into favour. Already the Expressionists had given up colour as a descriptive medium and used it without reference to nature. They used it 'klangartig'—music-like—a fact even more perceptible in abstract art.

Willy Baumeister (1889–1955), belonging to the generation after Kandinsky, after studying ancient art and the art of Mesopotamia (*Summerische Legenden*), used in his lithographs a kind of symbolic pictorial language (pl. 171). Ernst Wilhelm Nay (1902–68), most probably the most important representative of non-figurative art in Germany after the war, during the last years of his life made a number of lithographs. They are symphonies in flat forms of colour, with clear outlines without effects of light or shade (pl. 172). They are well-balanced compositions and are among the best made of this type in Germany during the 1960s. Fritz Winter (b. 1905), a pupil of Paul Klee and Kandinsky, also uses in his lithographs flat areas of tint.

Rudolf Belling, (b. 1886) in Berlin, a pioneer of modern sculpture and of great importance made in recent years some lithographs with chalk (pl. 188).

In contrast to these purely abstract works, the *Steindruck-Malereien* (paintings on stone) by Christian Kruck (b. 1925) are based on nature. Kruck uses as a rule for his glowing colour compositions only one stone, sometimes even for ten colours (pl. 178).[1]

Among the younger generation of internationally accepted painters and sculptors in Germany are Paul Wunderlich (b. 1927), with his slightly erotic lithographs (pl. 182); the highly gifted Horst Janssen (b. 1929) (pl. 180), his graphics often somewhat bizarre and self-willed; Bernhard Schulze, with his sensitive drawings; K. R. H. Sonderborg and his black and white abstractions; Horst Antes (pl. 183), a pupil of Grieshaber; the Austrian Hundertwasser his spirals forming strong coloured labyrinths and Hans Theo Richter, who died in 1969 in the D.D.R. (pl. 184). Another Austrian Ernst Fuchs (b. 1930), did some colour work, somewhat related to art-nouveau (pl. 186).

As now happened in other countries, an increasing number of art dealers and publishers in Germany published lithographs. Some of them are Edition Rothe in Heidelberg; Galerie Brusberg in Hanover, Galerie Der Spiegel in Cologne, as well as the Galerie Ketterer in Munich, which has made an international name for itself as publisher of graphics through the portfolios *Europäische Graphik*, and, in Switzerland, the *Erkerpresse* in St Gallen.

The Italian artists were also involved in the great popularity of lithography. Giorgio de Chirico (b. 1888), who in his early work (pl. 132) used architectural images in a metaphysical sense, had already lithographed for the Bauhaus, at the same time as Prampolini, Boccioni and Severini. Much later his paintings took on a neo-classical

---

[1] Kirchner had printed colour lithographs from one stone, even taking prints by rubbing. Having made the principal drawing (usually with the brush) on the stone, Kruck takes 10–15 impressions, he then reduces the stone; the drawing remains still visible, but the stone has lost is ability to deliver prints. The drawing for the next colour on the same stone follows and this process is repeated until all colours have been printed.

outlook, and so did his lithographs. Severini (1883–1966), who in 1906 settled in Paris, belonged originally to the group of painters and poets who, under the leadership of Marinetti joined together in 1909.[1] Later on he came under Cubist influence, which was reflected in his prints. One of the first abstract painters, Alberto Magnelli (b. 1888), who painted his first abstract in 1915, lithographed in flat colours in the style of his abstract geometrical pictures, developed after 1931. Massimo Campigli (b. 1895) often used the stone. As a figurative artist of repute his lithographs in colour, like his paintings, are stimulated by classical works and Punic gravestones. He has found his own personal form of expression and his well balanced compositions in sensitive colours prove him an outstanding graphic artist (pl. 173). The lithographs of the Sicilian Renato Guttuso (b. 1912) are forceful statements of his art, in a realist-expressionistic manner, avoiding any lapse into naturalism (pl. 170).

Marino Marini, sculptor and painter (b. 1901), internationally perhaps the best known Italian artist, has made a considerable number of lithographs since the 1940s. Originally using black and white, but later employing colour for accent, his favourite themes are horse and rider which he draws with a powerful hand on the stone, extracting the essential in his own typical way (pl. 192).

Afro (Basaldella) (pl. 177), a non-figurative, intuitive painter, has made lithographs in exciting colours. The combinations of Capogrossi's symbols in his lithographs are identical with his paintings, while the few prints of the sculptor Giacomo Manzu (b. 1908) are sensitive examples of his powerful handwriting. Of the younger generation in Italy, Dorazio and Perilli should be mentioned.

Apart from the Spaniards Picasso, Miró and Dali, who have been dealt with, the Catalan Antoni Clavé (b. 1913) has also produced a number of figurative lithographs of popular interest, while his compatriot Tapies, a non-figurative artist, is regarded as leading this field in Spain. In recent years the sculptor Chillida (b. 1924) has joined the ranks with his black and white lithographs.

Paul Delvaux (pl. 169), born in Belgium 1889, and famous for his dreamlike surrealist paintings, has lately made some lithographs which show him as a brilliant draughtsman and portrayer of the female figure; in style they are close to his paintings. Another Belgian, Cornelius Corneille (b. 1927), and the Dutchman Karel Appel (b. 1921), both abstract expressionists, and the Paris-born surrealist Yves Tanguy (1900–55) have also used the stone frequently. The Soviet Russian painter Anatoli Kaplan (b. 1902) (pl. 160) has made himself known with several series of lithographs. His thirty lithographs for *Stempenyu*, a novel by Sholem-Alejchem, showed him as a skilled lithographer, who understands how to interpret and to pass beyond conventional illustration.

When America emancipated itself from Paris and the rest of Europe to take an independent stand, this led to what is called Abstract-Expressionism, with Gorky (1905–48), and Jackson Pollock (1912–56) as exponents. In the end, this emancipation brought about quite a new conception of art which was re-exported to Europe. While in former days artists went to Paris to orientate themselves, New York now became their goal, particularly after having made contact with the leading American artists during their European visits.

Through the numerous publications of his lithographs, the action-painter Sam Francis (pl. 174) became well-known in Europe. In these prints of vivid colours, purely abstract compositions in well-arranged shapes, Sam Francis makes skilful use of the accidental. As in his paintings, he leaves great areas blank. However, the greatest impact on European art was made by Pop Art. Its main American representatives in the field of prints were Robert Rauschenberg (b. 1925), Roy Lichtenstein (b. 1923), Claes Oldenburg (b. 1922 in Sweden), Jim Dine (b. 1935), Tom Wesselmann (b. 1931) and James Rosenquist. Lichtenstein (pl. 176) brought the screen into painting. His lithographs, like his paintings, are similar to comic strips, greatly enlarged and influenced by art nouveau, which is popular at the present moment. According to Wieland Schmied (Kestner Gesellschaft, Hanover) 'Lichtenstein obtains through this simplification and enlargement of his model an aesthetic shock.' In contrast Rauschenberg (pl. 193), who

[1] Together with Carra, Boccioni, Balla and Russolo, Severini signed in 1910 the Futurist Manifesto.

studied with Josef Albers, shows a certain restraint in his graphics. These, often related to collages and perhaps somehow reminiscent of Schwitters, are nonetheless impressively independent, and the product of a skilled hand. Oldenburg, sometimes close to abstract expressionism, has made lithos of figures in movement, as has Tom Wesselman, while Rosenquist combines naturalistic shapes and objects with abstractions in strong colours. Richard Lindner (b. 1901 in Germany), a representative of Neue Sachlichkeit, has made a few figurative lithographs in colour, bringing the human figure into relationship with 'gadgets', and using huge forms.

Through some printers and publishers like the 'Tamarind Workshop' in Los Angeles, the Pratt Centre and Tanya Grossmann in New York, original lithography has been greatly promoted, and Gustave von Groschwitz has contributed to its growth by organizing for several years the International Biennial of Contemporary Color Lithography in the art museum of Cincinnati.

In these days one trend follows another in quick succession and conceptions of art alter. It cannot be predicted in which direction artists' lithography is going to develop. One truth, however, remains: the real 'peintre-graveur' distinguishes himself not only through his artistic qualities, but also by his complete command of technique. Such a mastery has to be worked for, little will be achieved with spade and wheelbarrow.

In the preface to the catalogue *Documenta II*, Kassel, 1959, Werner Haftmann wrote: 'Modern culture moves on a narrow ridge, there is always the danger of a sudden fall.'

1  Lorenz Quaglio *Portrait of Senefelder* 1818
28·6 × 22·5cm (11½ × 8⅞in.)

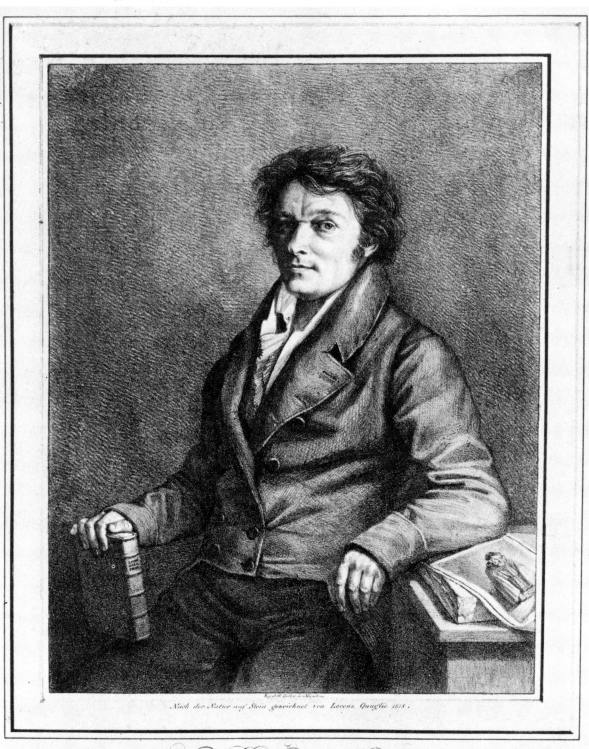

*Nach der Natur auf Stein gezeichnet von Lorenz Quaglio 1818.*

Alois Senefelder

*Erfinder der Lithographie und der chemischen Druckerey.*

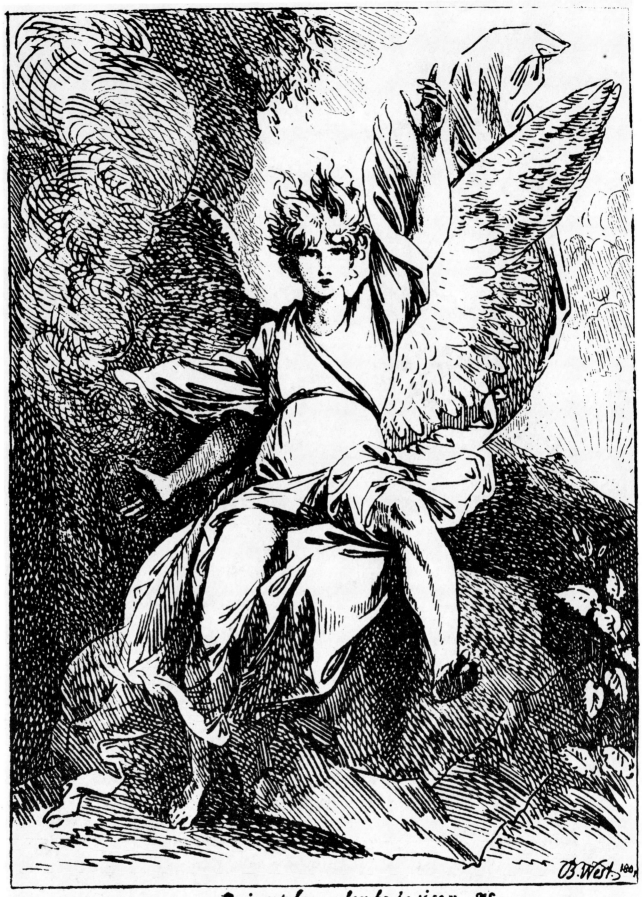

He is not here : for he is risen .oc.

2  Benjamin West *Angel of the Resurrection* 1801
32·7 × 22·5cm (12⅞ × 8⅞in.)

3 Conrad Gessner *Cavalry Charging* (1801)
   22·8 × 31·3cm (9 × 12⅜in.)

4 Richard Cooper *Landscape with Large Trees* 1802
   23·1 × 32·4cm (9⅛ × 12¾in.)

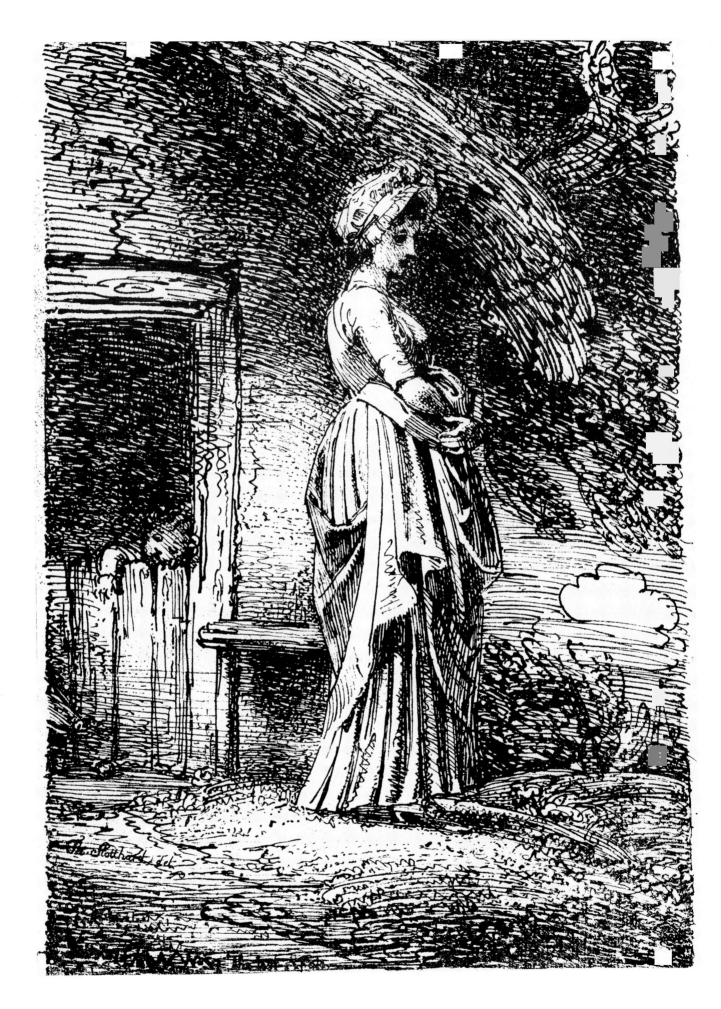

5 Thomas Stothard *The Lost Apple* (1803)
30·7 × 22·1cm (12$\frac{1}{8}$ × 8$\frac{3}{4}$in.)

6 Charles Heath
*Three Cupids Bathing* 1802
20·6 × 19·5cm (8⅛ × 7¾in.)

*C. Heath. Feb. 11ᵗʰ 1802.*

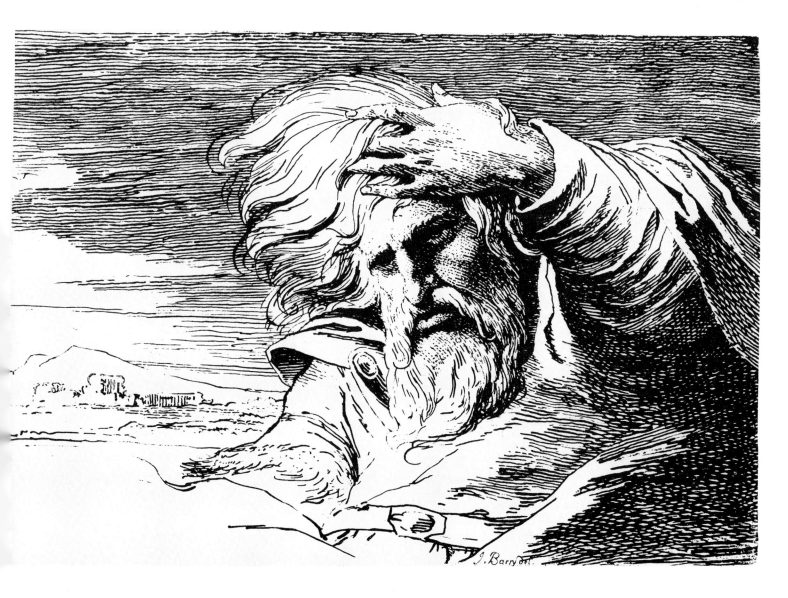

7 James Barry *Eastern Patriarch* (1803)
23·4 × 31·6cm (9¼ × 12½in.)

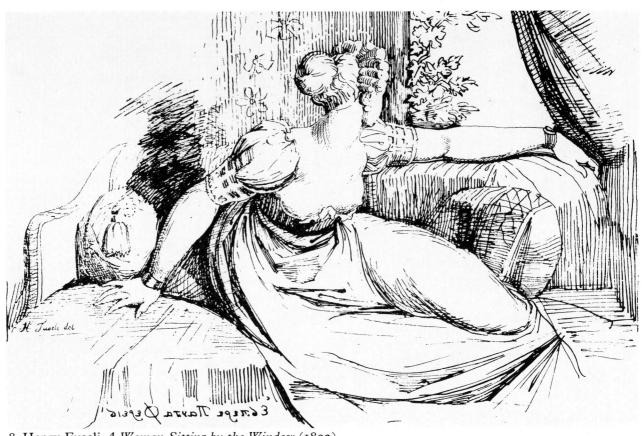

8 Henry Fuseli *A Woman Sitting by the Window* (1802)
21·5 × 31·6cm (8½ × 12½in.)

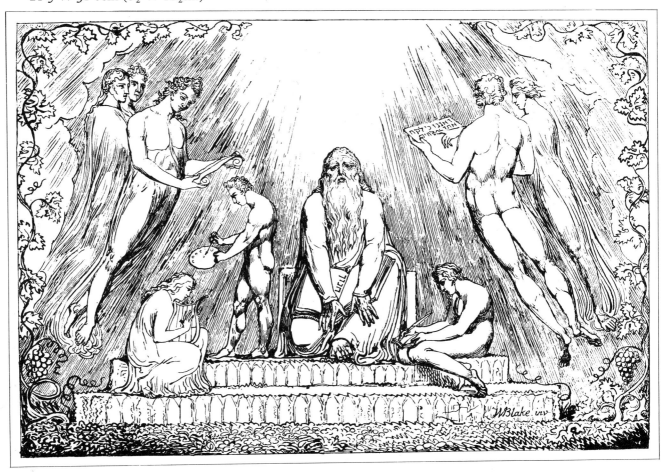

9 William Blake *Job in Prosperity* (1807)
21·5 × 31·6cm (8½ × 12½in.)

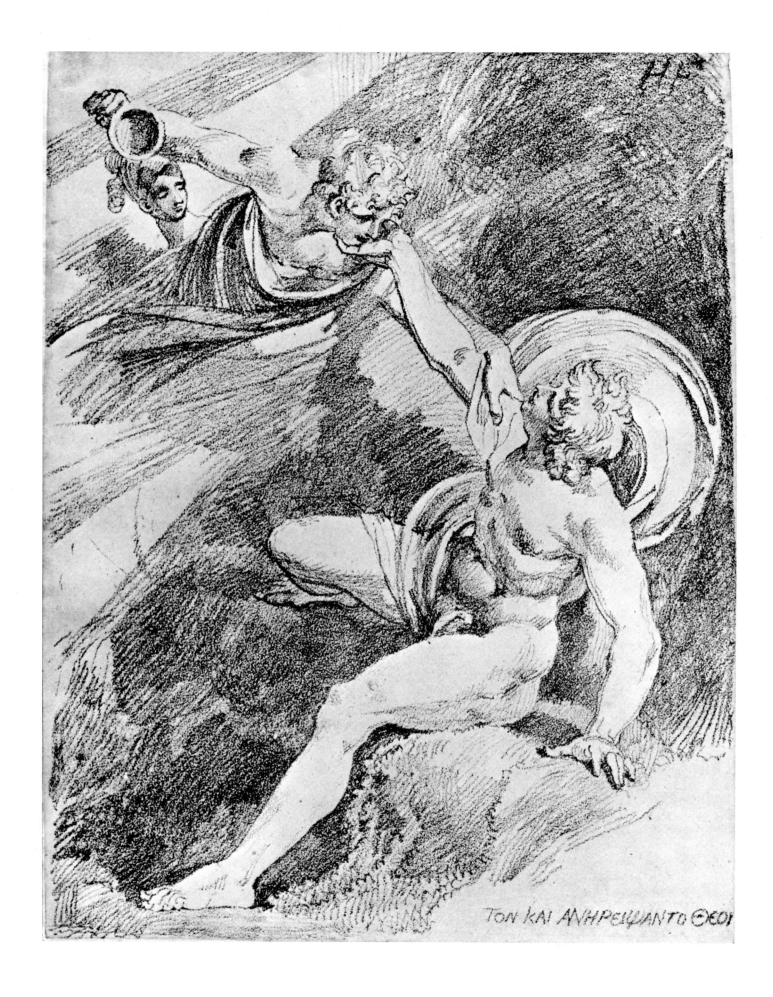

10 Henry Fuseli *The Rape of Ganymede* (1804)
31·1 × 23·6cm (12$\frac{3}{16}$ × 9$\frac{5}{16}$ in.)

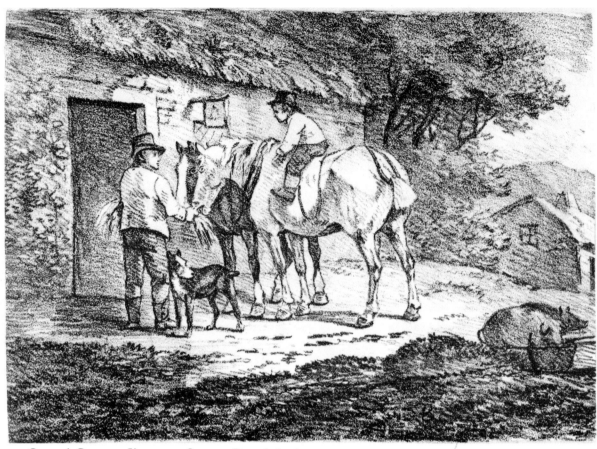

11  Conrad Gessner *Horses at Cottage Door* (1804)
22·8 × 32·4cm (9 × 12¾in.)

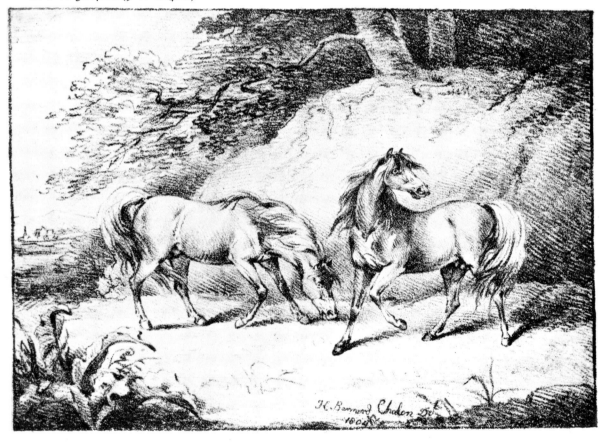

12  H. Bernard Chalon *Wild Horses* 1804
22·8 × 32·4cm (9 × 12¾in.)

13 Wilhelm Reuter *Rape of Proserpina* 1803
28·5 × 19cm (11¼ × 7½in.)

14 Electrina Stuntz *jupiter and Semele* 1810
18·5 × 26cm (7⅜ × 10³⁄₁₆in.)

15 Aloys Senefelder *Print in three colours* 1818
14·5 × 22cm (5¹¹⁄₁₆ × 8¹¹⁄₁₆in.)

16 Joseph Lanzedelly *Mummery, from the 'Theuerdank'* c. 1820
23·4 × 23·2cm (9$\frac{3}{16}$ × 9$\frac{1}{4}$in.)

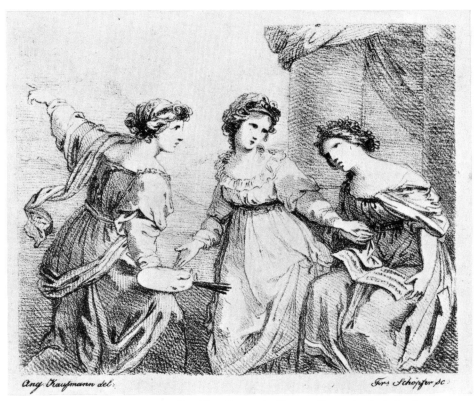

17 Francisca Schöpfer *Angelica Kauffmann's Farewell to Music* (1803)
10·5 × 13·5cm (4¼ × 5⁵⁄₁₆in.)

18 Johann Gottfried Schadow *Orestes and the Eumenides* 1804
28 9 × 40 1cm (11½ × 15¾in.)

Hefzustographische Zeichnung von C. F. Hampe

19 Carl Friedrich Hampe *Cain Slays Abel* 1804
27·4 × 36cm (10$\frac{13}{16}$ × 14$\frac{3}{16}$in.)

20 Matthias Koch *Landscape with Ruins* 1802
44 × 56cm (17$\frac{5}{16}$ × 22in.)

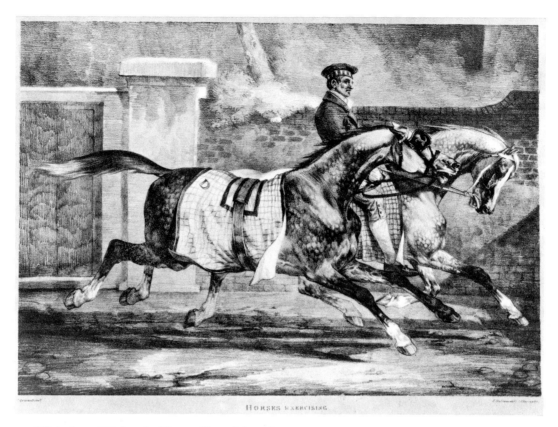

53 Théodore Géricault *Horses Exercising* 1821
28·6 × 40·6cm (11¼ × 16in.)

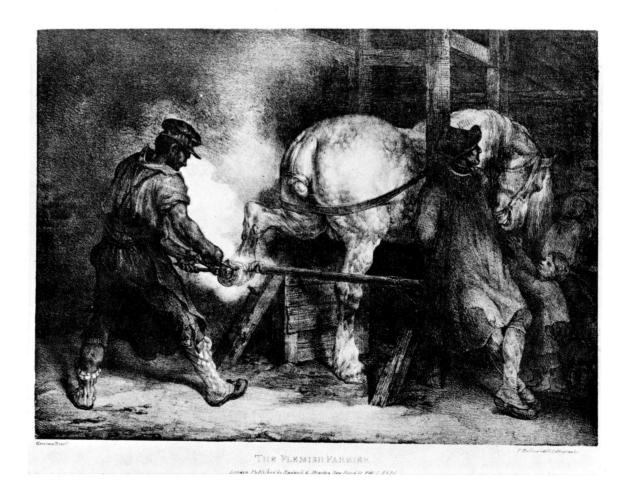

54 Théodore Géricault *The Flemish Farrier* 1821
22·6 × 31·3cm (8⅞ × 12¾in.)

55 Théodore Géricault *Lion Devouring a Horse* 1820
19·7 × 30·2cm (7¾ × 11⅞in.)

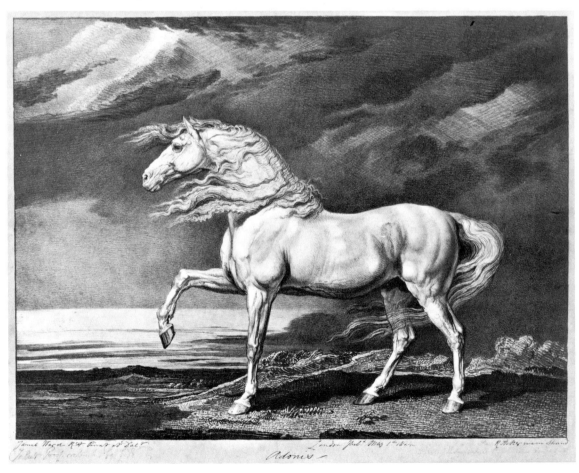

56 James Ward *Adonis* 1824
33·7 × 44·6cm (13¼ × 17¾in.)

57 Nicolas-Toussaint Charlet *The French Soldier* 1818
45·7 × 33·6cm (18 × 13¼in.)

58  Franz Krüger *Trainer Seeger* (1825)
   25·5 × 35·5cm (10$\frac{1}{16}$ × 13$\frac{5}{8}$in.)

59  Alexander Orlowski *Troika* 1819
   39·5 × 57·5cm (15$\frac{7}{16}$ × 22$\frac{5}{8}$in.)

60 Richard Parkes Bonington
*Rue du Gros Horloge, Rouen*
1824
24·4 × 25·5cm (9⅝ × 10in.)

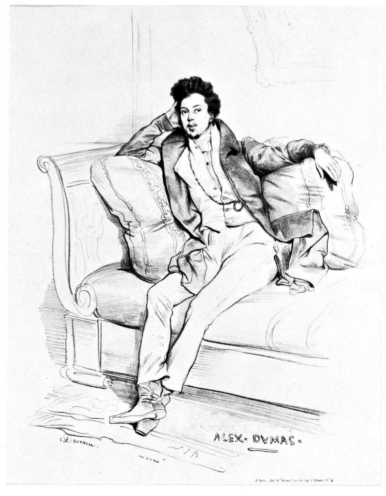

61 Achille Deveria
*Alexandre Dumas Père* 1829
33·7 × 25·4cm (13¼ × 10in.)

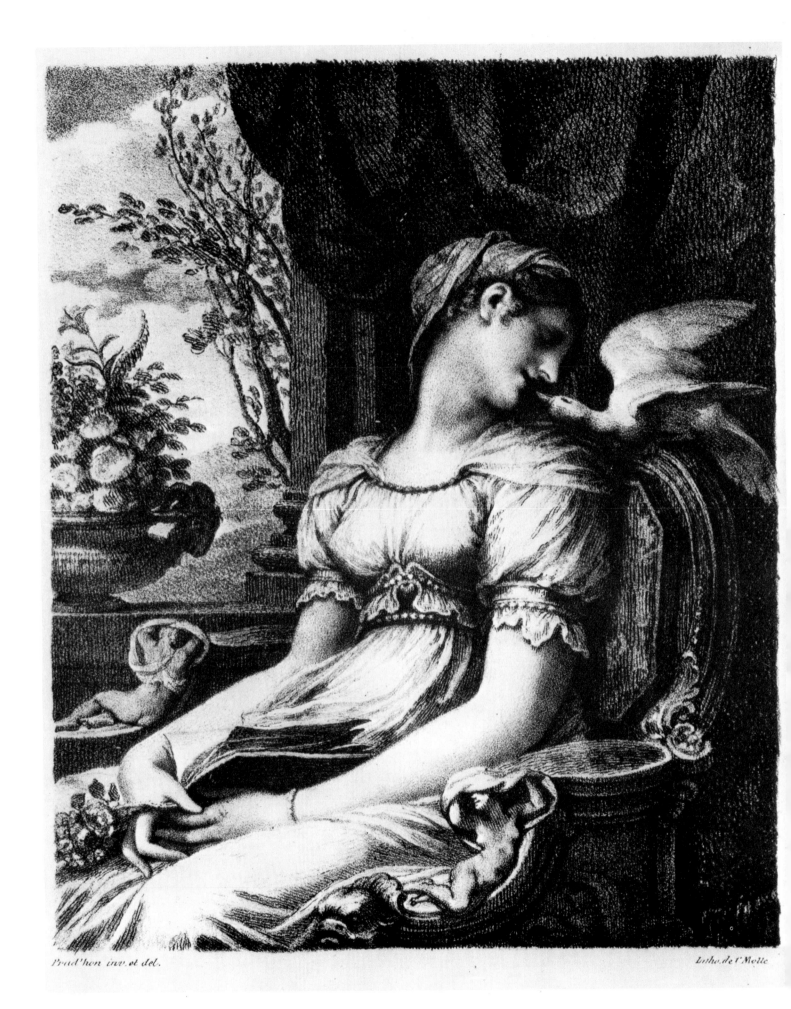

Prud'hon inv. et del.                                    Litho. de l'Motte

62  Pierre Paul Prud'hon *Reading* 1822
18·4 × 14·8cm (7¼ × 5¾in.)

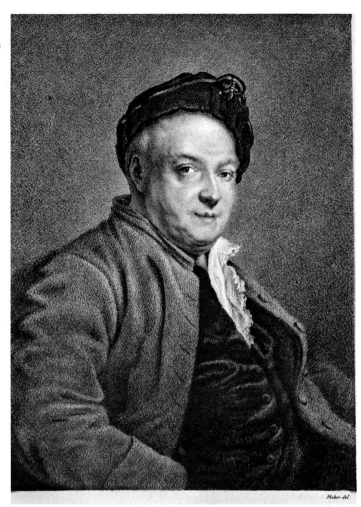

63 Godefroy Engelmann
*Portrait after Greuze* 1837
19 × 13·7cm (7½ × 5⅜in.)

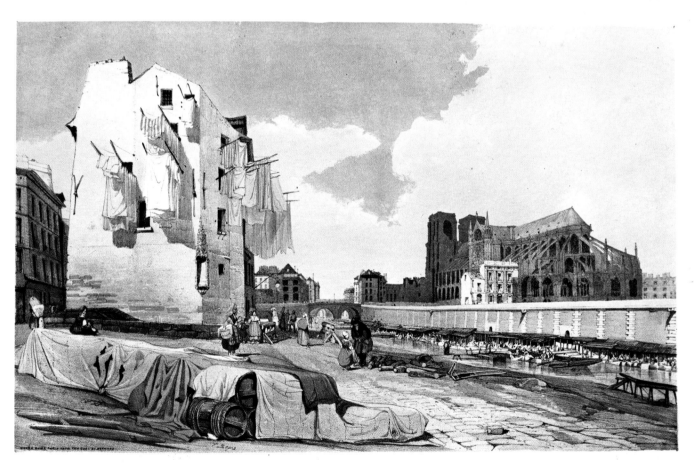

64 Thomas Shotter Boys *Notre Dame, Paris, from the Quai St Bernard* 1839
25 × 38·5cm (5⅞ × 15⅛in.)

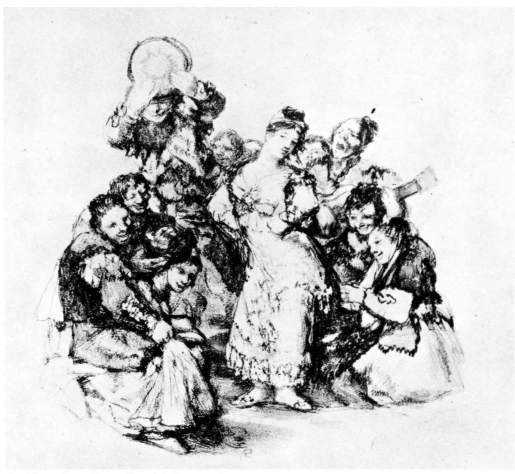

65 Francisco Goya *Spanish Dance* 1825
20 × 18·4cm ($7\frac{7}{8}$ × $7\frac{1}{4}$in.)

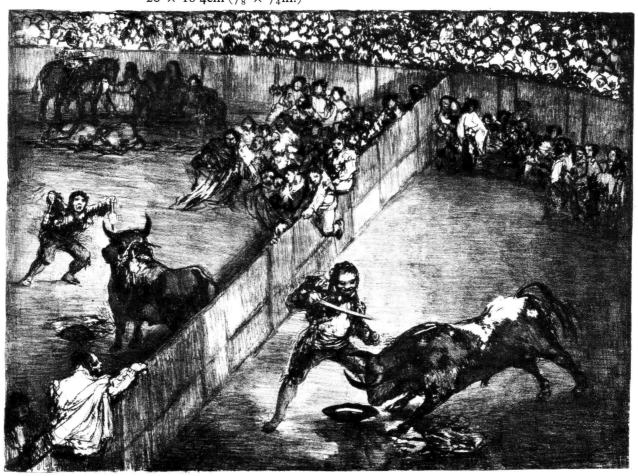

66 Francisco Goya *The Bulls of Bordeaux* 1825
30·7 × 41·3cm ($12\frac{1}{8}$ × $16\frac{1}{4}$in.)

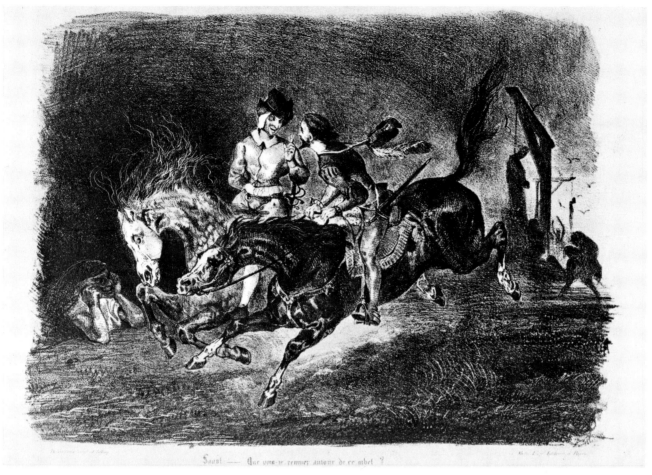

67 Eugène Delacroix *Faust and Mephistopheles Galloping during the Witches' Sabbath* 1828
20·6 × 28·5cm (8⅛ × 11¼in.)

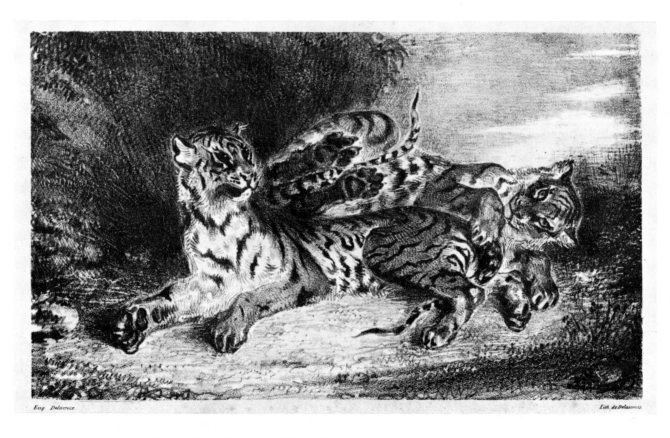

68 Eugène Delacroix *Young Tiger Playing with its Mother* 1831
11·1 × 18·7cm (4⅜ × 7⅜in.)

69  Paul Huet *The Hills of St Sauveur near Rouen* 1831
    11·4 × 17·8cm (4½ × 7in.)

70  Eugène Isabey *Near Dieppe* 1832-3
    25 × 30cm (9⅞ × 11¾in.)

71 Jules Dupré *Pastures near Limoges* 1835
11·4 × 18·4cm (4½ × 7¼in.)

72 Auguste Raffet *March Past at Night* 1836
25 × 30cm (9⅞ × 11¾in.)

73 Moritz von Schwind
*Portrait of Sophie Schröder* 1823
12·8 × 12cm (5 1/16 × 4 3/4 in.)

NIEDER OESTERREICH.

*Aussicht nach Klosterneuburg und Korneuburg.*

74 Jakob Alt *Neuburg Convent on the Danube* (1820)
25·7 × 35·5cm (10 1/8 × 17in.)

75  Karl Blechen *Park with Lake and Convent Church* 1827-8
45 × 35cm (17$\frac{11}{16}$ × 13$\frac{3}{16}$in.)

76  Adolph von Menzel *The Persecution* 1851
28·5 × 25·3cm (11¾ × 10⅛in.)

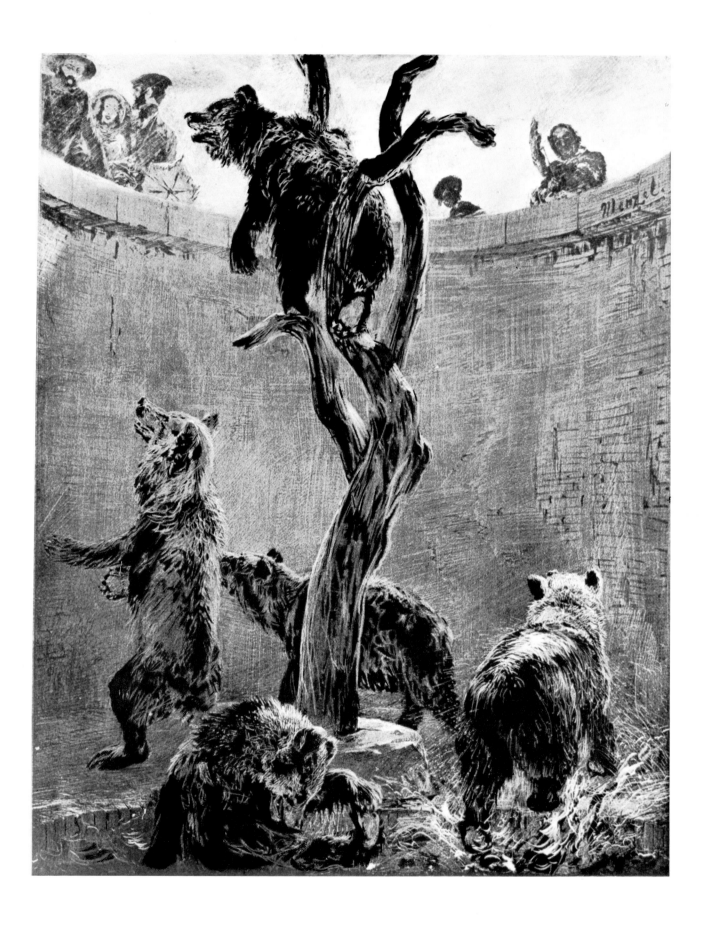

77 Adolph von Menzel *Bear Pit* 1851
24·7 × 19·7cm (9¾ × 7¾in.)

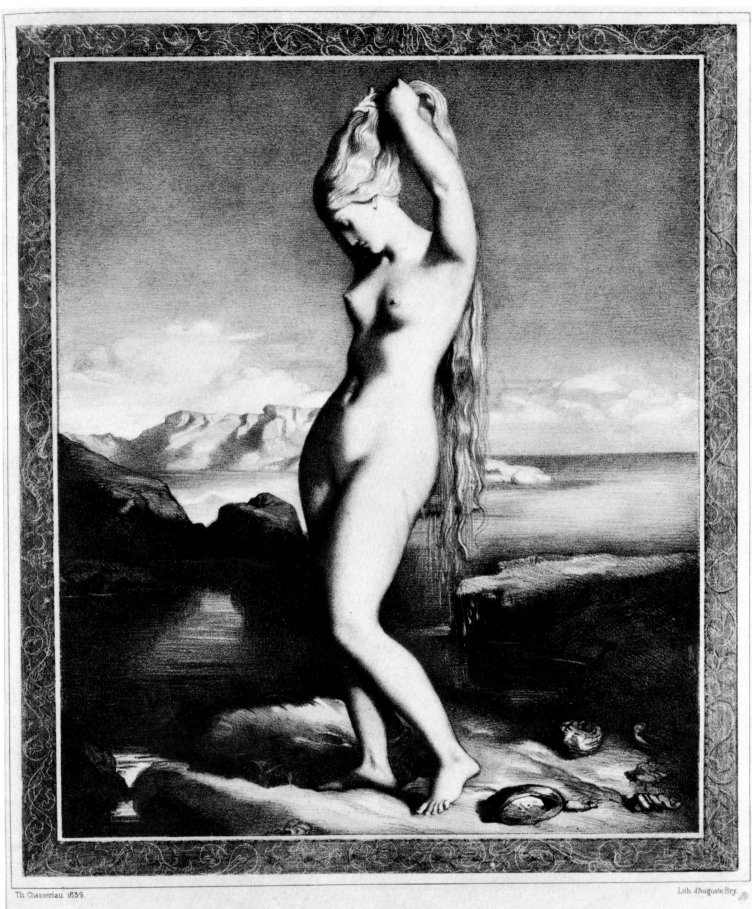

ΑΦΡΟΓΕΝΕΙΑ

Th. Chassériau 1839.

Lith. d'Auguste Bry.

78  Théodore Chassériau *Vénus Anadyomène* 1839
32 × 26·8cm (12$\frac{9}{16}$ × 10$\frac{9}{16}$ in.)

*Aux environs de Lausanne.*

79  Johann Martin Usteri (attributed)
*Swiss Incunabulum* 1807
12·8 × 11·5cm (5$\frac{1}{16}$ × 4$\frac{1}{2}$in.)

80  Gabriel Lory Père *Arbour near Lausanne* 1822
14·5 × 17cm (5$\frac{11}{16}$ × 6$\frac{11}{16}$in.)

81  Franz Niklaus König *Unspunnen* 1821
9·5 × 12·8cm (3$\frac{3}{4}$ × 5 in.)

82 Bass Otis *Landscape in Chalk* 1819
$9\frac{1}{2} \times 12\cdot7$cm ($3\frac{3}{4} \times 5$in.)

83 Bass Otis *Early American Specimen* 1820
*c.* $8\cdot5 \times 11\cdot5$cm ($3\frac{3}{8} \times 4\frac{9}{16}$in.)

84 Rembrandt Peale
*Portrait of George Washington* 1827
48·3 × 39cm (19 × 15¼in.)

85 Fanny Palmer *A Midnight Race on the Mississippi* 1860
45·7 × 71cm (18 × 28in.)

86 Edouard Manet *The Barricade* 1871
46·5 × 33cm (18⅜ × 13⅛in.)

87  Honoré Daumier *This has killed That* 1871
23·8 × 20cm (9⅜ × 7⅞in.)

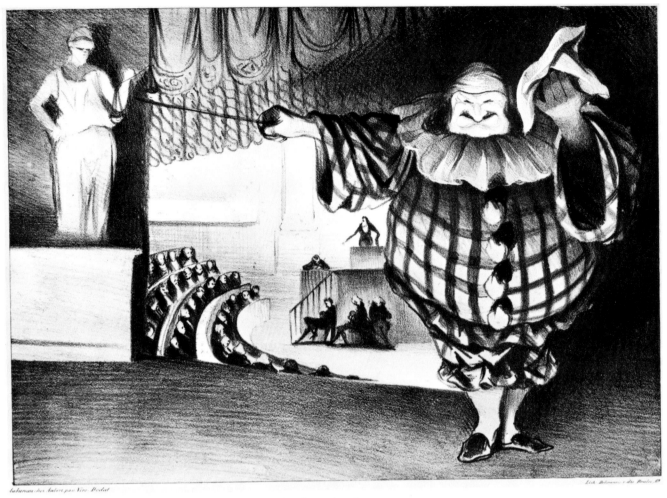

88 Honoré Daumier *Bring Down the Curtain* 1832
27·8 × 20cm (10$\frac{15}{16}$ × 7$\frac{7}{8}$in.)

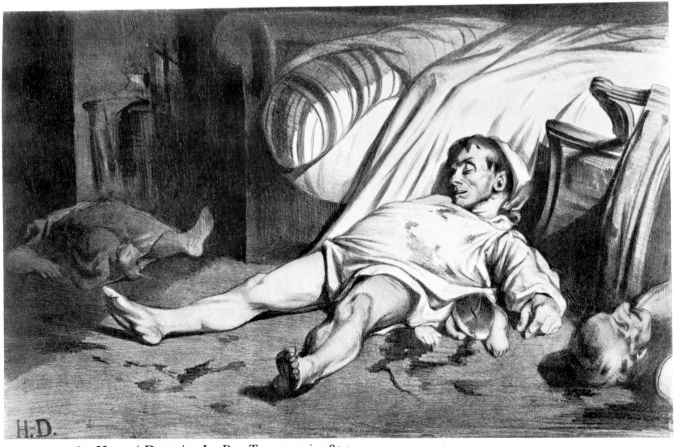

89 Honoré Daumier *La Rue Transnonain* 1834
30·5 × 46cm (12 × 18$\frac{1}{8}$in.)

90 Edouard Manet *Beneath the Lamp (The Raven)* 1875
27·5 × 37·5cm ($10\frac{13}{16}$ × $14\frac{3}{4}$in.)

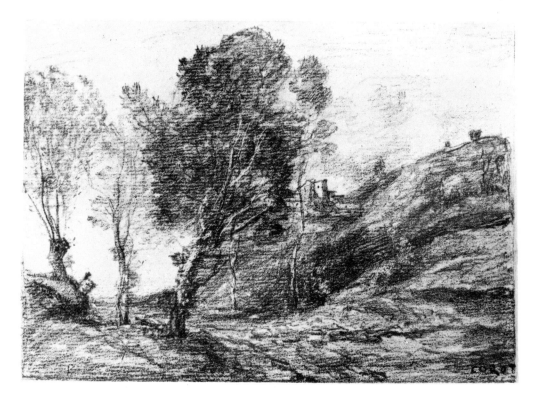

91 Camille Corot *Souvenir of Italy* 1871
12·7 × 17·8cm (5 × 7in.)

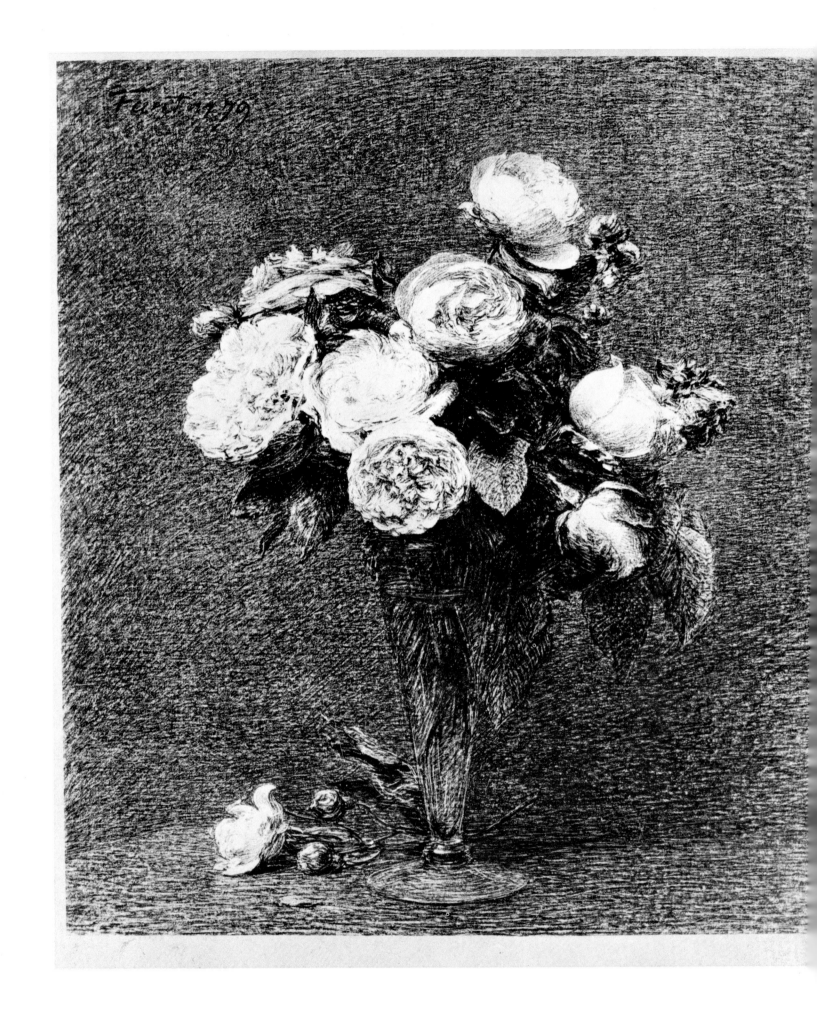

92  Henri Fantin-Latour *The Bouquet of Roses* 1879
41·5 × 35·5cm (16$\frac{5}{16}$ × 14in.)

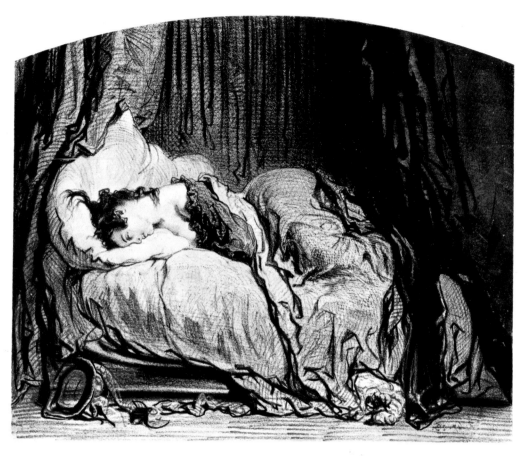

93 Sulpice Chevalier (called Gavarni)
*After the Ball* 1847
17·5 × 20·8cm (6⅞ × 8³⁄₁₆in.)

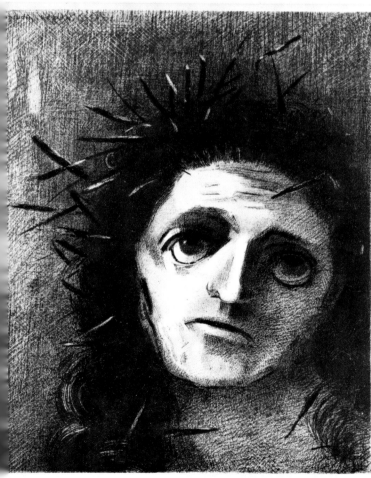

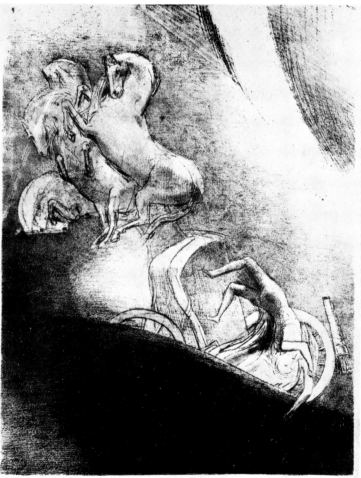

94 Odilon Redon *Head of Christ* 1887
33 × 27cm (13 × 10⅝in.)

95 Odilon Redon
*He Falls into the Abyss, Head-first* 1896
28 × 21·3cm (11 × 8⅜in.)

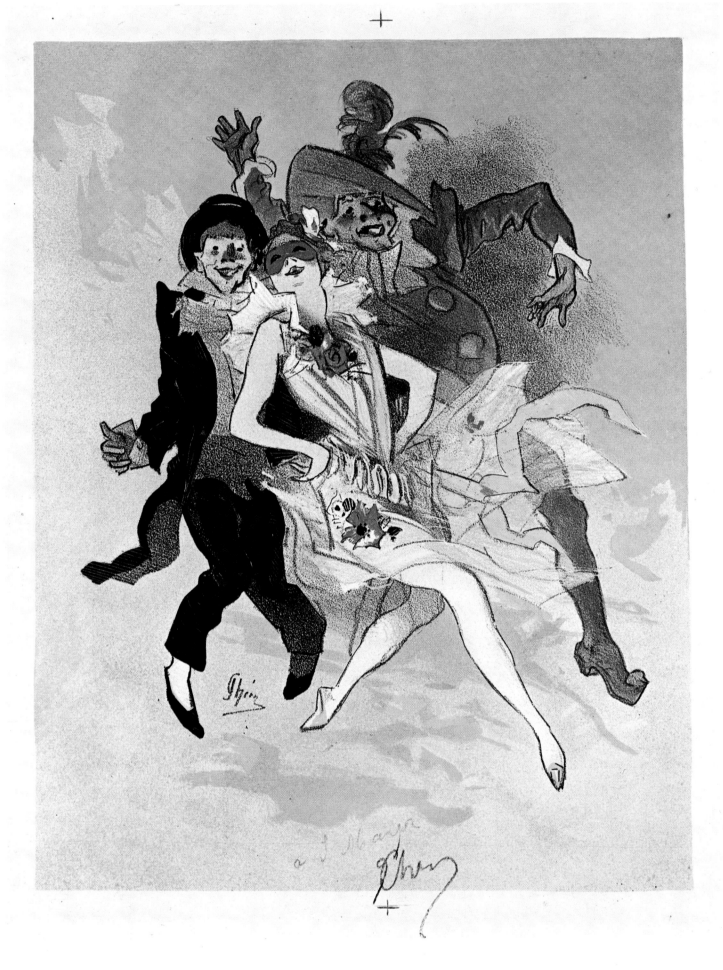

96  Jules Chéret *Fantasy, Dancer, Punch and Clown Dancing* (1896)
29 × 22·2cm (11 7/16 × 8 3/4 in.)

97 N. V. Diaz de la Pena *Beauty* 1849
19·8 × 15·8cm (7$\frac{13}{16}$ × 6$\frac{3}{16}$in.)

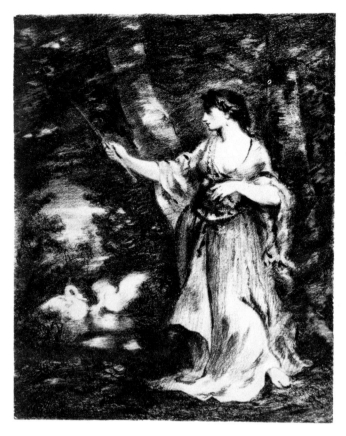

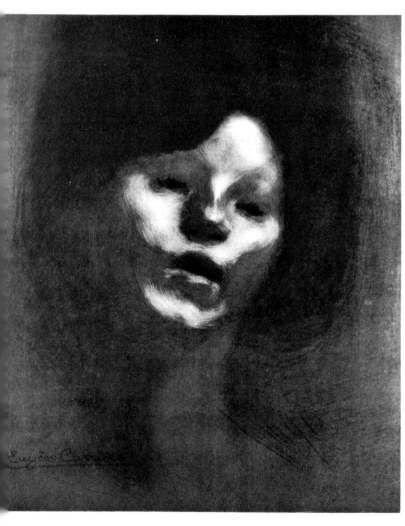

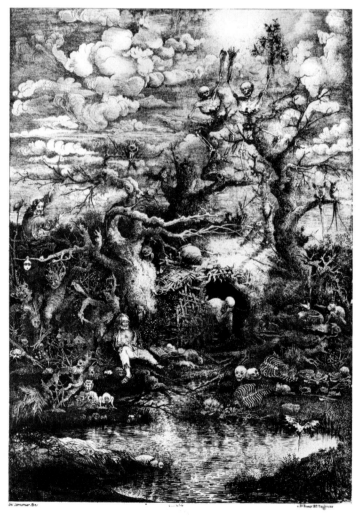

Eugène Carrière *Marguérite Carrière* 1901
43·5 × 35cm (17$\frac{1}{8}$ × 13$\frac{3}{4}$in.)

99 Rodolphe Bresdin *Comedy of Death* 1854
22·1 × 15·1cm (8$\frac{11}{16}$ × 5$\frac{15}{16}$in.)

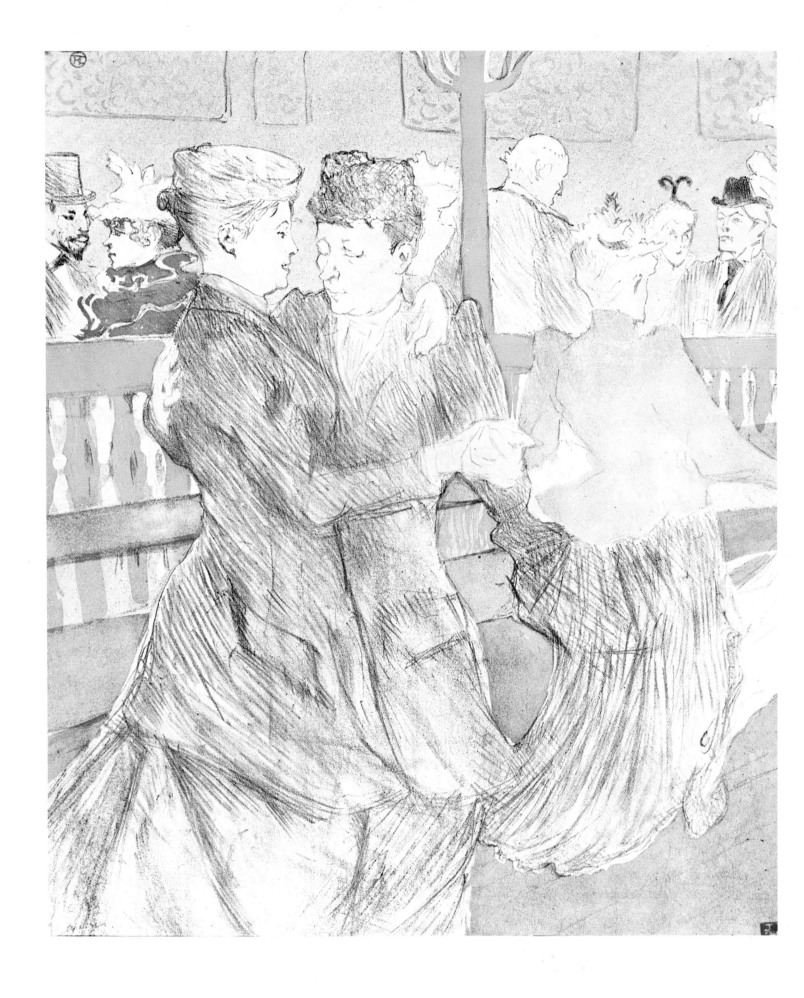

100  Henri de Toulouse-Lautrec *Dance at the Moulin Rouge* 1897
46 × 35cm (18⅛ × 13¼in.)

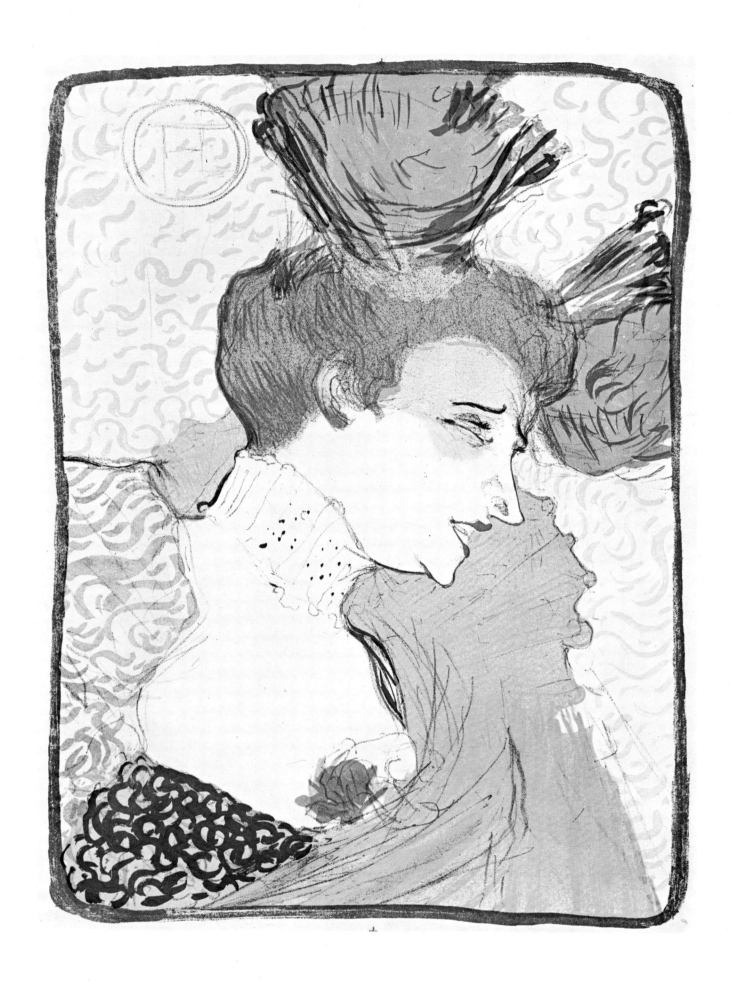

101 Henri de Toulouse-Lautrec *Miss Lender, half-length portrait* 1895
32·5 × 23·5cm (12 3/16 × 9 1/4 in.)

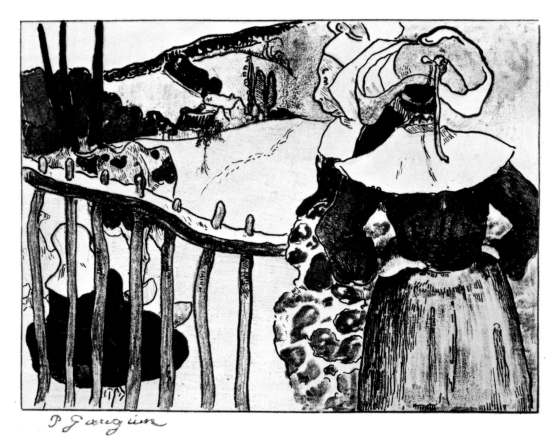

102  Paul Gauguin *Breton Women at the Barrier* 1889
17·2 × 21·9cm (6¾ × 8⅝in.)

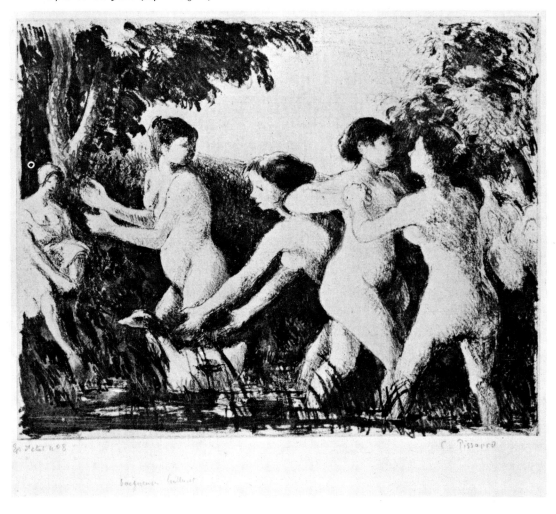

103  Camille Pissarro *Women Bathers Wrestling* 1896
18·5 × 23·3cm (7 5/16 × 9 3/16 in.)

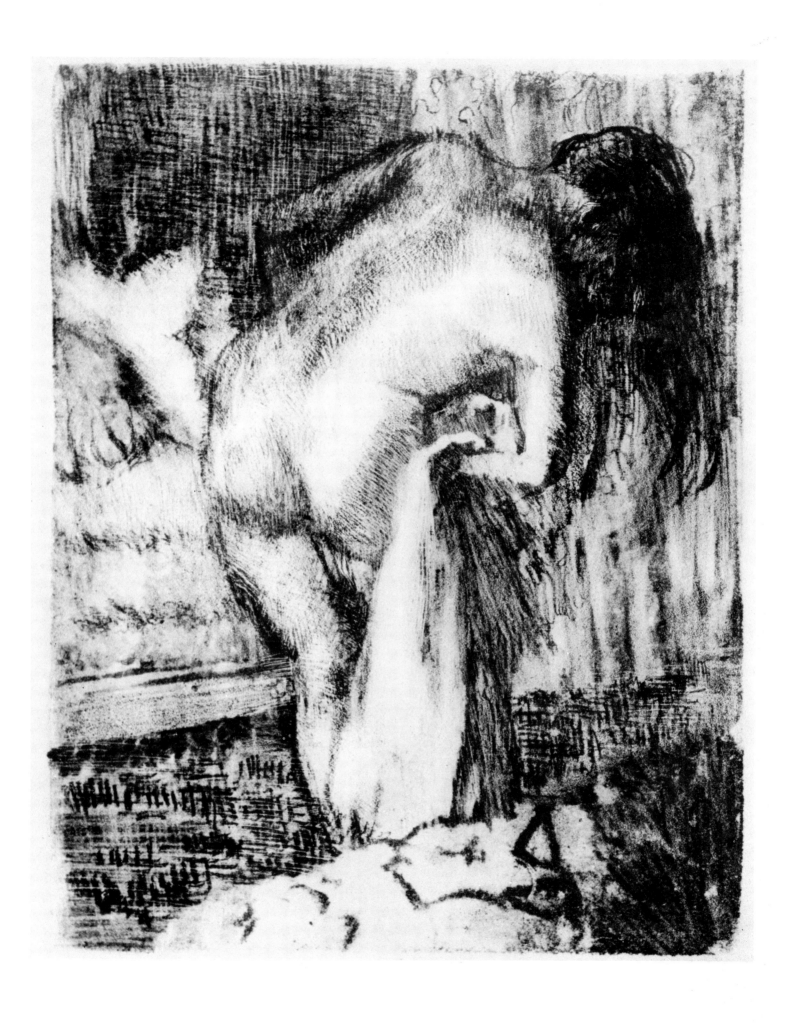

104 Edgar Degas *After the Bath* 1885
    19 × 14·6cm (7½ × 5¾in.)

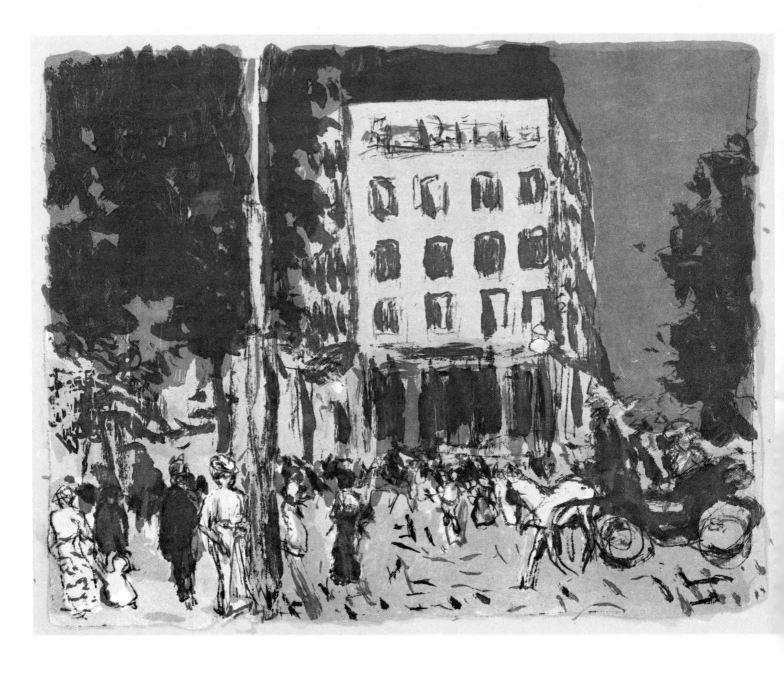

105 Pierre Bonnard *The Boulevards* 1899
25·7 × 34·7cm (10¼ × 13⅞in.)

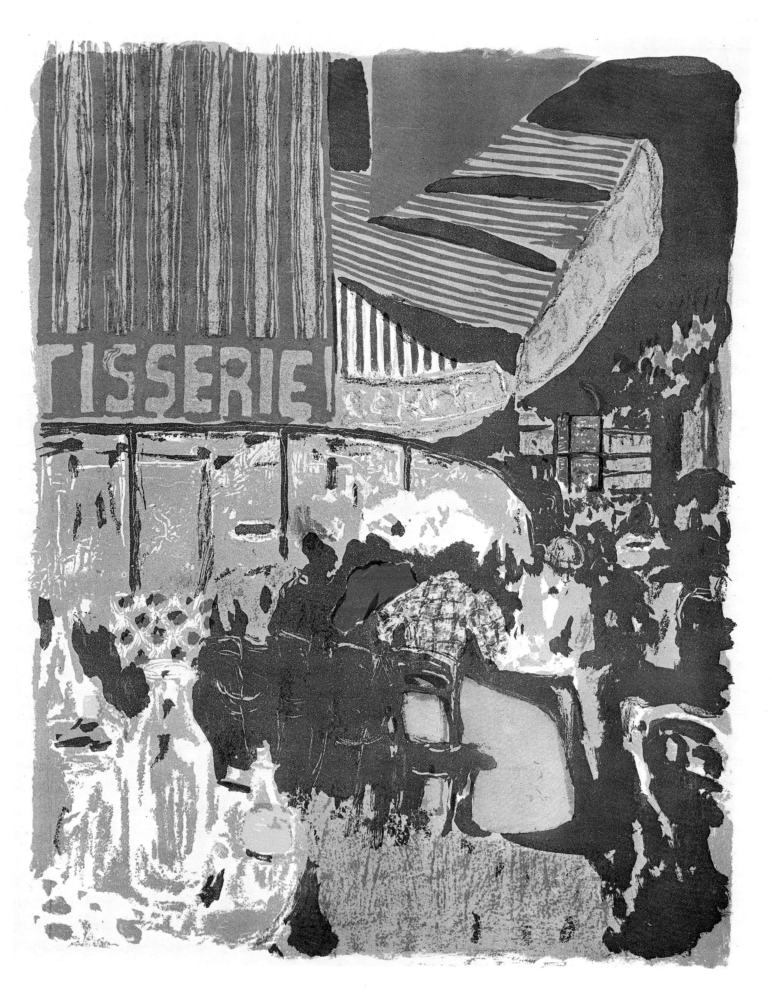

106 Edouard Vuillard *La Pâtisserie* 1899
35·5 × 27cm (14 × 10⅜in.)

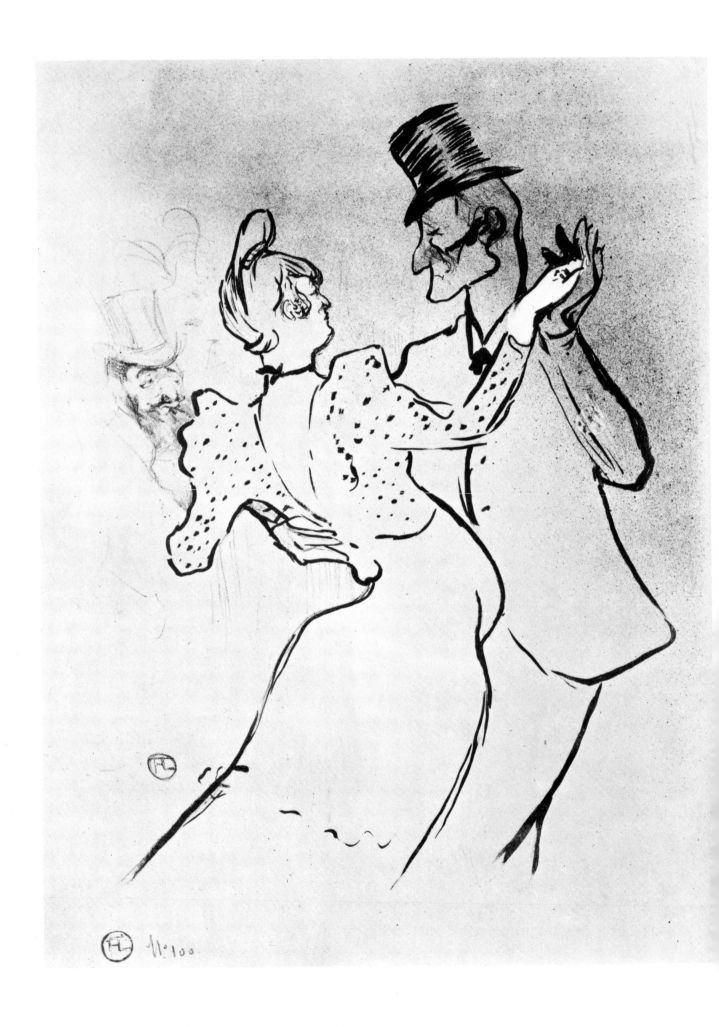

107  Henri de Toulouse-Lautrec *La Goulue and Valentin* 1894
     30·5 × 23·2cm (12 × 9⅛in.)

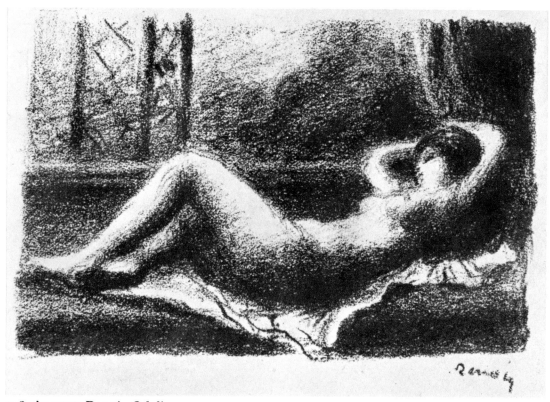

108 Auguste Renoir *Odalisque* 1904
7·9 × 12cm (3⅛ × 4¾in.)

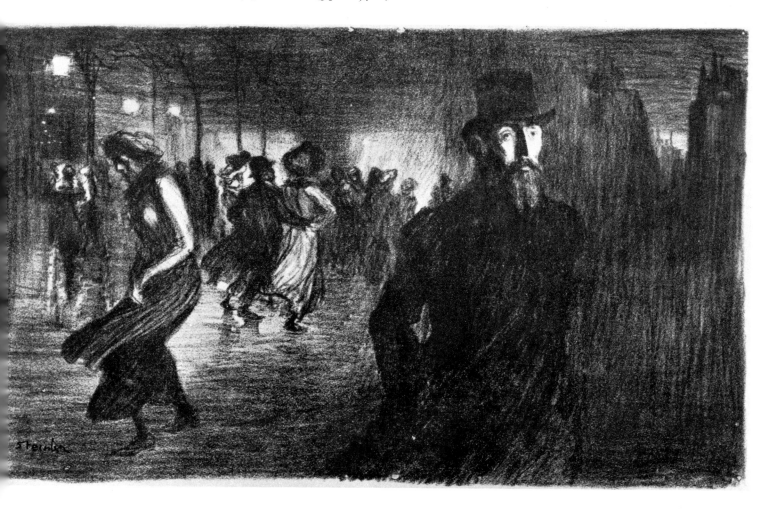

109 Théophile Alexandre Steinlen *Paris by Night* 1903
18·7 × 30·4cm (7⅞ × 12in.)

131 Erich Heckel *Portrait of a Man*
1919
38 × 32cm (14$\frac{15}{16}$ × 12$\frac{9}{16}$in.)

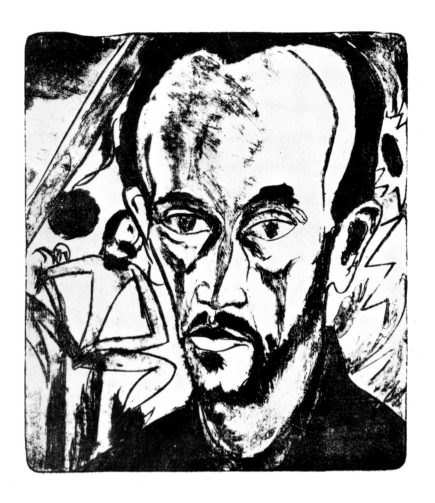

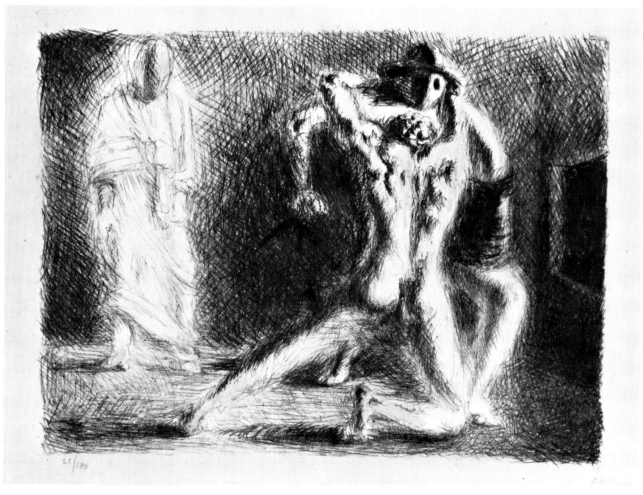

132 Giorgio de Chirico *School of Gladiators II* 1929
31 × 41·5cm (12$\frac{3}{16}$ × 16$\frac{5}{16}$in.)

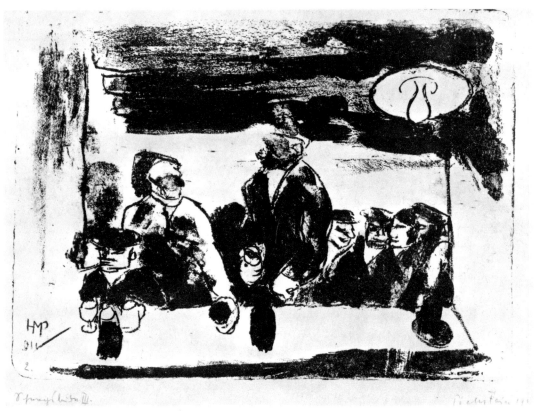

133 Max Pechstein *Drunkards* 1911
28 × 38cm (11 × 14$\frac{15}{16}$in.)

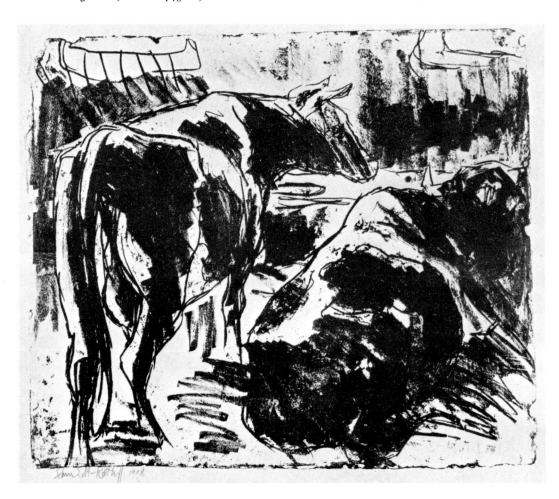

134 Karl Schmidt-Rottluff *Cows in the Stable I* 1908
33·7 × 39·8cm (13$\frac{1}{4}$ × 15$\frac{5}{8}$in.)

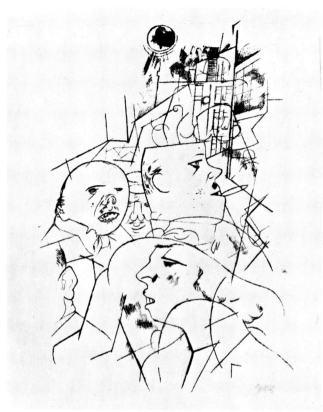

135 Georg Grosz *Street Scene* 1923
38·9 × 26·9cm (15 5/16 × 10 9/16 in.)

136 Ludwig Meidner
*The Listener into Time* 1920
20 × 14·5cm (7 7/8 × 5 11/16 in.)

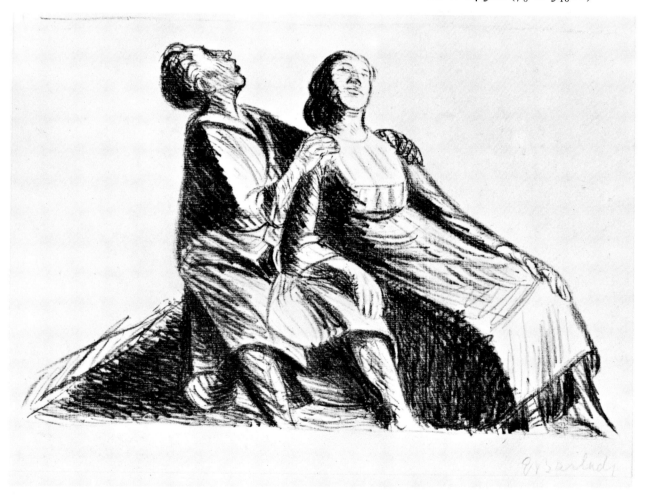

137 Ernst Barlach *Lovers* 1916–17
25·5 × 39·5cm (10 1/16 × 15 9/16 in.)

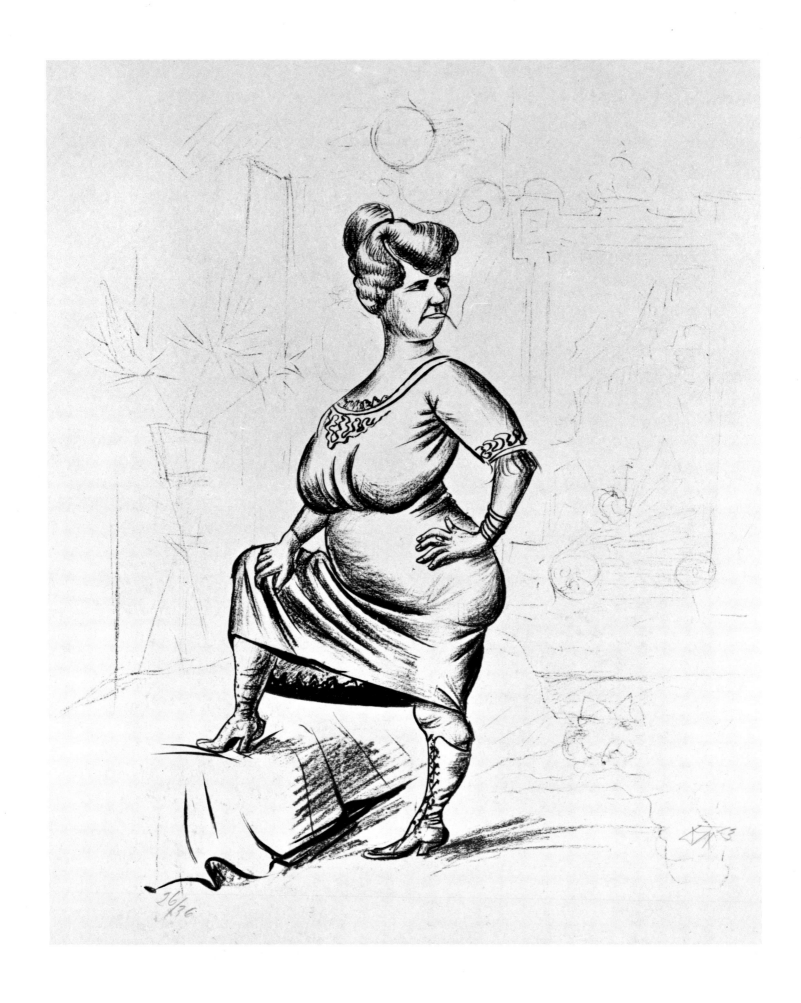

138 Otto Dix *Frieda* 1923
51 × 43cm (20$\frac{1}{16}$ × 16$\frac{15}{16}$in.)

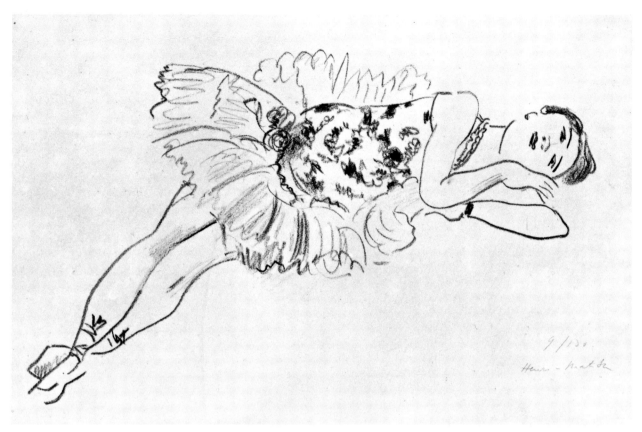

139 Henri Matisse *Reclining Dancer* (1928)
 27·3 × 45cm (10¾ × 17¾in.)

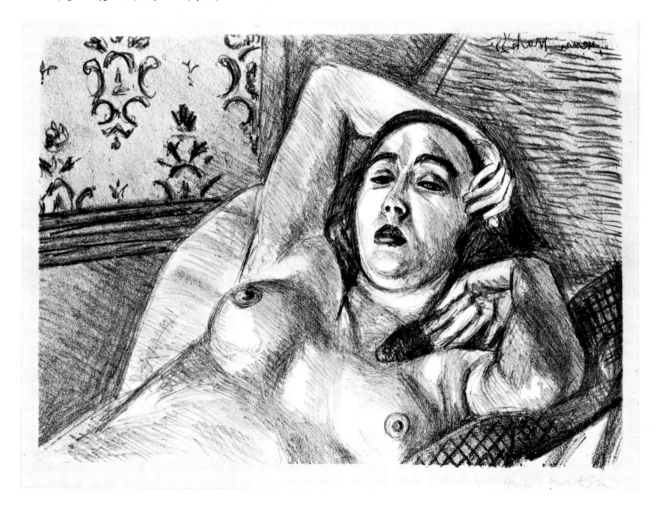

140 Henri Matisse *Model Resting* (1926)
 22·2 × 30·5cm (8¾ × 12in.)

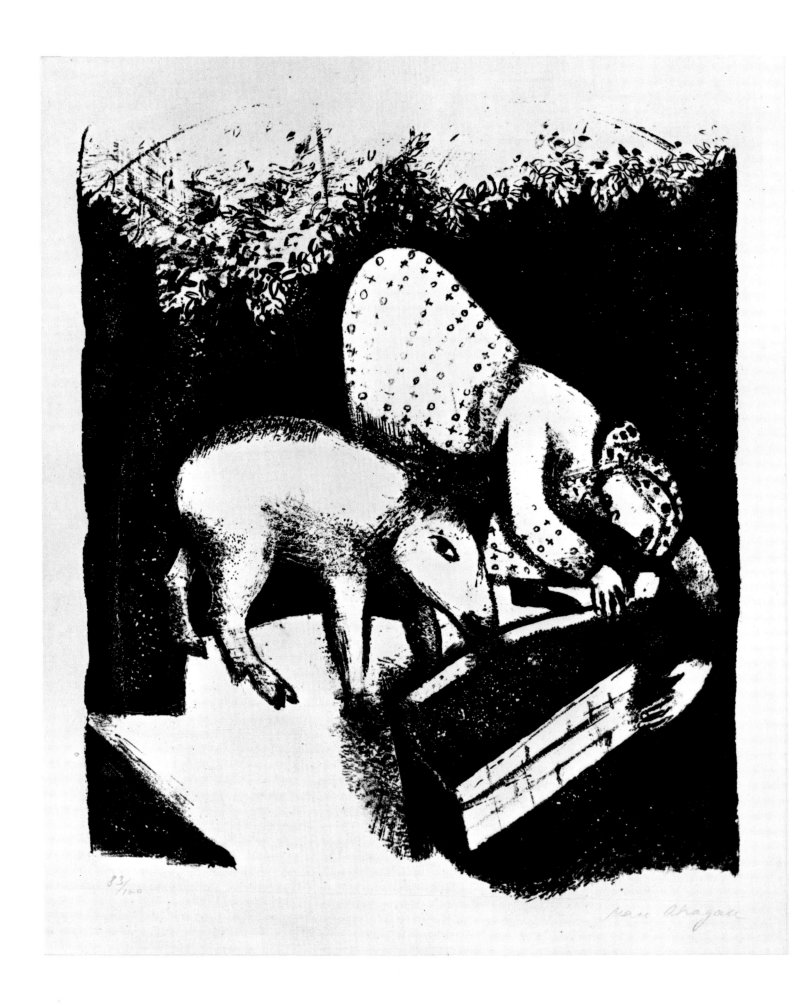

141 Marc Chagall *The Trough* 1923–5
  30·5 × 24cm (12 × 9$\frac{7}{16}$in.)

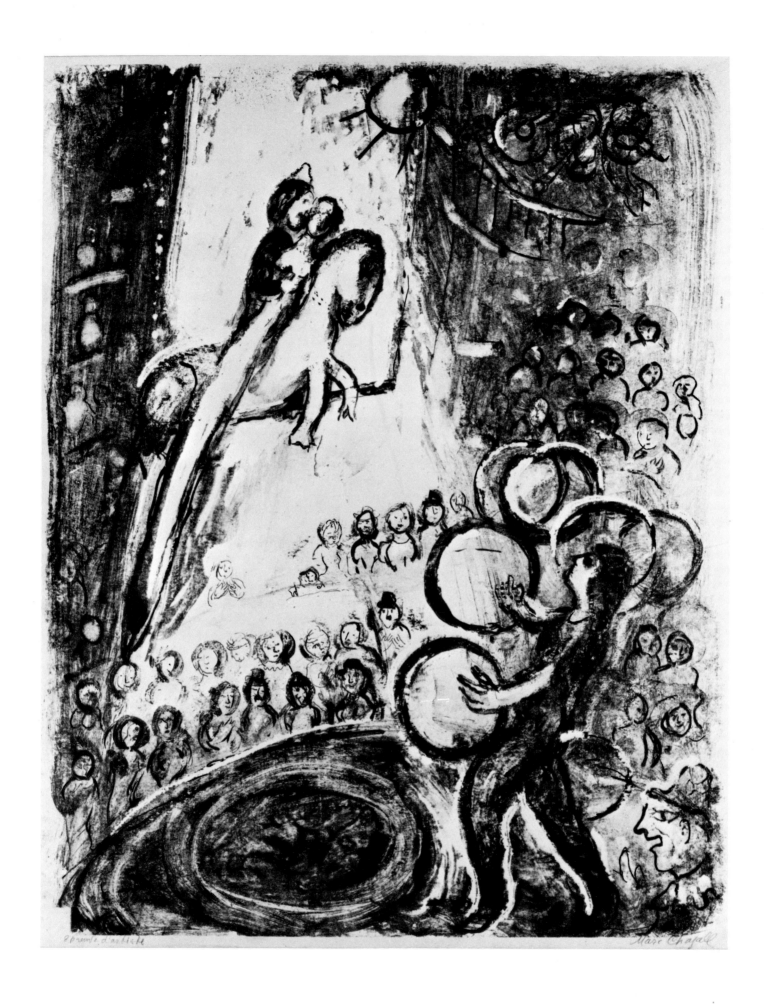

142  Marc Chagall *Flying Horse and Juggler* 1956
     64·6 × 50cm (25 7/16 × 19 3/4 in.)

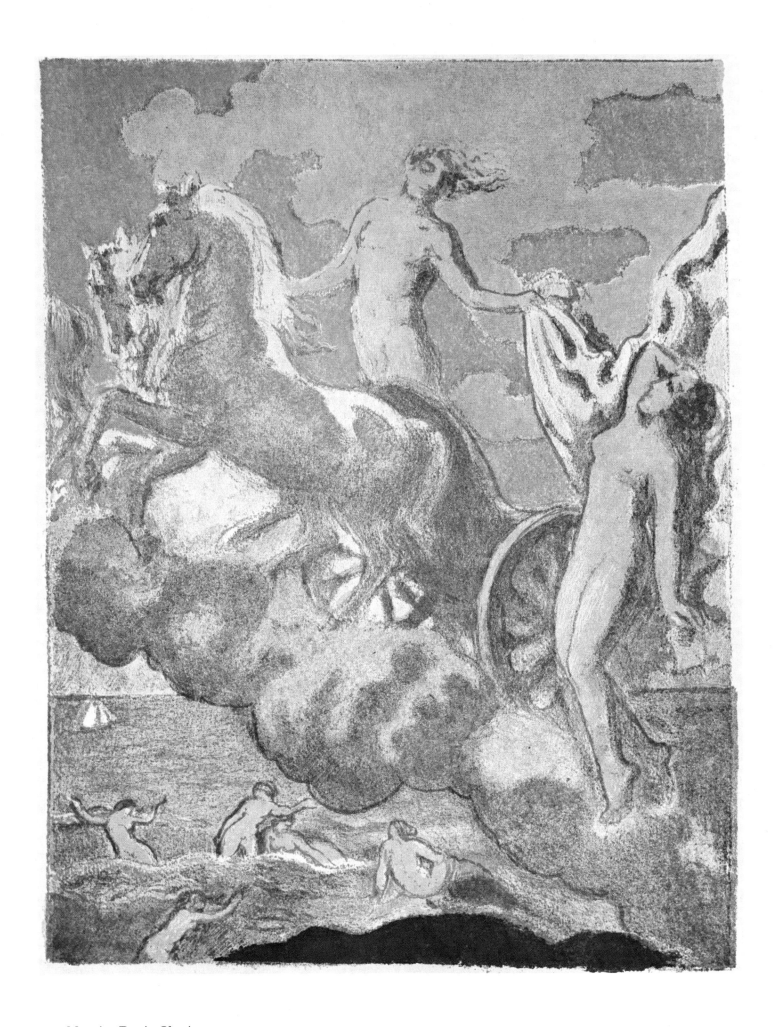

143 Maurice Denis *Chariot* 1939
24 × 18cm (9$\frac{7}{16}$ × 7$\frac{1}{16}$in.)

144  Wassily Kandinsky
*Composition with Blue Wedge*
1922
26·7 × 24·1cm (10$\frac{1}{2}$ × 9$\frac{1}{2}$in.)

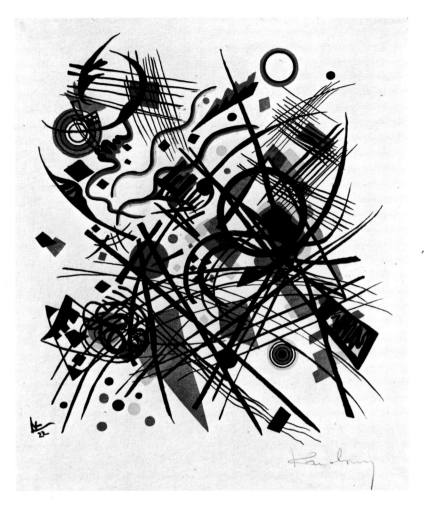

145  Maurice de Vlaminck *Entrance to a Village* 1922
24 × 33·8cm (9$\frac{7}{16}$ × 13$\frac{5}{16}$in.)

146 Georges Rouault *Clowns* (1929)
33·7 × 20·3cm (13¼ × 8in.)

147  Pablo Picasso *La Coiffure* 1923
      26 × 16½cm (10¼ × 6½in.)

148  Georges Braque *Teapot with Grey Background* 1947
33 × 50cm (13 × 19¾in.)

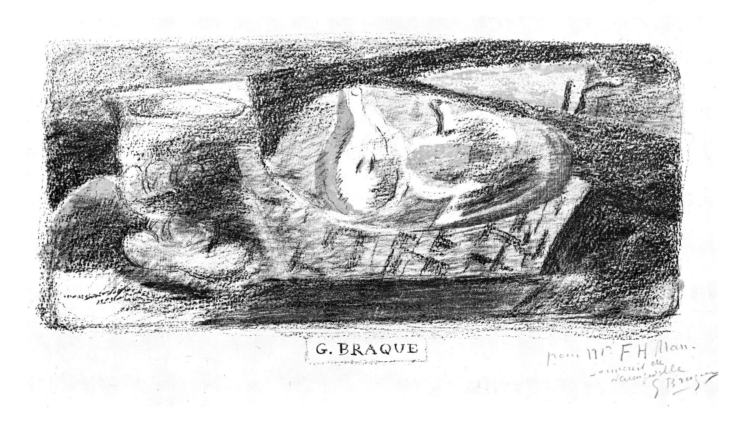

G. BRAQUE

149  Georges Braque *Glass and Fruit ( Still Life III )* 1921
20 × 40cm (7⅞ × 15¾in.)

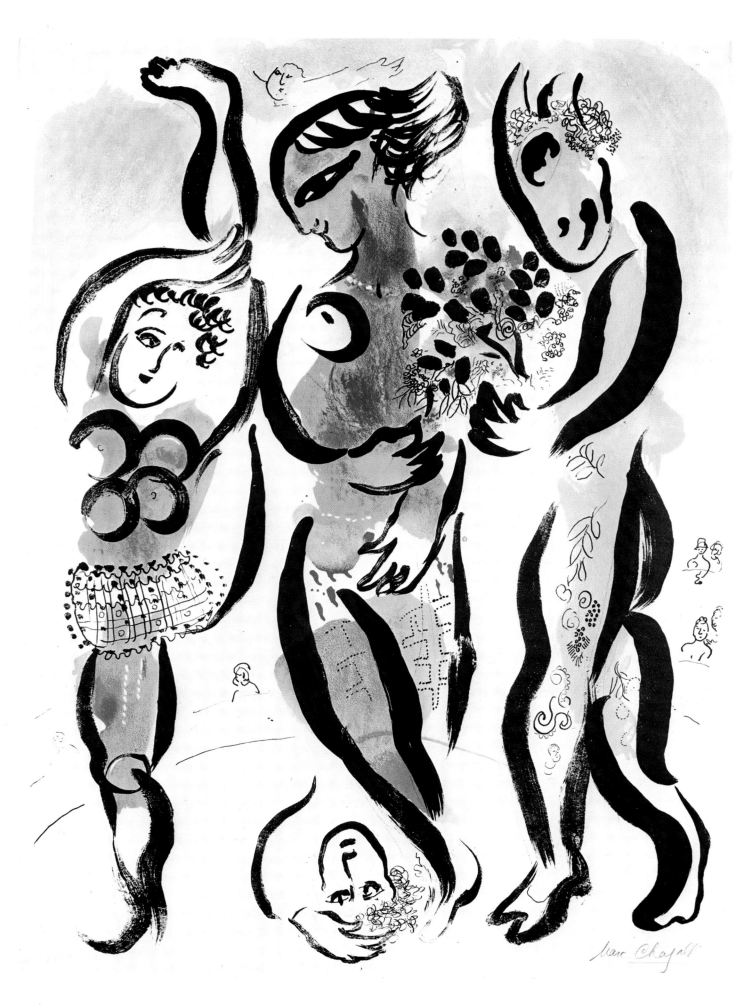

150 Marc Chagall *The Three Acrobats* 1956
63·5 × 48·3cm (25 × 19in.)

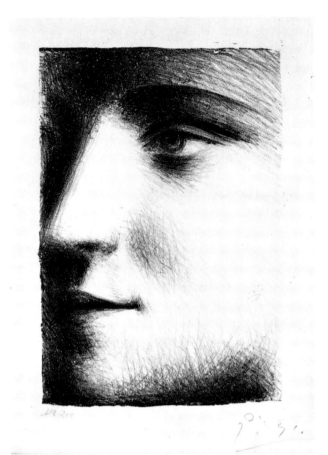

151  Pablo Picasso *Face* 1928
20·4 × 14·2cm (8$\frac{1}{16}$ × 5$\frac{9}{16}$in.)

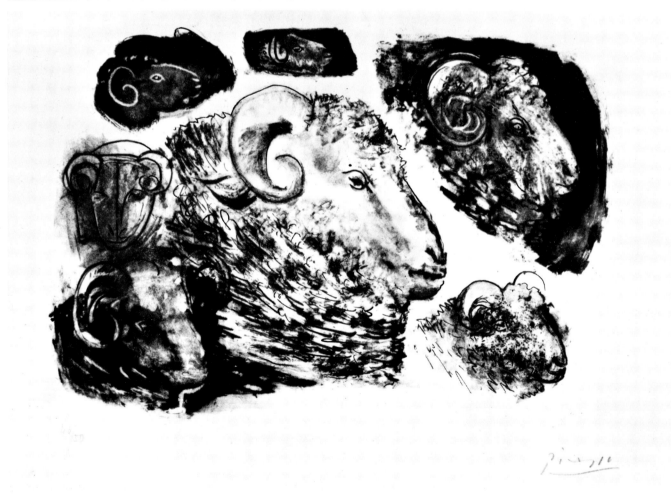

152  Pablo Picasso *Rams' Heads* 1945
23·5 × 34·5cm (9$\frac{1}{4}$ × 13$\frac{9}{16}$in.)

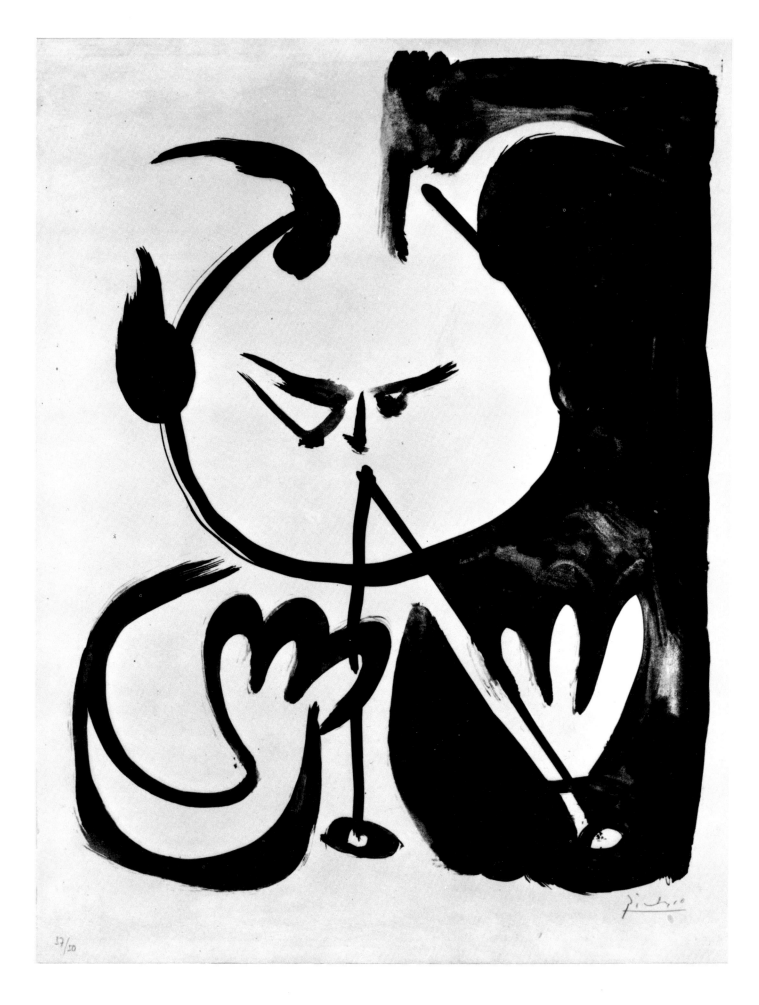

153  Pablo Picasso *Faune Musicien V* 1948
      68 × 51·3cm (27¾ × 20 3/16 in.)

154 Alberto Giacometti *Studio with Bottles* 1957
   37 × 53·8cm ($14\frac{9}{16}$ × $21\frac{3}{16}$in.)

155 Hans Purrmann *Fountain in Levanto II* 1966
   23·5 × 30cm ($9\frac{1}{4}$ × $11\frac{13}{16}$in.)

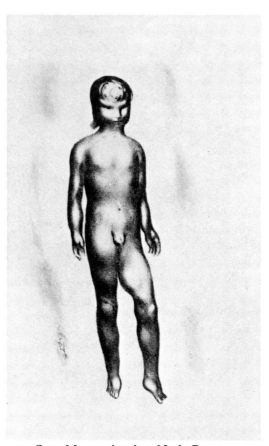

156  Ferdinand Hodler
     *Glance into Infinity* 1919
     52·5 × 29·cm (20⅞ × 11½in.)

157  Otto Meyer-Amden *Nude Boy* 1923
     20·3 × 11cm (8 × 4⁵⁄₁₆in.)

158  Paul Nash *Crater* 1917
     34·8 × 45·5cm (13¾ × 17⅞in.)

159 Alexander Archipenko *Still Life in Cubist Style* 1921
29·5 × 38·5cm (11⅝ × 15⅛in.)

160 Anatoli Kaplan *Wedding* 1965–7
60 × 41cm (25⅝ × 16⅛in.)

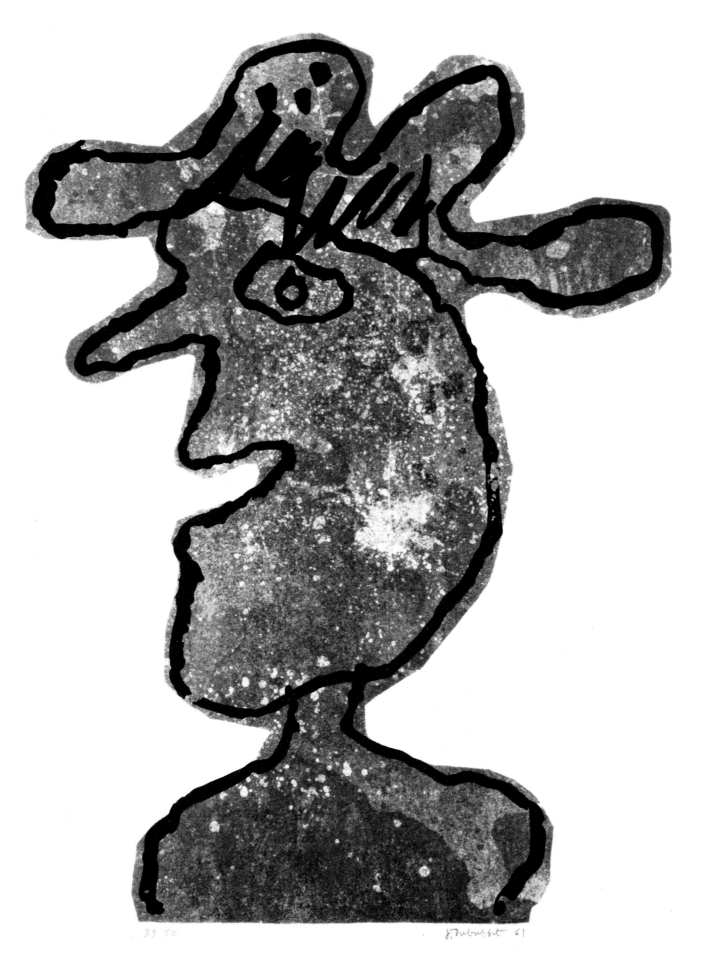

161  Jean Dubuffet *Man with Hat* 1961
65 × 50cm (25 9/16 × 19 3/4 in.)

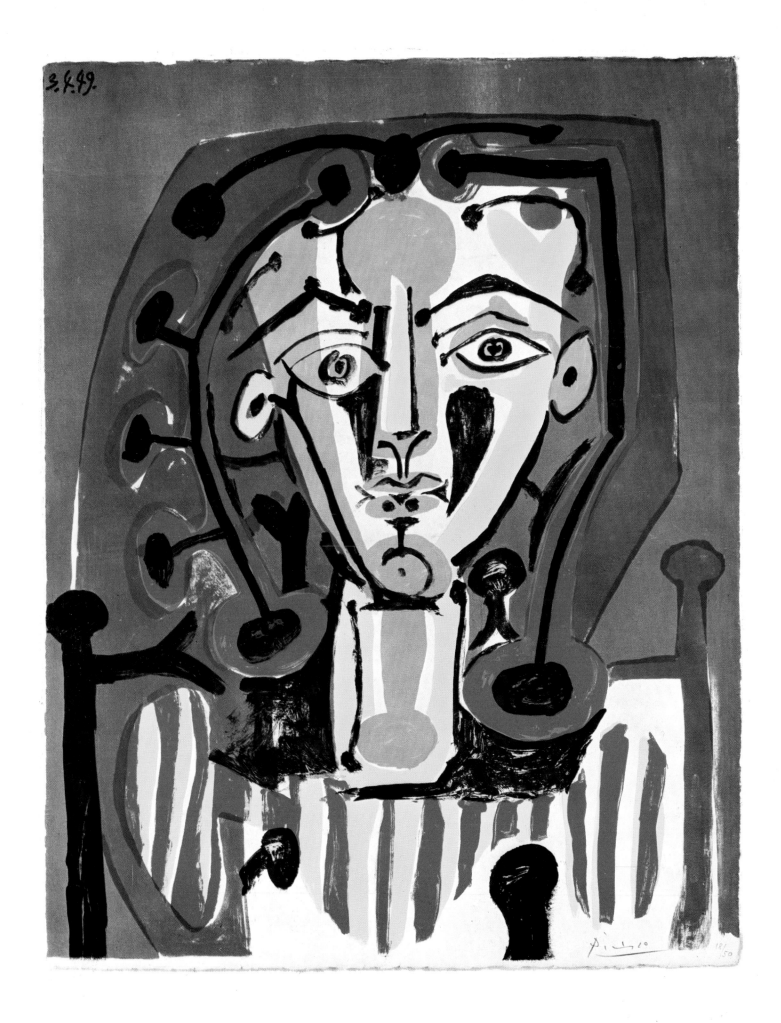

162  Pablo Picasso *Figure with Striped Bodice* 1949
65·5 × 50cm (25⅞ × 19⅝in.)

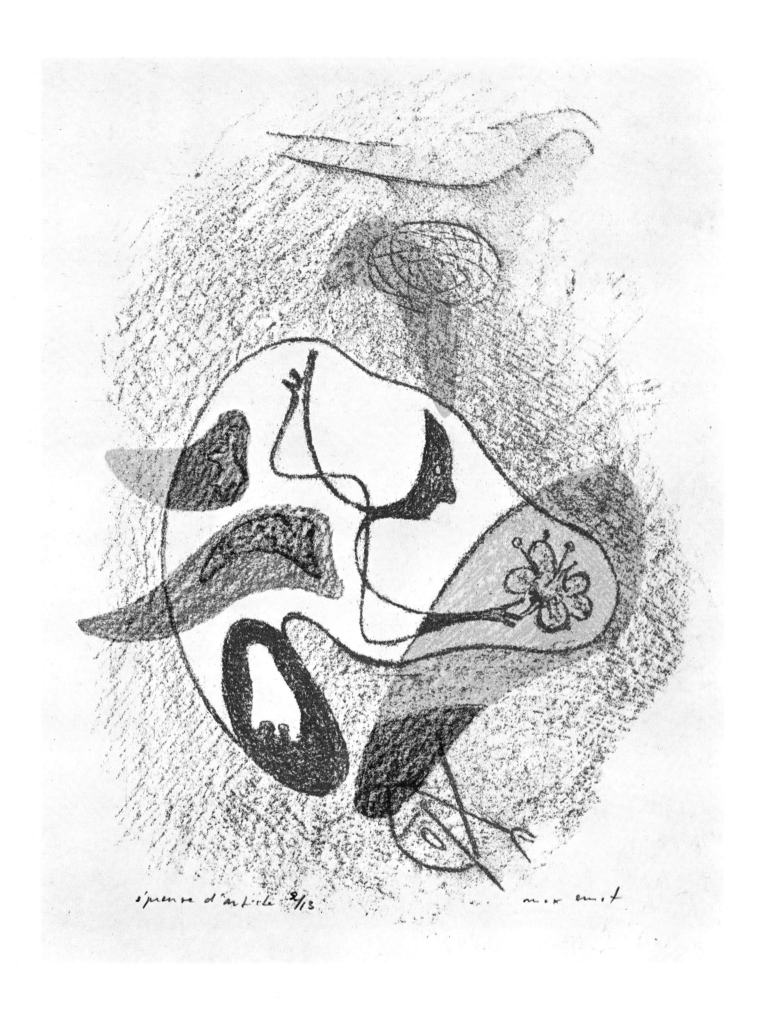

163 Max Ernst *Composition* 1950
23·5 × 17·8cm (9¼ × 7in.)

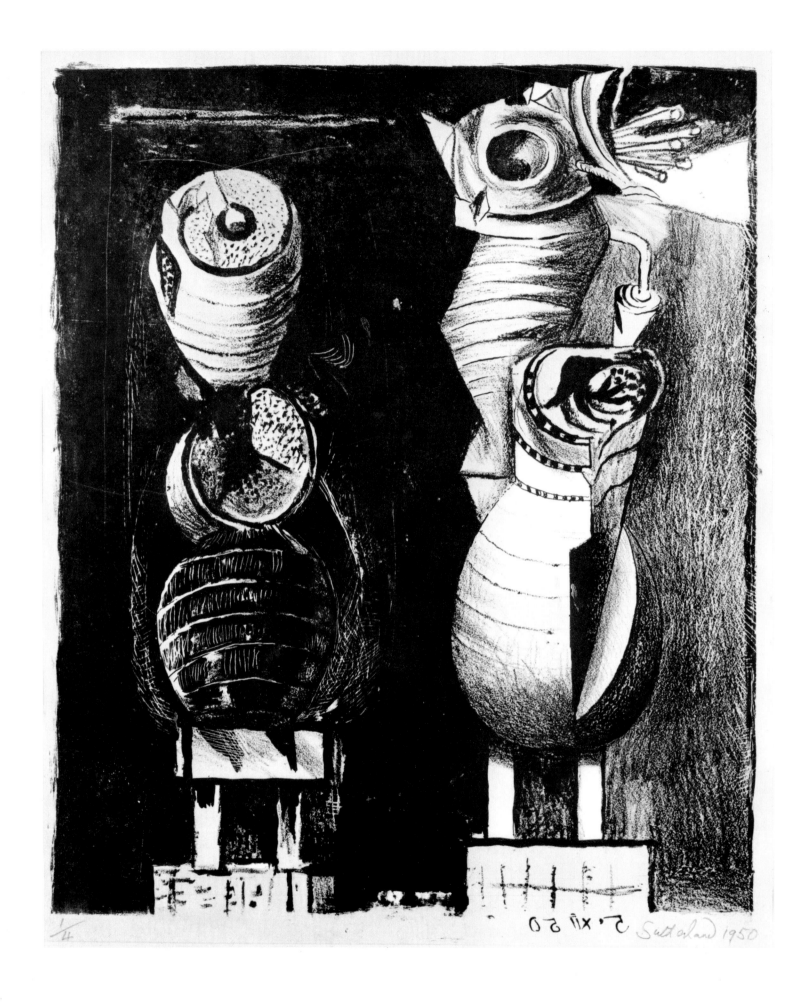

164 Graham Sutherland *Two Standing Figures* 1950
34 × 27cm (13¾ × 10⅝in.)

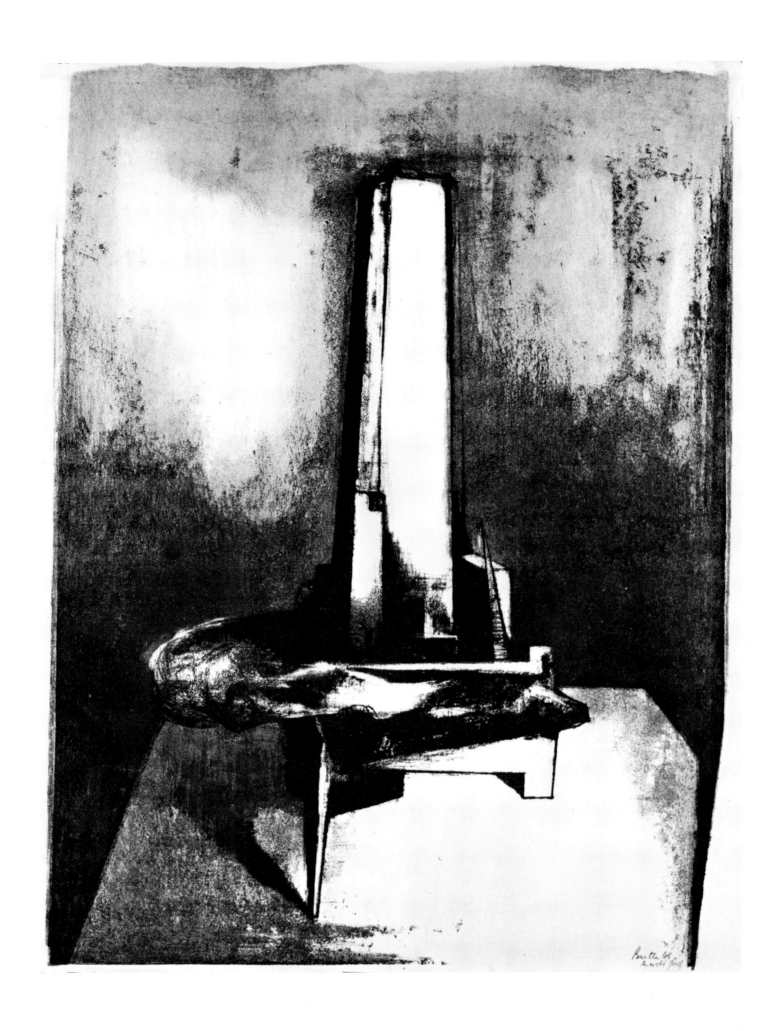

165 Reg Butler *Tower* 1968
   64·5 × 47·5cm (25¾ × 18¹¹⁄₁₆in.)

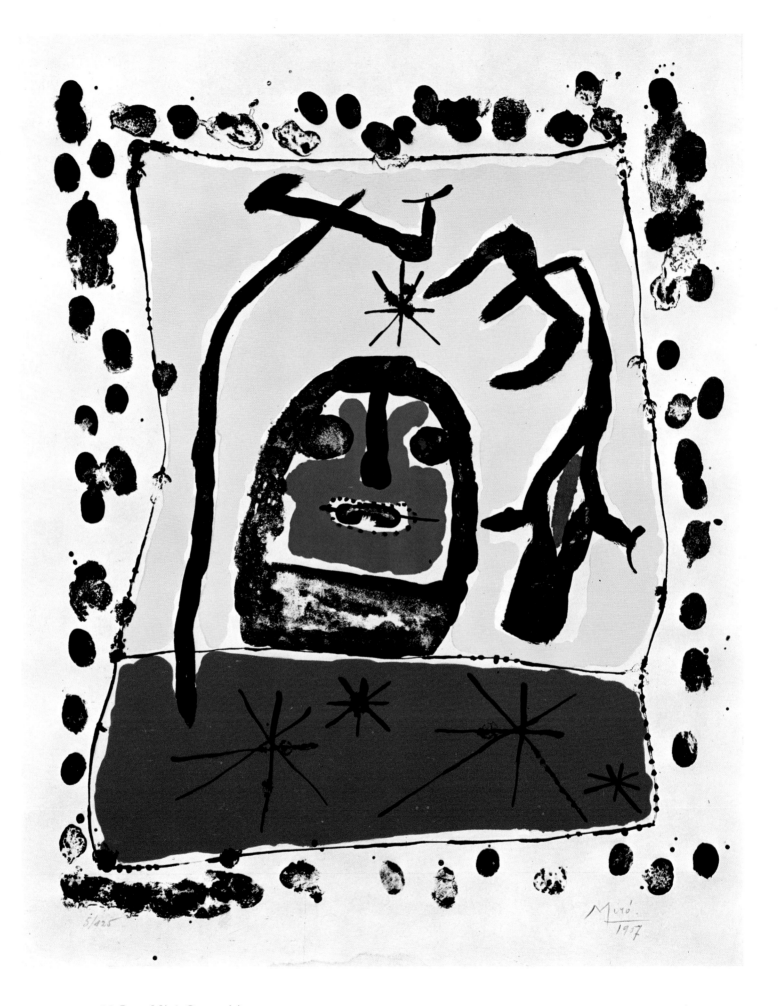

166  Joan Miró *Composition* 1957
55 × 44cm (21⅝ × 17⅜in.)

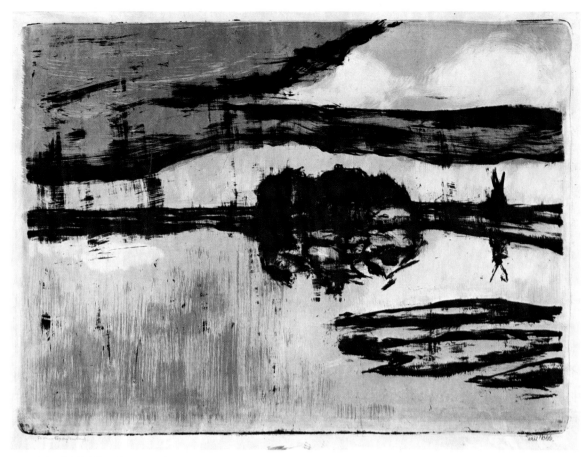

167 Emil Nolde *Autumn Landscape (Inundation)* 1926
60 × 80cm (23⅝ × 31½in.)

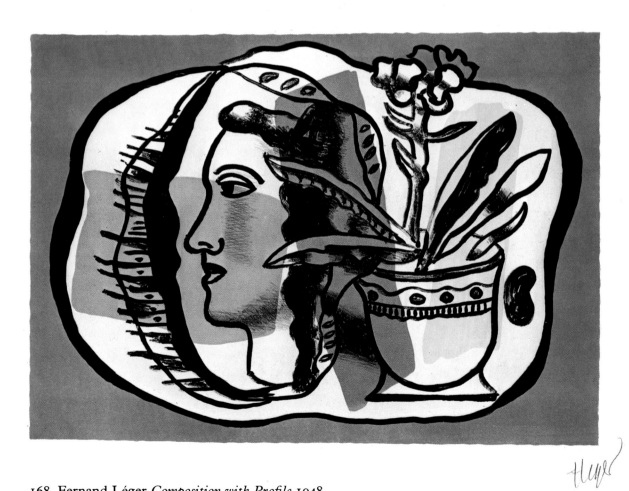

168 Fernand Léger *Composition with Profile* 1948
35·5 × 50cm (14 × 19¾in.)

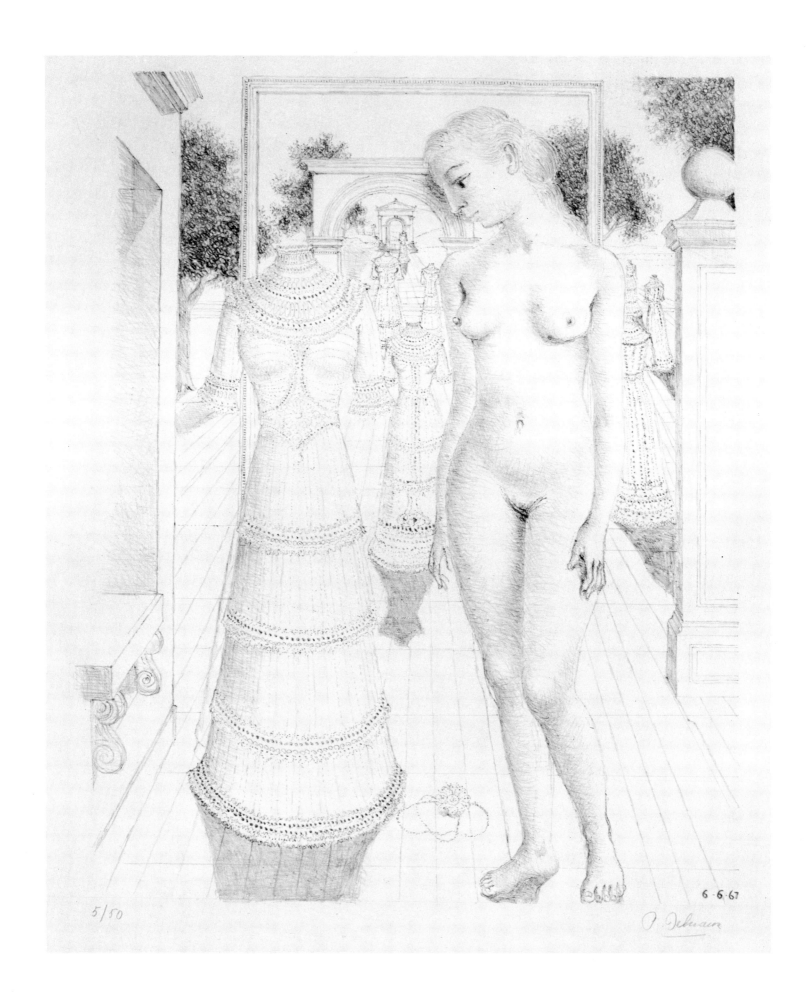

5/50

6·6·67

169  Paul Delvaux *The Sunday Dress* 1967
63·5 × 51cm (25 × 10$\frac{1}{16}$ in.)

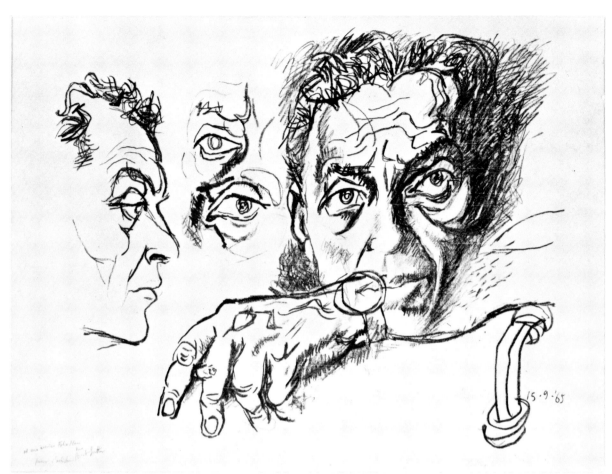

170 Renato Guttuso *Self-Portrait* 1965
44·5 × 55·5cm (17$\frac{11}{16}$ × 21$\frac{7}{8}$in.)

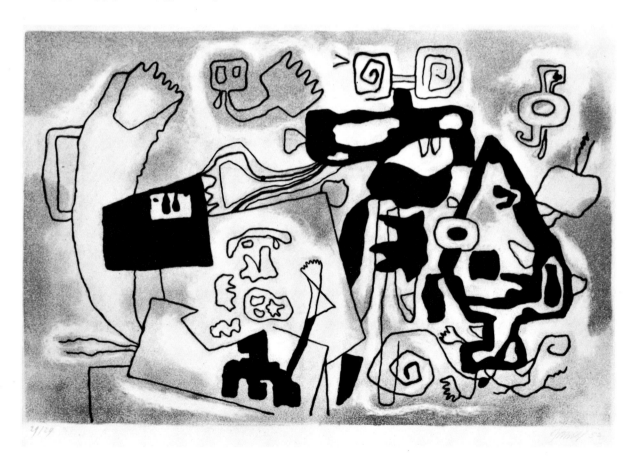

171 Willy Baumeister *Faust* 1952
30 × 45·3cm (11$\frac{13}{16}$ × 17$\frac{13}{16}$in.)

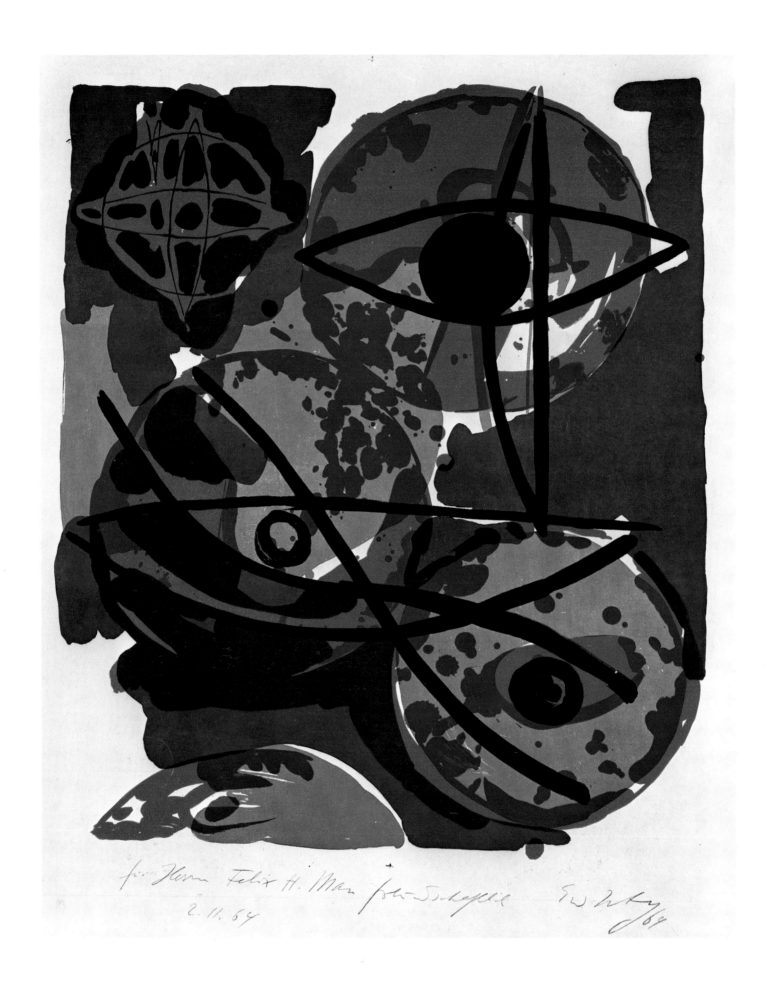

172  Ernst Wilhelm Nay *Red from Blue* 1964
55 × 46·5cm (21⅝ × 18⁵⁄₁₆in.)

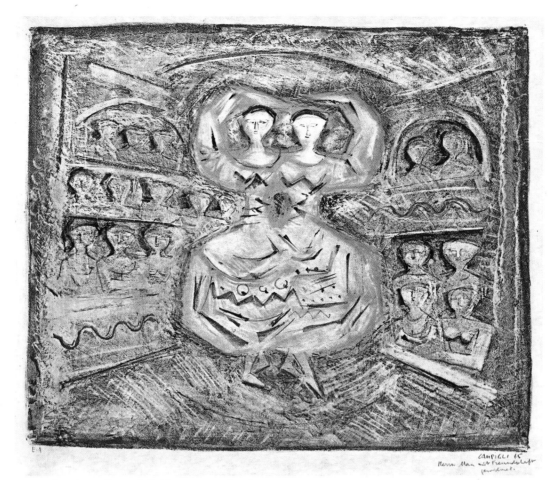

173 Massimo Campigli *Dancers* 1965–6
41·7 × 49·5cm (16⅜ × 19½in.)

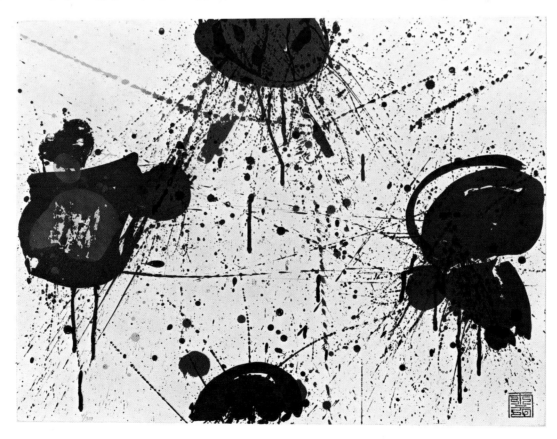

174 Sam Francis *Composition* 1965
50 × 64cm (19¾ × 25 3/16 in.)

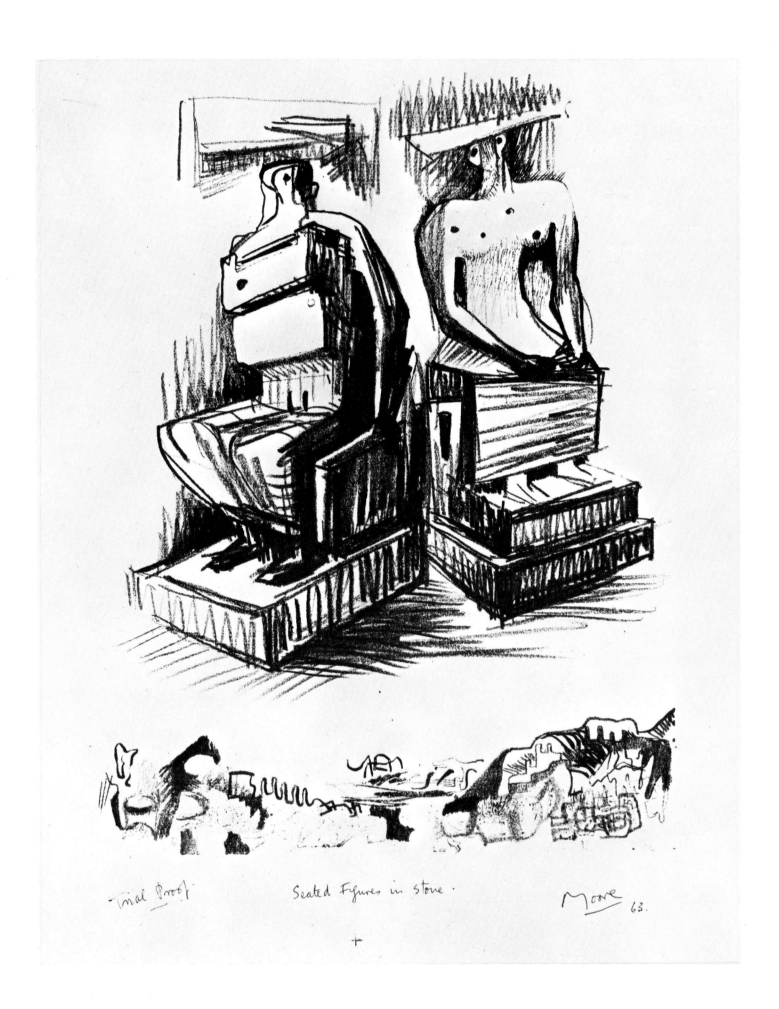

*Trial Proof*       Seated Figures in Stone.       Moore 63.

175   Henry Moore *Two Seated Figures in Stone* 1963
39·5 × 29cm (15 9/16 × 11 7/16 in.)

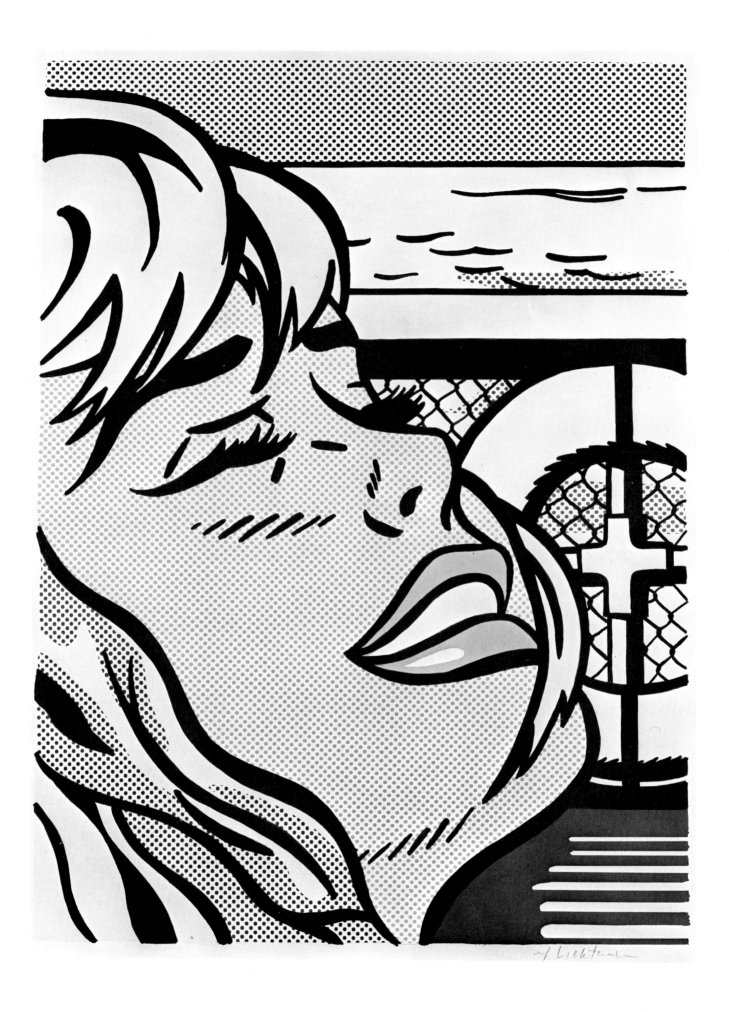

176 Roy Lichtenstein *Shipboard Girl* 1968
66 × 49cm (26 × 19¼in.)

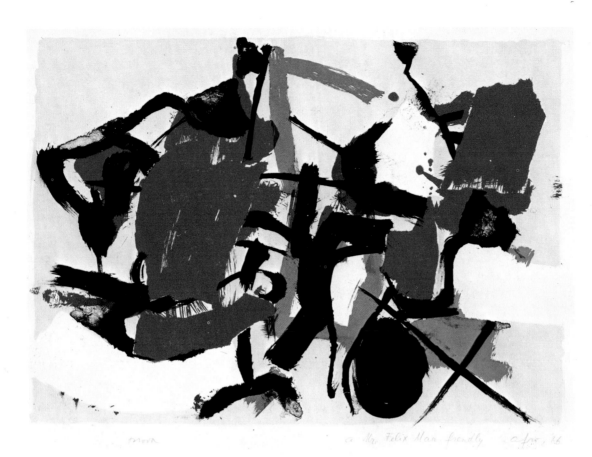

177 Afro (Basaldella) *Composition* 1965–66
40·5 × 56cm (15$\frac{15}{16}$ × 22$\frac{1}{16}$in.)

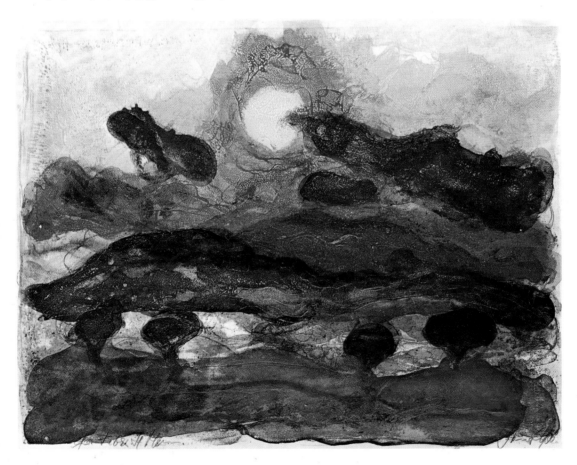

178 Christian Kruck *Landscape with Pines* 1966
49·5 × 64·5cm (19$\frac{1}{2}$ × 25$\frac{3}{8}$in.)

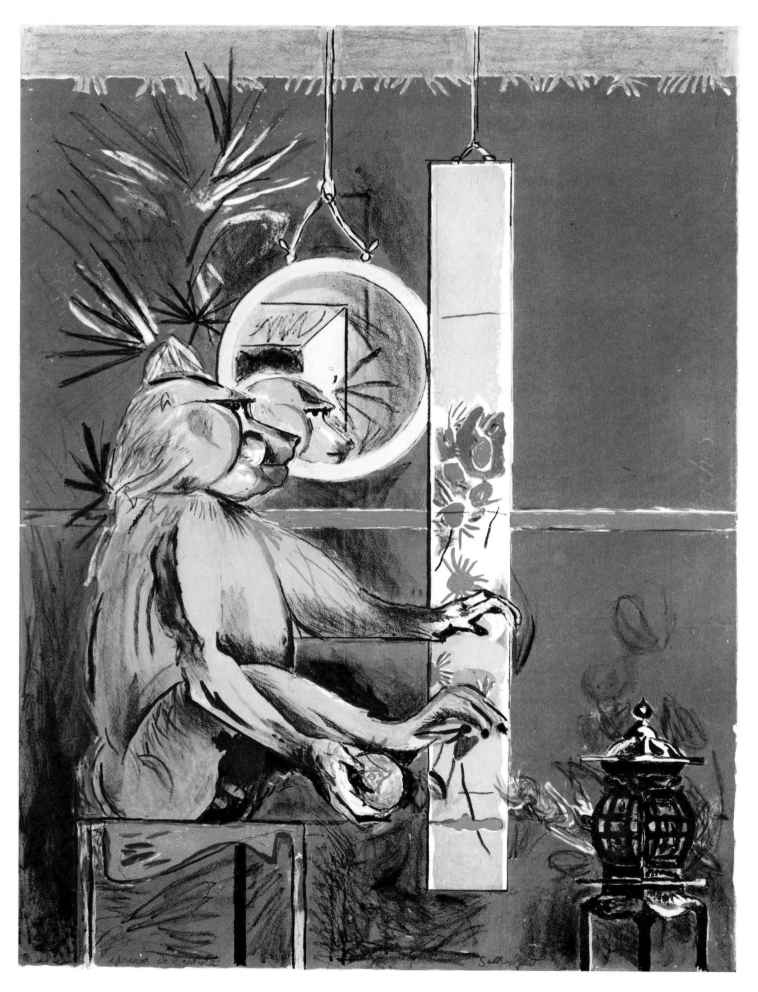

179 Graham Sutherland *Cynocephalus* 1968
66 × 55cm (26 × 21⅝in.)

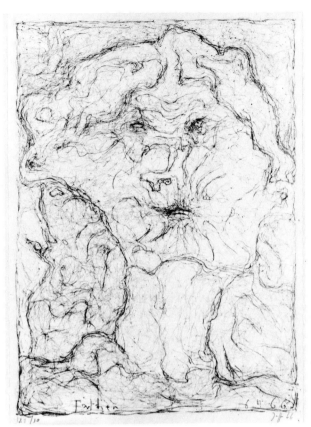

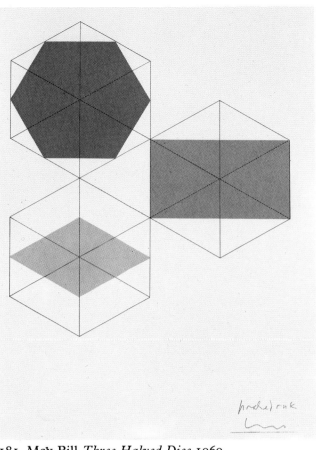

180 Horst Janssen *Auntie* 1966
48·5 × 34cm (19$\frac{1}{16}$ × 13$\frac{3}{8}$in.)

181 Max Bill *Three Halved Dice* 1969
38 × 33cm (14$\frac{15}{16}$ × 13in.)

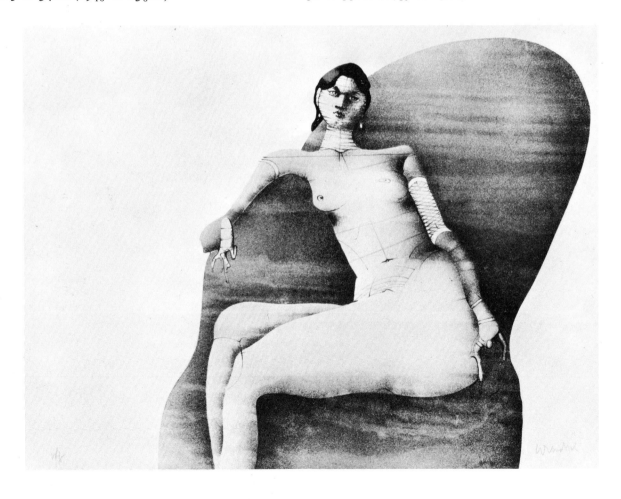

182 Paul Wunderlich *Juana Posing for Redfern* 1968
50 × 65cm (19$\frac{3}{4}$ × 25$\frac{5}{8}$in.)

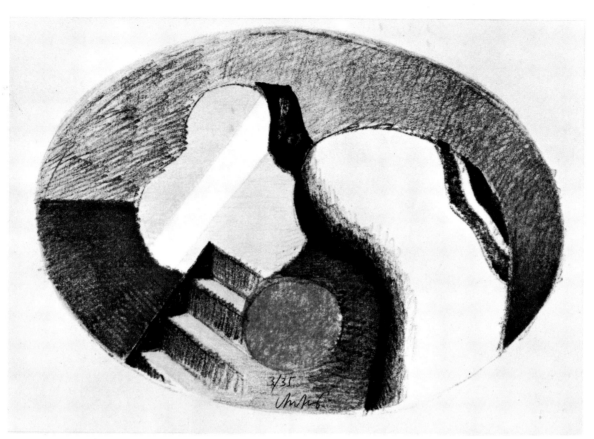

183  Horst Antes *Still-Life in an Oval* 1966
    21 × 29cm (8¼ × 11 7/16 in.)

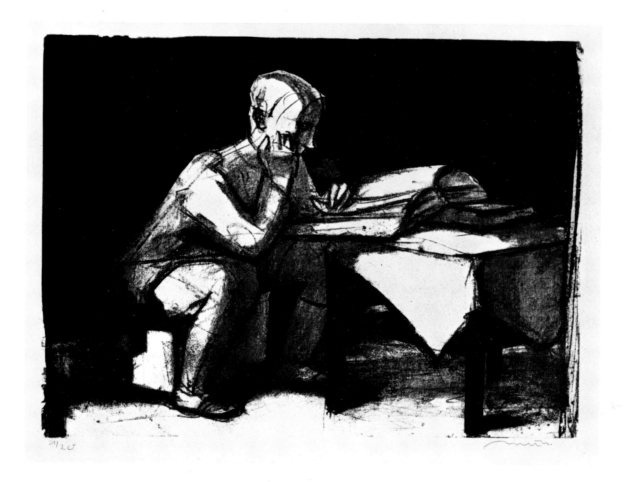

184  Hans Theo Richter *Boy Reading* 1954
    29·5 × 40·3cm (11 5/8 × 15 7/8 in.)

Poster in colour-lithography. Fuchs, living in Vienna, is very much under the influence of art nouveau and the Vienna school of the turn of the century.

**187 Motherwell, Robert b. 1915**
*Automatism B* 1965–6
Ink and brush. Motherwell, one of the leading American artists, stands with his abstractions in between Expressionism and Automatism. His lithos are published by Marlborough-Gerson, New York.

**188 Belling, Rudolf b. 1886**
*Composition* (Project for Metal Plates and Wire) [Entwurf für Metall-Platten und Draht] 1967
Chalk. Belling (born in Berlin), whose work in the 1920s had great influence on the development of modern sculpture, has only taken up lithography in recent years.

**189 Hockney, David b. 1937**
*The Print-Collector* 1969
Chalk. Hockney, best known for his series of etchings (*The Rake's Progress, Grimm's Fairy Tales*), is one of the leading figurative British artists of the younger generation and a remarkable portraitist. His style, out of the ordinary, is very much his own.

**190 Singier, Gustave b. 1909**
*Venice* 1957
Colour lithograph. Singier's colour lithographs are strong abstractions based on nature.

**191 Jones, Allen b. 1937**
*Icarus* 1968
Colour lithograph. Jones, one of the best known British Pop Artists, has worked in England and in the United States. His compositions are figurative.
Lent by the artist

**192 Marini, Marino b. 1901**
*Small Scene* [Piccolo Teatro] 1970
Lithograph in colour. Marini, probably the most important artist living in Italy today, is both sculptor and painter. His lithographs are fine documents of his art and of the method he uses to express himself. From *Europäische Graphik VII*

**193 Rauschenberg, Robert b. 1925**
*Suburban* 1962
Composition lithograph with collage. Rauschenberg, excellent draughtsman, did this lithograph for Tanya Grossman in New York. From the collection of Allen Jones

# Glossary

ALGRAPHY Process of chemical printing where aluminium sheets are used instead of stones

AQUATINT A process used in etching to obtain tonal effects similar to a wash, invented around 1760

ARTIST An artist is a painter, sculptor, engraver etc., who expresses himself in his own original way, creating a work of art and so transmitting his experience to others. The word is often misused for painter

AUTOGRAPHIE French term for transfer lithograph

AVANT LETTRE See *Before Letter*

BEFORE LETTER A proof taken from the finished plate, before any inscription or title is added

CATALOGUE OF PRINTS often named *Catalogue raisonné*. The graphic work of many artists has been catalogued and numbered, so as to make it possible to identify the prints. These catalogues also contain title, date, editions and a description of the various states which exist

CHALK MANNER also named *Crayon manner*. The very first lithographs were mostly done in ink, with pen or brush. Only after stones had been grained was a special chalk used satisfactorily

CHEMICAL PRINTING Based on the antagonism of water and grease, Chemical Printing, invented by Senefelder in 1798, comprises all methods of flat printing, independent of the material used to print from. Chemical printing is the only method of printing from a flat surface and is completely different in principle from mechanical printing, such as letterpress, wood-engraving or metal-engraving and etching

CHROMOLITHOGRAPHY Printing lithographs in colour from several plates, invented by Senefelder and first practised to reproduce paintings and watercolours on a larger scale by Engelmann of Mulhouse, who even obtained a privilege for his process

COLOUR The proper term for a lithograph printed from various plates in colour is 'colour lithograph' or 'lithograph in colour' and *not* coloured lithograph, as this latter term indicates a lithograph afterwards coloured by hand

DRY STAMP In France called *timbre sec*, used by publishers to verify the genuineness of prints

ÉPREUVE French term for proof

ESTAMPE French term for print, engraving, etching, wood-cut or lithograph, not made as illustration for a text

ÉTAT French term for state

INCUNABULA In lithography all lithographs from the early days are regarded as incunabula. The term has been adopted from early book-printing where books printed before 1500 are called incunabula. Dussler, who catalogued the German early lithographs, takes the year 1820 as limit, a time when many thousands of lithographs had already been produced. The year 1810 would be more suitable, also for England; for France the year 1818

INK For lithography the ink must contain greasy substances; a pen or a brush is used and the ink can be thinned out (washes)

INTAGLIO PROCESS The lines which print are deeper than the surface of the plate and filled with ink before an impression is taken

LITHOGRAPHY Term used today for the various methods of Chemical Printing, even when no stone is used

LITHOTINT Lithotint is a method of applying washes of various densities with the brush to the stone. Invented by Senefelder, the process was given its name by Hullmandel. In France Engelmann called the method *Procédé du lavis lithographique*

ORIGINAL LITHOGRAPH This is a lithograph drawn by the artist himself after his own design and invention on the stone, plate or transfer paper. The technical process used has no bearing on whether a lithograph is an 'original' or not, and it does not matter whether stone, zinc or transfer paper has been used. If, however, another person draws the lithograph after a painter's design, the product is a mere reproduction. The same applies to colour lithographs, which can only be regarded as originals when the artist does all the necessary design for the various colour plates himself on the plates or transfer paper

PAPYROGRAPHIE French term for lithography on stone paper

PAPIER AUTOGRAPHIQUE French term for transfer paper

PAINTER A painter is, properly speaking, someone who knows how to handle paint and to draw

PEINTRE-GRAVEUR French term for a painter or sculptor who produces original graphic works

PLATE In lithography or chemical printing the plate can be stone, metal or a suitable substitute

POLYAUTOGRAPHY Name used early on in Britain and Germany for what we today call lithography

PRINT Term used for the products of original graphic art

PROOF French term *épreuve*. In general, all impressions taken from a plate are called proofs. Special meanings: 'trial proof' is an impression taken while the work on the plate is still in progress; 'artist's proof', impressions taken for the 'artist', which are usually taken before an edition is printed

RELIEF PROCESS The lines or surfaces which print are raised in comparison to the surrounding area (letterpress, woodcut, etc.)

REMARQUE French term for small sketches often made outside the actual area of the drawing on the plate, to be removed before an edition is printed

REPORT French term for transfer

SCRAPING By scraping one can make a complete drawing or take out parts of an existing drawing on the stone, for the purpose of correction or addition to the design. Charlet did some lithographs in the scraping method from a stone blackened beforehand all over with greasy ink

SIGNATURE There are two kinds of signatures: on the plate itself or on the paper after printing. This latter method of signing by hand afterwards did not come into general use before about 1880

SIZE The size of a lithograph indicates the actual area covered by the drawing, including all framing lines, signature on the plate; in short everything drawn by the artist on the plate. Heights are given first. This method differs from the one used in measuring etchings or engravings, where the plate-mark on the paper determines the size

STATE In French *état*. In order to judge his work, the artist takes some pulls while a lithograph or engraving is in progress. He then decides what alterations have to be made. These pulls taken while the work is in progress constitute the different states until the work is finished, then called final state. Further states may be created by adding a printed text or altering or omitting this again. The states before title or printer's or publisher's name are added are described as 'before letters'. These are of a higher intrinsic and commercial value

STONE PAPER French term *carton autographique*. Invented by Senefelder, this consists of sheets of card on to which a mixture of grained stone has been laid, after a special process. The idea was to gain a printing surface with the qualities of the stone, without having its weight. Stone paper was used by Géricault for a number of lithographs

TRANSFER PAPER Invented by Senefelder, transfer paper was greatly improved about 1868. It has the great advantage that the artist can work in his studio, without being forced to make the drawing in reverse. When transferred to the stone, the artist usually continues to work on his drawing. The transfer method when properly used has no influence on quality, authenticity or value of a lithograph

ZINCOGRAPHY Technical term for chemical printing where the plate from which the impressions are taken is made from zinc instead of stone

# Selected bibliography

Adhémar, J. *L'Estampe Française: la Lithographie Française au XIXe Siècle* Paris 1944

Aufseesser, J. *Sammlung Aufseesser* (Catalogue of his collection) Berlin 1902

Aufseesser, J. 'Künstlerische Frühdrucke der Lithographie' *Zeitschrift für Bücherfreunde*, I Jahrg. Vol. III, June 1897

Banks, H. *Lithography or the Art of Making Drawings on Stone* Bath 1813, 2nd ed. 1816

Bénézit, E. *Dictionnaire des Peintres, Sculpteurs, Dessinateurs et Graveurs* Vols 1–8, Paris 1960

Beraldi, H. *Les Graveurs du XIXe Siècle* 12 vols Paris 1885–92

Bock, E. *Die Deutsche Graphik* Munich 1922

Bock, E. *Geschichte der Graphischen Kunst, Ergänzungsband zur Propyläen Kunstgeschichte* Berlin 1930

Bouchot, H. *La Lithographie* Paris 1895

Buchheim, G. L. *Graphik des Deutschen Expressionismus* Feldafing 1959

Calabi, A. *Saggio sulla Litografia* Milan 1958

Cowdrey, Mary B. 'Fanny Palmer, an American Lithographer' *Prints* New York 1962

Craven, Th. *A Treasury of American Prints* New York 1939

Delteil, Loys Le Peintre Craveur Illustre, 21 vol. Paris 1906–25; Manuel de L'Amateur d'Estrauipes du XIXe & XXe siecles. 2 vol. text 2 vol. plates. Paris 1925

Denzinger and Hirschfeld 'Ergänzungen zu Dussler' *Münchner Jahrbuch* Munich 1929

Duchatel, E. *Traité de la Lithographie Artistique* Paris (1893)

Dunst, J. M. *Praktisches Lehrbuch der Lithographie und Steindrucker Kunst* Bonn 1836

Dussler, L. *Die Incunabeln der Deutschen Lithographie* Munich 1925 and 1955

Engelmann, G. *Rapport sur la Lithographie introduite en France par G. E. Engelmann, de Mulhouse (Haut Rhin)* 1815

Engelmann, G. *Manuel du Dessinateur Lithographe* Paris 1822

Engelmann, G. *Rapport sur la Chromolithographie* Mulhouse 1837

Engelmann, G. *Traité Théorique et Pratique de Lithographie* Mulhouse (1838?)

Ferchl, F. M. *Geschichte der Errichtung der ersten lithographischen Kunstanstalt der Feiertagsschule in München* Munich 1862

Ferchl, F. M. *Übersicht der besten und einzigen Incunabel-Sammlung der Lithographie* Munich 1856

Friedlander, M. J. *Die Lithographie* Berlin 1922

Fumagalli, G. *Incunabuli della Litografia d'Italia* Rome 1937

Gensel, Walther 'Die Einführung der Steindruckerei in Berlin' *Velhagen und Klasings Monatshefte* 18 Jahrg. Vol. 10, 1904

Glaser, Curt *Die Graphik der Neuzeit* Berlin 1923

Gollerbakh, E. *History of Engravings and Lithography in Russia* St Petersburg 1923 (in Russian)

Gräff, Walter, *Die Anfänge der Lithographie in Frankreich* (Gesellschaft für vervielfältigende Kunst) Vienna 1904

Gräff, Walter *Die Einführung der Lithographie in Frankreich* Heidelberg 1906

Gräff, Walter, 'Die Einführung der Lithographie in Italien' *Zeitschrift für Bücherfreunde* Vol. II p. 324ff., 1913

Groschwitz, G. von 'The Original Lithography in Color in the Nineteenth Century' *Marsyas* Vol. VI p. 81ff., New York 1954

Groschwitz, G. von 'Nineteenth-Century Color Lithographs' *Gazette des Beaux Arts* Vol. VI p. 243ff., 1954

Hammerle-Ohlenroth *Die Lithographie in Augsburg* Maximilian-museum Augsburg 1927

Hartlaub, G. *Die Neue Deutsche Graphik* Berlin 1920

Hartlaub, G. *Die Graphik des Expressionismus in Deutschland* Stuttgart 1947

Hédiard, G. *Les Maîtres de la Lithographie* n. d.

Henrici, Karl E. *Katalog LXIX: Meister der Lithographie, 1800–1880* Berlin 1921

Hoffmann, Paul *Ein Beitrag zur Geschichte der Lithographie* Berlin 1924

Hullmandel, C. *The Art of Drawing on Stone* London 1824

Kann, E. 'Lithographica' *Zeitschrift für Bücherfreunde* Vol. III p. 185ff., 1899–1900

Korostin, A. F. *Russian Lithography in the Nineteenth Century* Moscow 1953

Man, Felix H. *150 Years of Artists' Lithographs* London 1953

Man, Felix H. 'Die Frühe Künstlerlithographie in Deutschland' *Börsenblatt für den Deutschen Buchhandel* No. 22a 1959

Man, Felix H. 'Lithography in England, 1801–1810' *Prints* New York 1962

Man, Felix H. *Lithographie in England, 1801–1810* Hamburg 1967

Man, Felix H. 'Die Ingres Lithographien' *Düsseldorfer Handelsblatt* No. 135, Art Supplement 1965

Mayer, Rudolph *Die Lithographie* Dresden 1955

Mellerio, A. *La Lithographie Originale en Couleurs* Paris 1898

Moulijn, S. *Die Ersten Jaren der Lithographische Prentkunst in Nederland* S-Gravenhage 1927

Nagler, G. K. *Alois Senefelder und der Geistliche Rat Simon Schmid als Rivalen* Munich 1862

Ozzola, L. *La litografia italiana dal 1805–1870* Rome 1923

Pennell, Joseph and E. R. *Lithography and Lithographers* London 1898 and 1915

Pennell, Joseph 'The Truth about Lithography' *The Studio* London 1899

Peters, H. *Currier & Ives* 2 vols New York 1929 and 1931

Peters, H. *America on Stone* New York 1931

Pfister, Kurt *Deutsche Graphiker der Gegenwart* Leipzig 1920

Platte, Hans *Die Anfänge der Künstlerlithographie in Deutschland* Freiburg 1953 (Dissertation)

Platte, Hans 'Studien zur frühen Künstlerlithographie in Deutschland' *Börsenblatt für den Deutschen Buchhandel* No. 95a, 1958

Rapp, H. *Das Geheimnis der Steindruckerey* Tübingen 1810

Ratta, C. *L'Arte della Litografia in Italia* Bologna 1930

Roger-Marx, C. *La Gravure Originale en France de Manet à nos Jours* Paris 1939

Rosenthal, Léon *La Gravure* Paris 1909

Senefelder, A. *Vollständiges Lehrbuch der Steindruckerey* Munich 1818

Senefelder, A. *A Complete Course of Lithography* London 1819

Senefelder, A. *L'Art de la Lithographie* Munich and Paris 1819 (Italian edition, Naples 1824)

Sickert, Walter 'The Old Ladies of Etching-needle Street' *The English Review* London January 1912

Singer, H. W. *Die Moderne Graphik* Leipzig 1914

Skira, A. *Anthologie du Livre* Geneva 1946

Thieme U. and Becker F. *Allgemeines Lexikon der Bildenden Künste* 1950 ff.

Wagner, Carl *Alois Senefelder sein Leben und Wirken* Leipzig 1914

Watt, P. B. 'Early English Lithography' *The Artist* London May 1896

Weber, W. *Saxa Loquuntur* 2 vols Munich 1961 and 1964; London 1966

Weishaupt, Heinrich *Theoretisch-praktische Anleitung zur Chromolithographie* Quedlinburg and Leipzig 1848

Weishaupt, Heinrich *Verzeichnis der Lithographischen Inkunabeln Sammlung* Munich 1884

Winkler, R. A. 'Zur frühen Künstlerlithographie' *Börsenblatt für den Deutschen Buchhandel* No. 22a, 1959

Winkler, R. A. *Wie Sammle Ich Lithographien* Munich 1965

Artaria, *Katalog einer Sammlung zur Geschichte der Entwicklung und Blüte der Künstlerlithographie* Vienna 1928

*The Analectic Magazine* Vol. XI p. 163; Vol XII p. 350, p. 430 1818; Vol. XIV p. 67ff., 1819 and 1820 Philadelphia

*The Art Chronicle* 'The Revival of Lithography' February 1910 London

*Englische Miscellen* Vol. XIII No. 1 October 1803 Cotta, Tübingen

*Gentleman's Magazine* Vol. LXXVIII p. 193 March 1808 London

*Le Lithographe (Journal des Artistes et des Imprimeurs)* (Artists' and Printers' Journal) 1838–39 Paris

*Schorn's Kunstblatt* 'Über das Ätzen von Marmor' Nos 99 and 100 1820 Cotta, Tübingen

Gesellschaft für Vervielfältigende Kunst *Die vervielfältigende Kunst der Gegenwart* Vol. IV, Lithographie, Vienna 1887–1903

Haus der Kunst München *Fünf Jahrhunderte Europäische Graphik* Munich 1965

Staatliche Graphische Sammlung Munich *Katalog Bild vom Stein* Munich 1961

Staatliche Kunst Sammlung Dresden *150 Jahre Russische Graphik, 1813–1963* Dresden 1964

Verein Schweizerischer Lithographiebesitzer *Die Lithographie in der Schweiz* Berne 1944

# Catalogues, biographies, etc.

BECKMANN   Curt Glaser *Beckmann mit Katalog von Beckmann's Graphik* 1900–23 N.D. (1924)
  Klaus Gallwitz *Max Beckmann, Druckgraphik* Karlsruhe 1962

BLAKE   Archibald G. D. Russel *The Engravings of William Blake* London 1912
  Keynes, G. *William Blake's Engravings* 1950
  Gilchrist *Life of W. Blake* London 1863

BONINGTON   A. Curtis *Catalogue de l'oeuvre gravée et lithographiée de R. P. Bonington* Paris 1939

BONNARD   Charles Terasse *Bonnard* Paris 1927
  Claude Roger-Marx *Bonnard Lithographe* Monte Carlo 1952

BOYS   Gustav v. Groschwitz, Shotter Boys *Prints* New York 1962

BRAQUE   Fernand Mourlot *Braque Lithographe* Monte Carlo 1963

BARLACH   F. Schult *Das Graphische Werk* II Hamburg 1958

CARRIÈRE   L. Delteil *Le Peintre-Graveur Illustré VIII*

CÉZANNE   L. Venturi *Cézanne. Son Art, son Oeuvre* 2 vols Paris 1936

CHAGALL   F. Mourlot *Marc Chagall, Lithographe* I, II, III Monte Carlo 1960, 63ff.

CHARLET   La Combe *Charlet sa vie* etc. with catalogue of his lithographs Paris 1856

CHASSÉRIAU   L. Bénedite *Chassériau, sa Vie et son Oeuvre* Paris 1931

CORINTH   K. Schwarz *Das graphische Werk von Lovis Corinth* Berlin 1922
  Heinr. Müller *Die späte Graphik von L. Corinth* 1960

COROT   A. Robaut *L'Oeuvre de Corot* Paris 1905
  L. Delteil *Le Peintre-Graveur Illustré.* V Paris 1910

COURBET   G. Riat *Gustave Courbet Peintre* Paris 1906

DAUMIER   L. Delteil *Le Peintre-Graveur Illustré.* XX–XXIX (bis), 11 vols Paris 1925–30

DEGAS   L. Delteil *Le Peintre-Graveur Illustré.* IX Paris 1919
  Denis Rouart *Degas à la Recherche de sa Technique* Paris 1945

DELACROIX   L. Delteil *Le Peintre-Graveur Illustré.* III Paris 1908
  R. Escholier *Delacroix, peintre, graveur, écrivain* 2 vols Paris 1926–29

DENIS   Pierre Cailler *Catalogue raisonné de l'oeuvre gravé et lithographié de Maurice Denis* Geneva
  1968

DENON   de la Fizelière *Vivant Denon* Paris 1883

DEVERIA   Max Gauthier *Achille et Eugène Deveria* Paris 1925

DIAZ   G. Hédiard *N. Diaz* Paris

DUPRÉ   L. Delteil *Le Peintre-Graveur Illustré* I. Paris 1906

ERNST   *Le Point Cardinal, Max Ernst, Ecrits et Oeuvre gravé* Paris 1963
  (a new comprehensive catalogue by Dr. H. R. Leppien is in preparation)

FANTIN-LATOUR   G. Hédiard *Catalogue de l'Œuvre Lithographique* Paris 1906

FUSELI   A. Federmann *Heinr. Fuseli* Zurich 1927

GAUGUIN   M. Guérin *L'Œuvre gravé de Gauguin* Paris 1927
  Ch. Maurice *Paul Gauguin* Paris 1919

GAVARNI   P.-A. Lemoisne *Gavarni Peintre et Lithographe* 2 vols Paris 1924–8
  J. Armelhaut and E. Bocher *L'oeuvre de Gavarni* Paris 1873

GÉRICAULT   L. Delteil *Le Peintre-Graveur Illustré* XVIII Paris 1924

GOYA   L. Delteil *Le Peintre-Graveur Illustré* XIV and XV Paris 1922
  Hofmann, F., Goya, *Katalog seines graphischen Werkes* Vienna 1907
  Miguel Velasco Y Aguirre *Grabados y Litografias de Goya* Madrid 1928

GRIS   Henri Kahnweiler *Sa vie, son œuvre, ses écrits* Paris 1946. English translation, London
  1947

GROS   R. Escholier *Ses Amis et ses Elèves* Paris 1936

HUET   L. Delteil *Le Peintre-Graveur Illustré* VII Paris 1911

INGRES   L. Delteil *Le Peintre-Graveur Illustré* III Paris 1908
  Vct. H. Delaborde *Ingres, sa vie, ses travaux, sa doctrine* Paris 1870

ISABEY   A. Curtis *Catalogue de l'œuvre lithographié d'Eugène Isabey* Paris 1939

JOHN   C. Dodgson *Catalogue of etchings by Augustus John* London 1920

KANDINSKY   Will Grohmann *Kandinsky* Paris 1930
  W. Kandisky *Über das Geistige in der Kunst* Munich 1912
  W. Kandisky *Concerning the Spiritual in Art* London 1914; New York 1947
  W. Kandisky *Punkt und Linie zu Fläche. Bauhausbücher* No 9 Munich 1926
  W. Kandisky *Point and line to plane* New York 1946
KIRCHNER   Gustav Schiefler *Die Graphik Ernst Ludwig Kirchners* 2 vols Berlin 1926
  Dube-Heyning *E. L. Kirchner, Graphik* 1961
KLEE   J. T. Soby *The prints of Paul Klee* New York 1945
  E. W. Kornfeld *Verzeichnis des graphischen Werkes von Paul Klee* Berne 1963
KOKOSCHKA   Paul Westheim *Oskar Kokoschka* Berlin 1918
  Wilhelm Arntz *Das Graphische Werk Oskar Kokoschka* 1908–49 Munich 1950
KOLLWITZ   Johannes Sievers *Die Radierungen und Steindrucke von Käthe Kollwitz* Dresden
    1913
  A. Wagner *Die Radierungen, Holzschnitte und Lithographien von Käthe Kollwitz seit 1912* Dresden
    1927
  Aug. Klipstein *Käthe Kollwitz* Berne 1955
LÉGER   Douglas Cooper *Fernand Léger* London and Paris-Geneva 1949
  Exhibition catalogues, Tate Gallery, London 1950
LIEBERMANN   G. Schiefler *Das Graphische Werk von Max Liebermann* vol. I, Berlin 1902;
    vol. II, Berlin 1914; and Berlin 1923
  M. Friedländer *Max Liebermann's Graphische Kunst* Dresden 1920
MANET   Moreau-Nelaton *Manet, Graveur et Lithographe* Paris 1906
  Marcel Guérin *L'Œuvre gravé de Manet* Paris 1944
  Théodore Duret *Histoire d'Edouard Manet et de son œuvre* Paris 1902. English edition: *Manet
  and the French Impressionists* London 1910
MASSON   M. Leiris et G. Limbour *André Masson et son Univers* Geneva-Paris 1947
MATISSE   Alfred H. Barr, Jr *Henri Matisse* New York 1951
MENZEL   Elfried Bock, Adolf Menzel *Verzeichnis seines graphischen Werkes* Berlin 1923
  W. Kurth *Adolf Menzels Graphische Kunst* Dresden 1920
MIRÓ   M. Leiris *The prints of Joan Miró* New York 1947
MOORE   Herbert Read *Henry Moore, Sculpture and Drawings* 3rd edition London 1949
  James J. Sweeney *Henry Moore* New York 1946
MUNCH   Gustav Schiefler, *Verzeichnis des Graphischen Werkes Edv. Munch* Vol. I bis 1906,
    Berlin 1907; Vol. II 1906–26 Berlin 1928.
  G. Schiefler, 'Edvard Munch's Graphische Kunst' *Arnold's Graphische Bücher* Vol. VI
    Dresden 1923
  Rolf Stenerson *Edvard Munch* Oslo and Zurich 1949
  Curt Glaser *Edvard Munch* Berlin 1918
NASH   Ed. Margot Eates *Paul Nash* London 1948
NOLDE   G. Schiefler *Das Graphische Werk von Emil Nolde* Vol. I bis 1910, Berlin 1911; Vol. II
    1910–25 Berlin 1926
  Schiefler-Mosel *Emil Nolde, Das graphische Werk II* Cologne 1967
PICASSO   Bernhard Geiser *Picasso peintre-graveur* Berne 1933
  Fernand Mourlot *Picasso lithographe* Vol. I (1919–47); Vol. II (1947–49).
  1949 and 1950; Vol. III 1956; Vol. IV 1964 Monte Carlo
  Alfred H. Barr, Jr *Picasso, Fifty Years of his Art* New York 1946
PISSARRO   L. Delteil *Le Peintre-Graveur Illustré* XVII Paris 1923
PRUD'HON   Ed. de Goncourt *Catalogue de l'œuvre peint, dessiné et gravé de P. P. Prud'hon* Paris
    1876
  J. Guiffrey *L'Œuvre de Prud'hon* Paris 1924
REDON   André Mellerio *Odilon Redon* Paris 1913
  André Mellerio *Odilon Redon, Peintre, Dessinateur et Graveur* Paris 1923
  Odilon Redon *A Soi-même* Journal (1867–1915) Paris 1922
RENOIR   L. Delteil *Le Peintre-Graveur Illustré* XVIII Paris 1923
  Cl. Roger-Marx *Les Lithographies de Renoir* Monte Carlo 1951
REUTER   P. Hoffmann *Wilhelm Reuter, ein Beitrag zur Geschichte der Lithographie* 1924
ROUAULT   James T. Soby *Georges Rouault, paintings and prints* New York 1945

SCHADOW  H. Mackowsky *Schadow's Graphik* Berlin 1936

SCHMIDT-ROTTLUFF  Rose Schapire *K. Schmidt-Rottluff, Graph. Werk* 1924

SCHINKEL  Dussler *Die Inkunabeln der Deutschen Lithographie* Berlin 1928

SIGNAC  U. Johnson *Ambroise Vollard* New York 1944
　Paul Signac *D'Eugène Delacroix au Néo-Impressionisme* Paris 1939

SISLEY  L. Delteil *Le Peintre-Graveur Illustré* XVII Paris 1923

SLEVOGT  A. Rümann *Verzeichnis der Graphik von Max Slevogt* S.D. Hamburg
　E. Waldmann *Max Slevogts graphische Kunst* Dresden 1921

STOTHARD  Bray *Life of Th. Stothard* London 1851

SUTHERLAND  Felix H. Man *Graham Sutherland, The Graphic Work* 1922–1970 Munich
　1970

THOMA  J. A. Beringer *Hans Thomas Griffelkunst* Frankfurt 1916
　J. A. Beringer *Hans Thomas Graphik* 1922
　H. Tannenbaum *Hans Thomas Graphische Kunst* Dresden 1920

TOULOUSE-LAUTREC  L. Delteil *Le Peintre-Graveur Illustré* X–XI Paris 1920
　Maurice Joyant 'Henri de Toulouse-Lautrec' *Dessins, Estampes, Affiches*, vol II, Paris 1927
　Ludwig Charell, *Toulouse-Lautrec, his lithographic work* Exhibition Catalogue, London 1951
　Jean Adhémar *Toulouse-Lautrec, his complete lithographs and drypoints* London 1965

UTRILLO  M. Gauthier *Utrillo* Paris 1944

VERNET  Armand Dayot *Les Vernet, Josef, Carle, Horace* Paris 1898

VILLON (Jacques)  J. Auberty and Ch. Perussaux *Catalogue de son œuvre gravé* Paris 1950

VUILLARD  Cl. Roger-Marx *L'Œuvre gravé de Vuillard* Monte Carlo 1948

WARD  C. Reginald Grundy *James —ard, R.A. with a Catalogue of his Engravings and Pictures*
　London 1909

WHISTLER  T. R. Way *Whistler's Lithographs* London 1905

# Acknowledgments

For permission to reproduce lithographs the following acknowledgments are made: Pls. 124, 125 by permission of Paul Klee Foundation, Museum of Fine Arts, Berne. Pls. 126, 127 Copyright by Roman Norbert Ketterer, Campione d'Italia. Pl. 167 Reproduced by permission of Marlborough Fine Art (London) Ltd. Pl. 119 © Copyright by Cosmopress, Geneva. Works by Picasso (pls. 147, 151, 152, 153), Léger (pl. 168), Vuillard (pl. 106), Steinlen (pl. 109), Klee (pls. 124, 125), Matisse (pls. 139, 140), Denis (pl. 143), Ernst (pl. 163), Vlaminck (pl. 145) Rouault (pl. 146) are © by S.P.A.D.E.M. Paris. Works by Braque (pls. 148, 149), Bonnard (pl. 105), Laurencin (pl. 118), Dubuffet (pl. 161), Kandinsky (pl. 144) Rights Reserved A.D.A.G.P. Paris.

The following lithographs were lent for reproduction by the
British Museum, Department of Prints, London: pls. 9, 10, 36, 65, 104.
Victoria and Albert Museum, Department of Prints, London: pls. 100, 101, 106.
Philadelphia Museum of Art, Philadelphia: pls. 83, 84, 110, 114.
Kunsthaus, Zurich: pl. 79.
Städelsches Kunstinstitut, Frankfurt/M: pl. 20.
Redfern Gallery, London: pls. 161, 182.
All the other lithographs reproduced are from the author's collection.

# Index

Figures in italic refer to illustration plates on pages 73–192